JAZZ

"A cat's a cat in any language. You blow that horn,
that note, he knows what you're talking about."
—Louis Armstrong

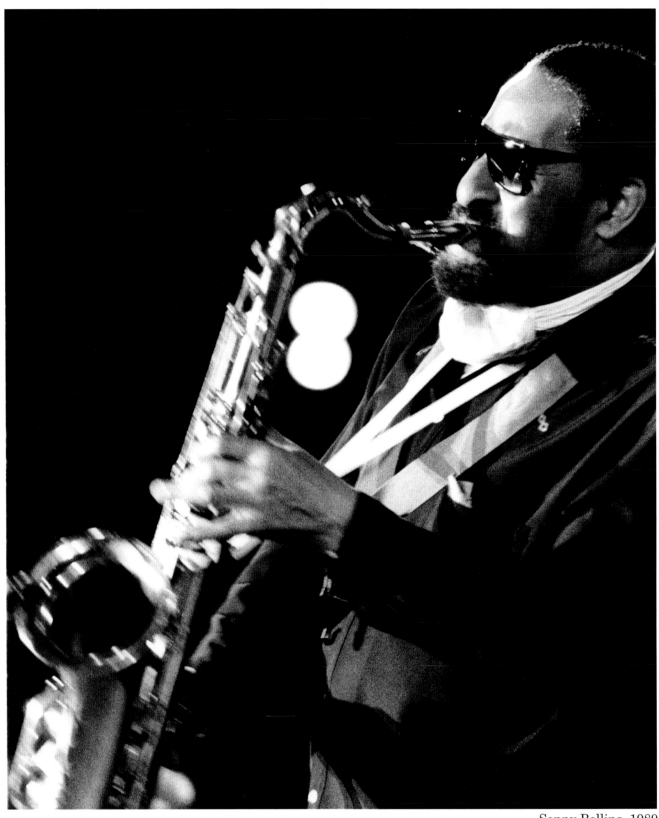

Sonny Rollins, 1989

"A lot of things I do are intuitive. If I'm in good shape, then I usually find some way to communicate with the audience. If I'm struggling on any particular night, then this can all be lost. This is what makes playing so much fun for me. It's not set; it's very problematical." —Sonny Rollins

JAZZ

Photographs by
David D. Spitzer

Introduction by Ira Gitler

Woodford Press

San Francisco

To Susana Sosa, who made my life much richer.
—D.S.

Published by
Woodford Press
660 Market Street
San Francisco, California, 94104

Book Design: Laurence J. Hyman
Editor: Jon Rochmis

Special thanks to Bob Rusch and *Cadence* magazine.

Quotations contained herein were excerpted from interviews
that appeared in editions of *Cadence: The American Review of Jazz & Blues*
(© Copyright *Cadence,* Redwood, New York, 13679), between 1977-1992*.

*Except for the following, which have been reprinted with permission from the respective publishers:
Keith Jarrett, Page 61 (*Talking Jazz: An Illustrated Oral History*, 1992, Pomegranate Artbooks, Petaluma, California)
Buddy DeFranco, Page 67 (*Barney, Bradley, and Max: Sixteen Portraits in Jazz*, 1989, Oxford University Press)
Mary Lou Williams, Page 68 (*The Jazz Scene*, 1991, Oxford University Press, New York)
Miles Davis, Page 82 (*Miles, the Autobiography* [© Copyright 1989 by Miles Davis], Simon and Schuster, Inc., New York)
Chris Connor, Page 107 (*The Jazz Scene*, 1991, Oxford University Press, New York)
Anita O'Day, Page 111 (*Jazz Voices*, 1983, Quartet Books, London)
Stan Getz, Page 123 (On the sleeve-note to *The Dolphin*, Concord CJ-158)
Oscar Peterson, Page 134 (*From Satchmo to Miles*, 1972, Da Capo Press, New York)
Horace Silver, Page 157 (*Talking Jazz: An Illustrated Oral History*, 1992, Pomegranate Artbooks, Petaluma, California)

ISBN: 0942627-14-8
Library of Congress Card Catalog Number: 94-78174

Typeface: New Century Schoolbook
Pre-press duotones: ScanArt Graphics, Richmond, California
Printed in Hong Kong

Preface

THIS VISUAL ESSAY attests to my predilection for jazz. My appreciation extends beyond the music's appeal to include the image of jazz musicians captured in the process of creation.

I was introduced to jazz in the late 1950s while attending Stetson University in Central Florida. Although live jazz in that area was almost nonexistent and recordings were not as prevalent as they are today, a jazz concert staged by a group of Stetson School of Music students featuring the work of Thelonious Monk and my classmates' recordings of Miles Davis and others piqued my curiosity for this music.

During the 1940s, my father—an amateur photographer—liked to take 35mm color slides of our family with his Kodak camera. His interest in human subject matter etched itself on my developing consciousness. He gave to me the gift of noticing.

The images gracing the covers of many jazz albums of the 1960s began to capture my interest. I know now that part of the reason I purchased many of these recordings—which offered the entire spectrum of jazz from bebop to the avant-garde—was for the cover photographs. This exploration of jazz visions and sounds created for me a group of heroes: jazz musicians.

In the 1970s—on a whim and with a borrowed camera—I took an Introduction to Photography course. Soon after, I bought my first camera. It didn't take long to select my primary subject matter, and I embarked on a rewarding photographic journey.

I shoot in black and white because it affords a greater degree of flexibility in its ability to lower or increase contrast through using graded paper or filters. Some years ago I began using recording film—which has a high ASA rating—and I exposed it at 3200. Later, I changed to a new addition to the film market, T-Max, 3200 ASA. These films gave me the ability to work in a low-light situation without a flash.

The black-and-white medium is my aesthetic preference because the images are abstracted by reducing all of the colors of the visible spectrum into the wide range of tonalities between black and white. Images of jazz artists seem to lend themselves naturally to this transformation. My primary photographic interest is to see how the jazz musician is transformed in the photographic image. It is the form and meaning conveyed by this change that really interests me.

My work attempts to freeze a moment that captures the wide range of emotions revealed by the performing musician. Body language, tactility and the shapes of instruments are all elements that I want to integrate meaningfully within the picture plane. The image, however, must stand on its own in its representation of the musician. I am especially gratified when someone is drawn to a photograph purely on aesthetics and not as a result of recognizing a famous performer.

There is much serendipity in my approach to photography. Each time I photograph, I am challenged by what I can make out of a situation that is not staged for my benefit. After more than two decades of photographing jazz musicans, I still become anxious in anticipation of capturing a meaningful shot. There is, after all, only so much a photographer can do within the confines of a live session.

My photographs of jazz musicians are displayed in exhibitions throughout the country, on album and CD covers, in books and periodicals, and now in this volume. These images document both innovators and "keepers of the flame" who advance and preserve this rich tradition in American music. While the artists represented have made significant contributions to musical history, this visual essay does not attempt to be historically complete. Rather, it reflects the fortuitous crossing of the paths of the photographer/fan and the musician.

David D. Spitzer
Miami, 1994

Introduction

AS SOMEONE WHOSE life has been consumed largely by describing jazz performances with the written word, I am well aware that ultimate understanding can be reached only in the hearing. True, wordsmiths can come close to approximating what the music represents, although naturally most fare better when writing about the musicians rather than the music itself. We should always be mindful, however, of that old adage about the worth of one picture.

In reality, all means of expression are necessary in attempting to illuminate a subject as vital and spiritual as jazz, a music that has the power to capture one's heart and imagination. This is the force that originally inspires writers and photographers to devote major portions of their lives to chronicle the jazz world's people and events.

When I use the term "jazz photographer," I am referring to someone who has produced a substantial body of work in the field even if he or she is also engaged outside the jazz realm. They have earned their reputations not by how many times they have aimed a camera at various jazz subjects but by the way they have used their entire range of photographic equipment and professional sensibilities to produce the result that most closely and tangibly represents an aesthetic. It is the inner vision that fuels the outer view.

The jazz photographer has the true passion for the music and an abiding interest in the people who make it. The best of them are, in a sense, like jazz musicians (or any creative artists) in that once they have mastered the necessary fundamental techniques they employ them in the service of their art. David Spitzer is such a photographer. I became familiar with his work in considerable breadth and depth when he contributed a large number of his photographs to *The Encyclopedia of Jazz in the Seventies*, which I wrote with Leonard Feather.

At a cursory glance, a photograph may be without motion, but it nevertheless can capture movement in such a way as to convey the action taking place. Certainly the portraiture involved in catching a musician in the act of playing—revealing the total immersion of the person in the music at a given moment—can transmit a mood very deeply. The many highly individual personalities within the jazz world have always offered rich opportunities for delineation.

Everyone who has known the musicians depicted in the following pages—either through recorded and live performances or perhaps on a personal level as well—will experience a variety of reactions in the viewing. For me, *JAZZ* presents the images of many acquaintances and more than a few very close friends. Too many are no longer here, but just as their music renders them immortal, so do their likenesses summon up vivid memories of their music and beyond.

A few months before I sat down to write this introduction, Red Rodney died. My friendship with him dated to 1948, although the first time I heard him play in person was at a Sunday afternoon jam session in 1945 when he teamed with Dexter Gordon on "Groovin' High." A virtually unknown Miles Davis (attending Juilliard at the time) was part of the session's final ensemble. Looking back, seeing those three at one time, for the very first time, was quite a milestone.

Each viewing of the pictures in this book provided me with waves of memories that became profound in their clarity: Johnny Griffin, behind Air Corps sunglasses, sitting in Lionel Hampton's sax section at the Strand Theater on Broadway, circa 1946; Jackie McLean being invited up on the stand at Birdland by Bud Powell around 1951 to play "Night in Tunisia;" Phil Woods jamming at the Open Door in 1953; Tony Williams playing with Jackie's group in the 1960s at the very same Fraternal Clubhouse on West 48th Street where I first saw Miles—and Miles was sitting next to me, digging Tony and hiring him shortly thereafter; Zoot Sims in St. Louis on the Tune Town Ballroom bandstand with Woody Herman in December 1947 and, after the gig in his hotel room, shuffling discs off a tall tower of 78s onto a portable phonograph, playing bandmates' requests for all the Basie sides featuring Lester Young; Roy Haynes playing the hippest "fours" in the world at Georgie Auld's Tin Pan Alley on West 47th Street in 1949; Sonny Stitt playing my alto on a Prestige recording date in December 1950; Sonny Rollins recording with Miles in January 1951 and, at the end of that year, with me in the studio as a first-time producer of Sonny's first date as a leader; Coltrane and Jimmy Heath as the altos in Dizzy Gillespie's big band at Lincoln University in Jefferson City, Mo., in late 1949; and Diz himself—freshly returned from California and the historic gig with Bird at Billy Berg's—opening at the Spotlite on 52nd Street in 1946.

With a giant such as Diz, there are so many visual residuals: Moving, as only Dizzy could, in front of his band at the Town Hall Christmas concert in 1946; drinking Scotch in his milk at the Downbeat Club's bar, Summer 1947; suddenly appearing in Buddy Rich's trumpet section at the 1967 Newport Jazz Festival; traveling with Carmen McRae and their groups on the bus during a 1982 Japanese typhoon.

As I write and look, look and write, the associations flow faster and freer: Watching with mixed horror and awe at Frank Rosolino's uncapping a Coke bottle with his teeth; finding a Chinese restaurant in Düsseldorf with Dexter Gordon in 1974; playing pool with Joe Venuti at Dick Gibson's Colorado Jazz Party; watching the fireworks when Joe and Zoot Sims jammed together for the first time at that same party; playing softball with Zoot and Al Cohn in Central Park; interviewing Mary Lou Williams at her apartment on Hamilton Terrace; watching football with Pepper Adams—the New York Giants at Yankee Stadium and the Tottenham Hotspurs up on White Hart Lane near London; eating roast beef at Simpson's with Lee Konitz.

But enough about my reveries and revelations. Go on and have some of your own. The important thing is the jazz spirit. Your share of it will be enhanced by going back, again and again, to study this sampling of Spitzer's scene. One picture I keep returning to is of Roy Eldridge. As much as any musician I've ever known, Eldridge embodied what it's all about.

Ira Gitler
New York, 1994

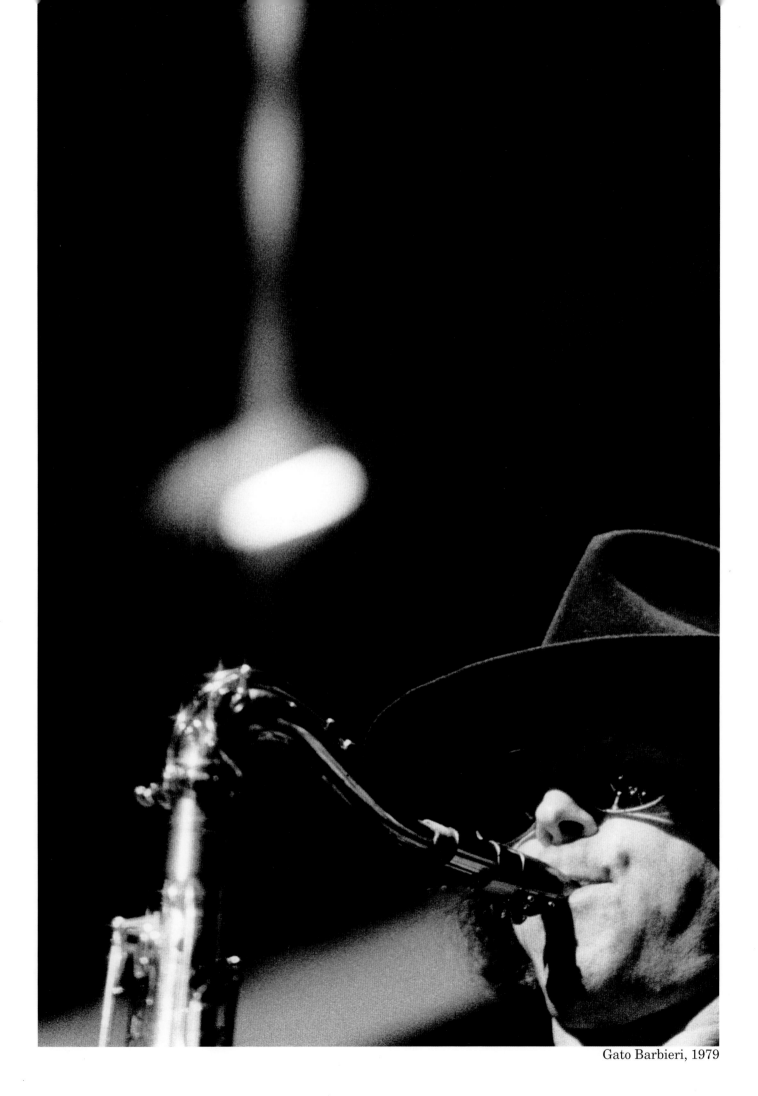

Gato Barbieri, 1979

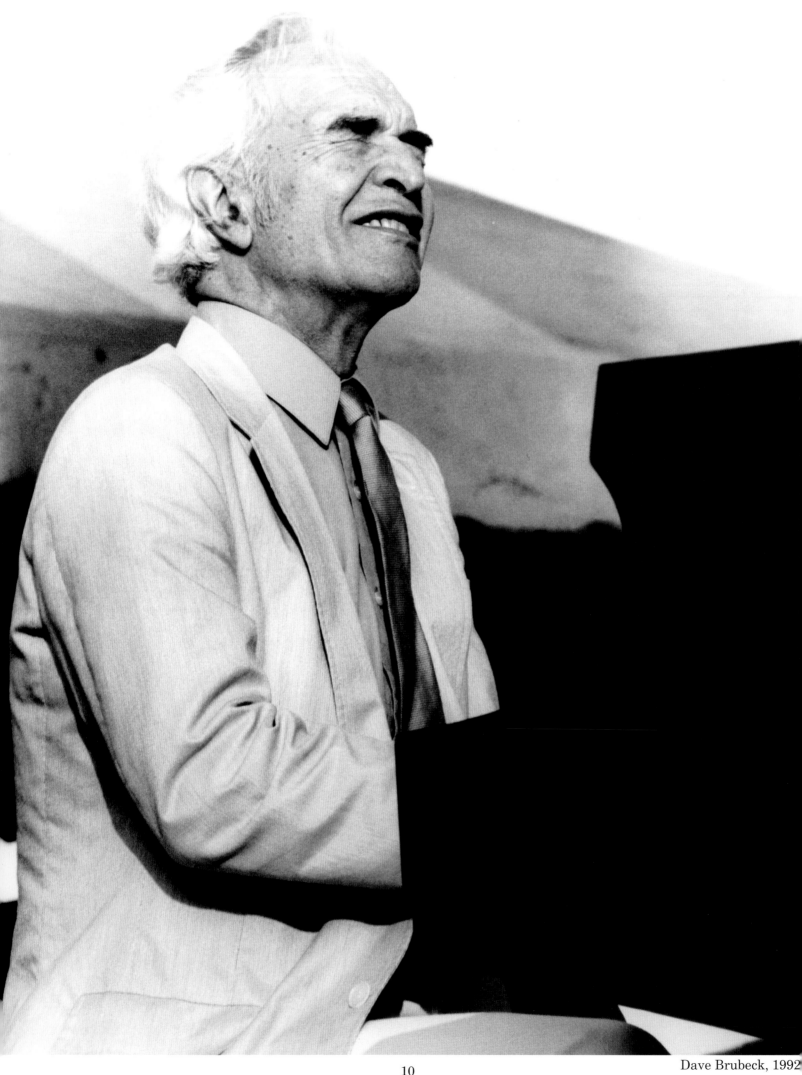

Dave Brubeck, 1992

"When Charlie Parker came along, I gave up wanting to be a composer-arranger, and I wanted to play—to play with someone like him who composed on his horn, because that's what good jazz is—spontaneous composition."
—Charles Mingus

Charles Mingus, 1973

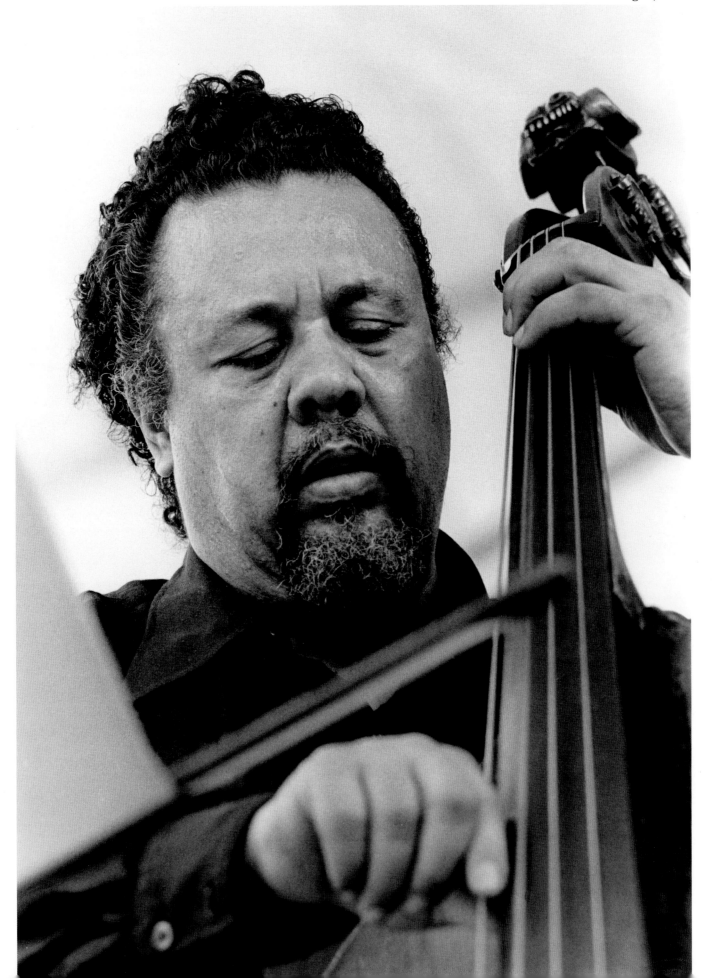

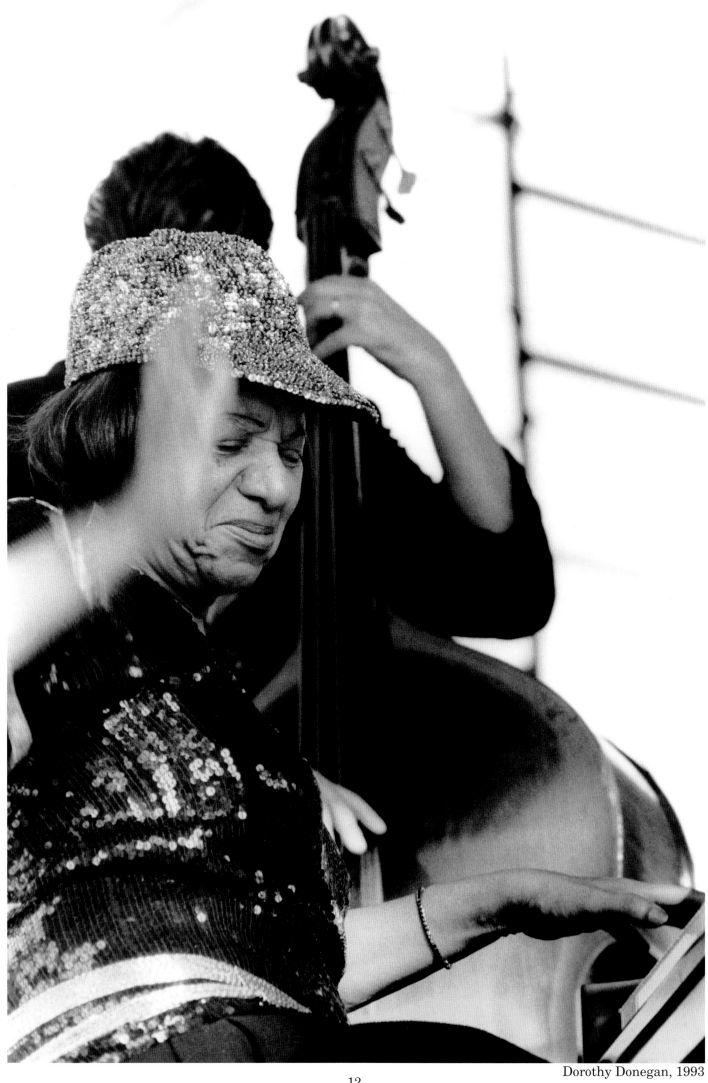

Dorothy Donegan, 1993

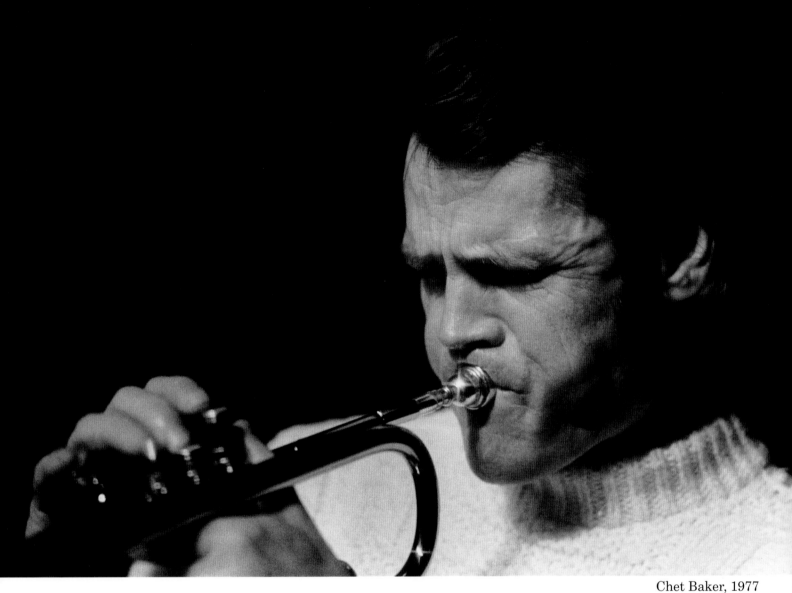

Chet Baker, 1977

"I just learned to play on my own. I hate
to practice. I like to hear a chord and from
what I hear I respond. I hear something
and I try to get it out the end of the horn."
—Chet Baker

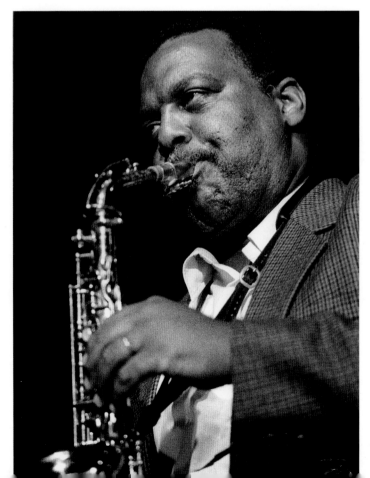

"I feel that I'm a receiver of the musi-
cal spirit, and it comes through me
and exits through the horn. I act as a
mediator for the source and the horn
acts as a mediator for me."
—Arthur Blythe

Arthur Blythe, 1989

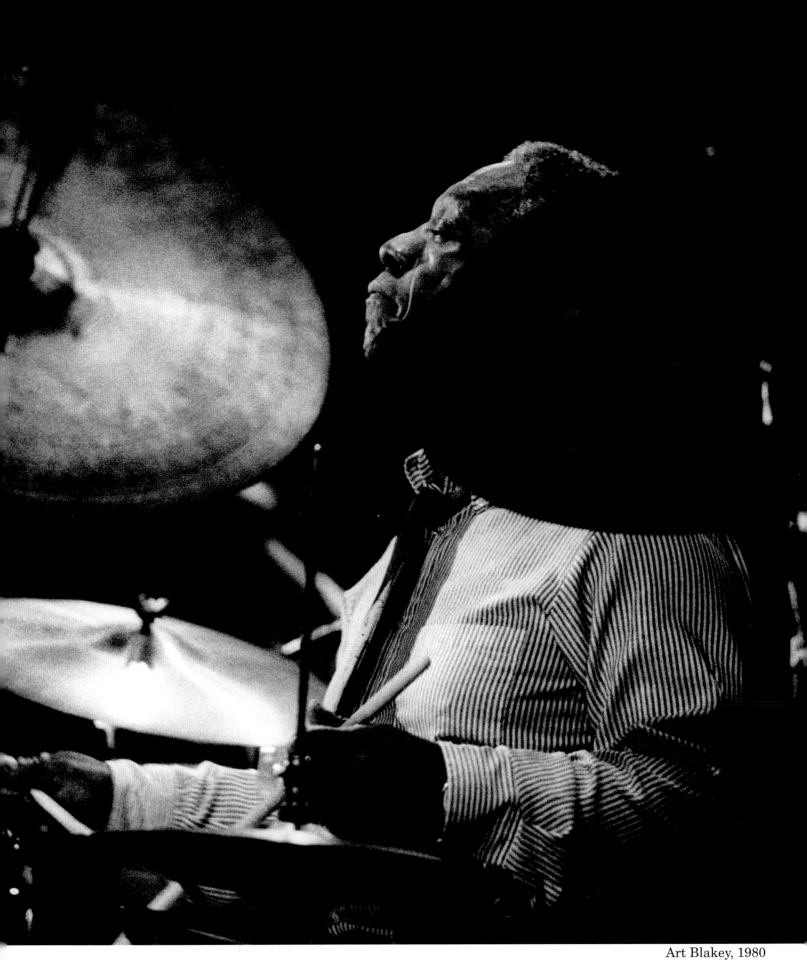

Art Blakey, 1980

"Music is a talent, but it's a loan, just for a little while in life. Nature takes its course and the talent will be removed from you and handed over to someone else. The talent belongs to the people and if you don't play, if you go for the money, you're going to lose your talent." —Art Blakey

Roy Eldridge, 1979

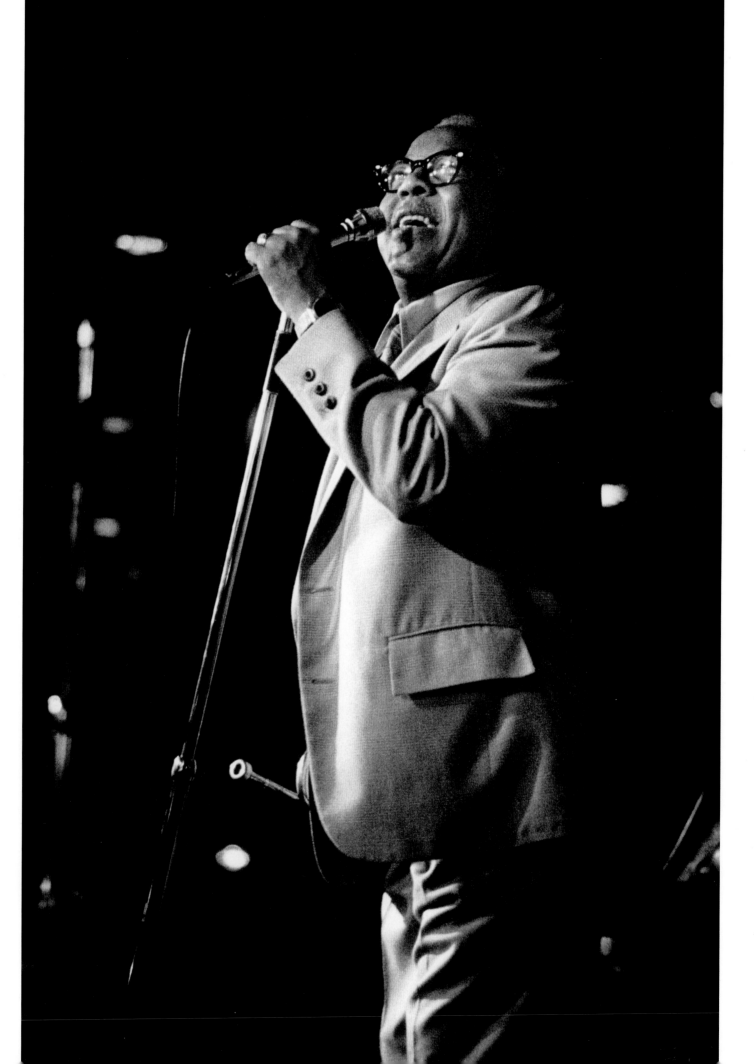

"I never liked the term 'cool.' I don't think my
quartets were cool. I had some fiery little bands
in the 1950s and 1960s." —Gerry Mulligan

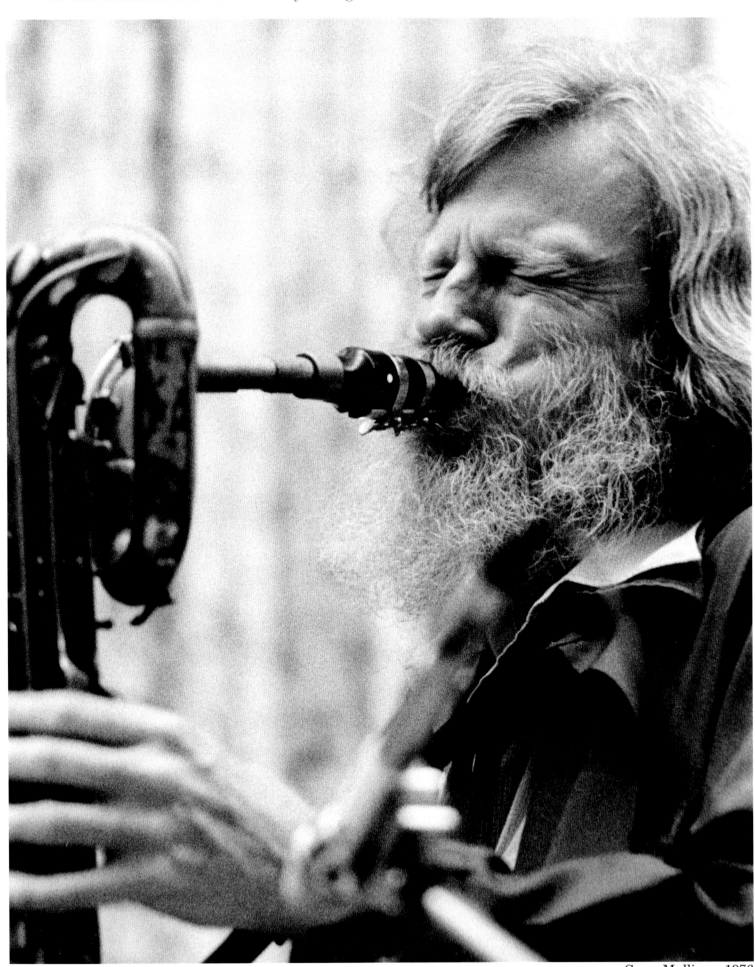

Gerry Mulligan, 1976

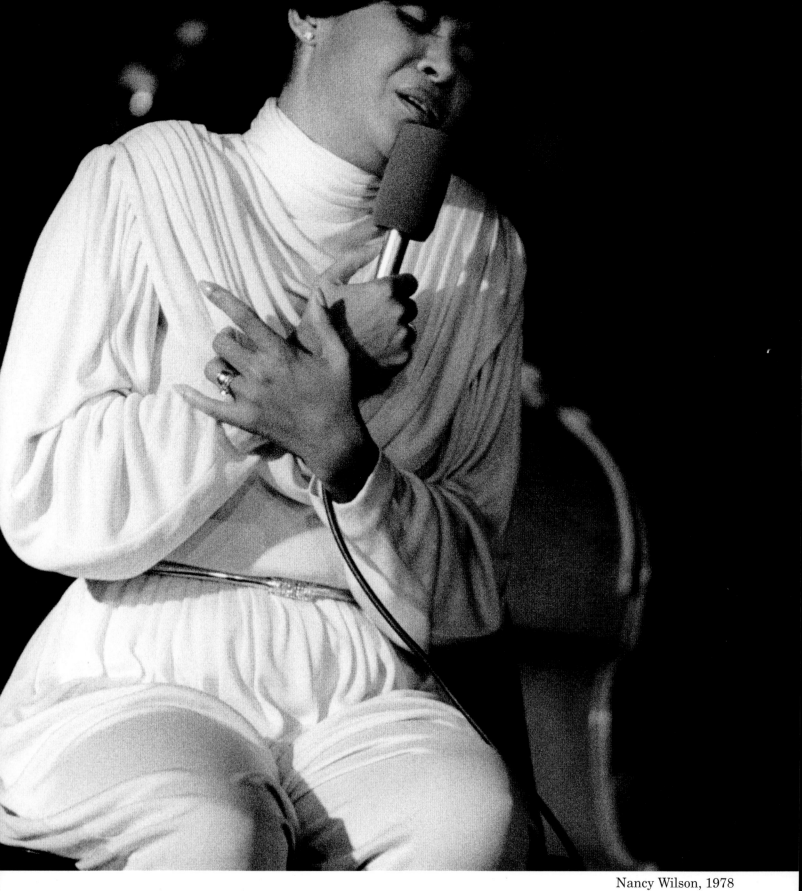

Nancy Wilson, 1978

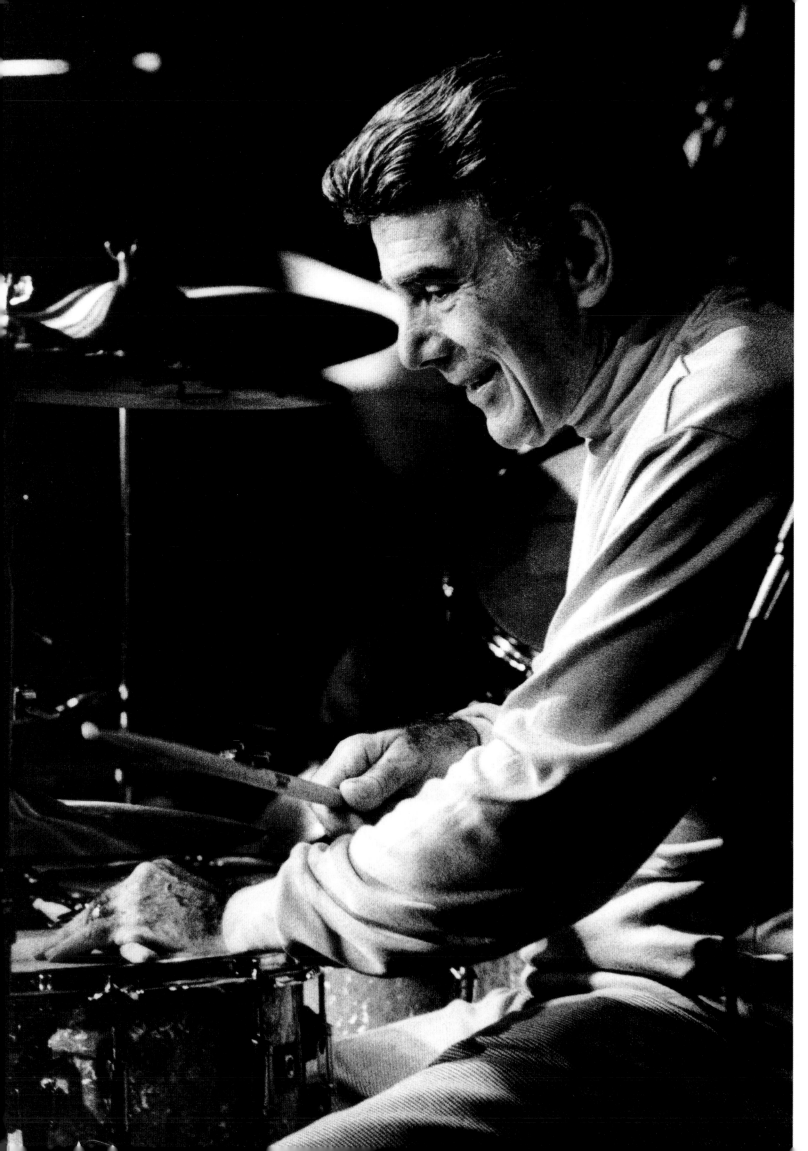

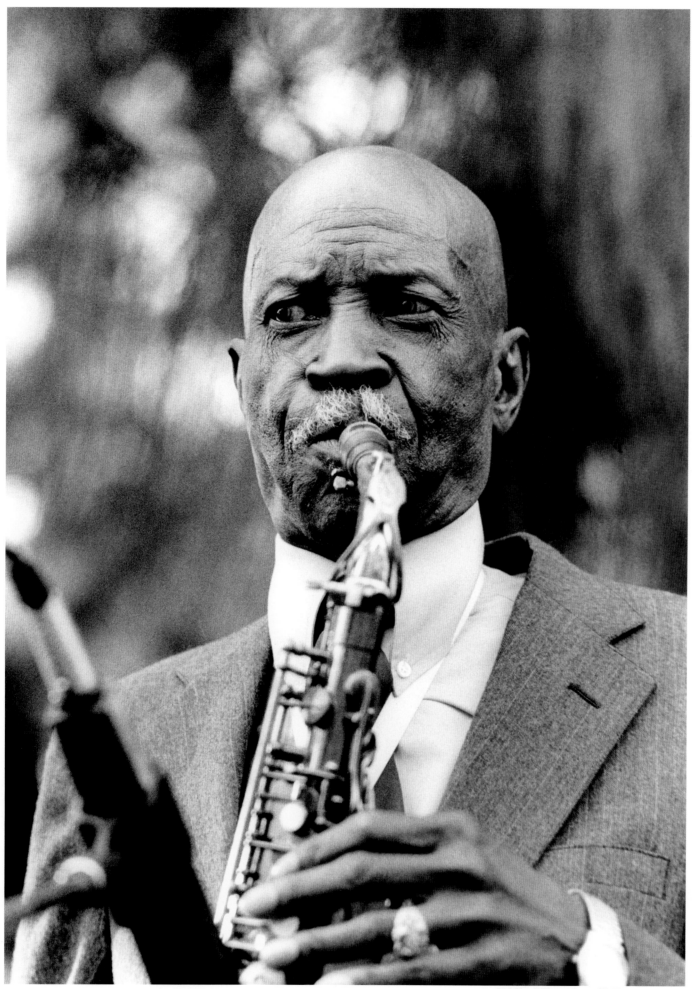

Eddie "Cleanhead" Vinson, 1987

Louis Bellson, 1993

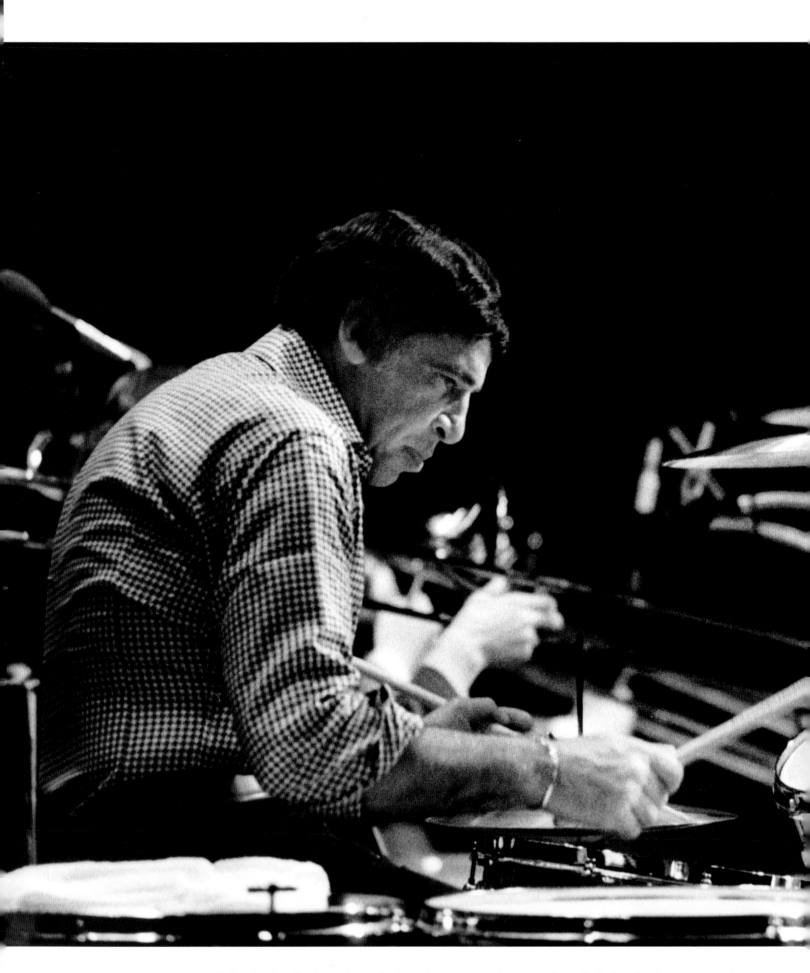

"I don't think there's a chain of command in my band, I think there is a chain of suggestion. I don't run my band as an army." —Buddy Rich

Buddy Rich, 1974

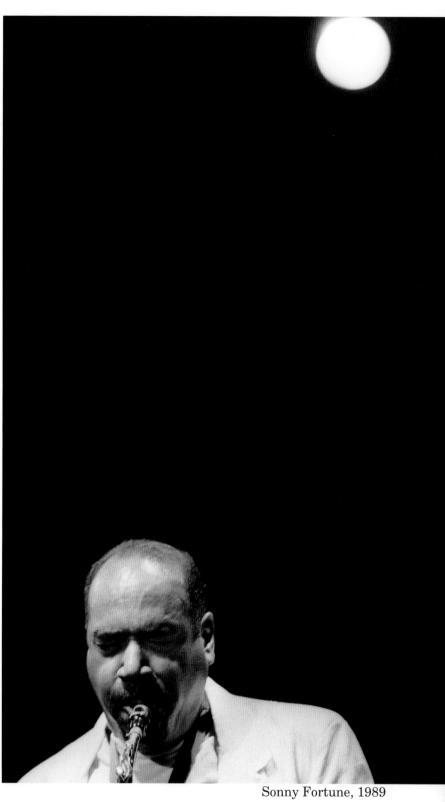

Sonny Fortune, 1989

John Lewis, 1973

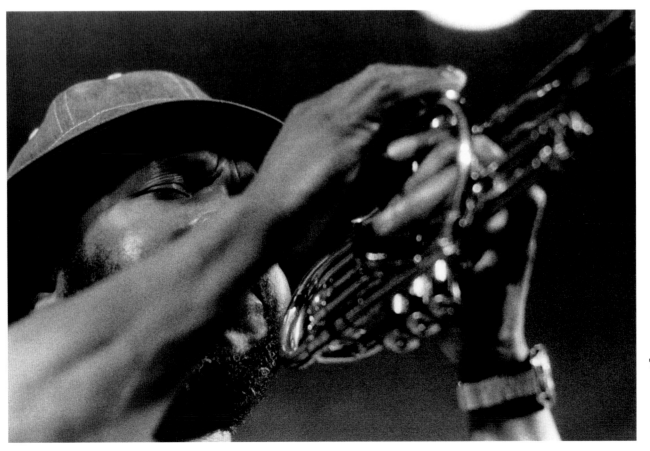

Thad Jones, 1977

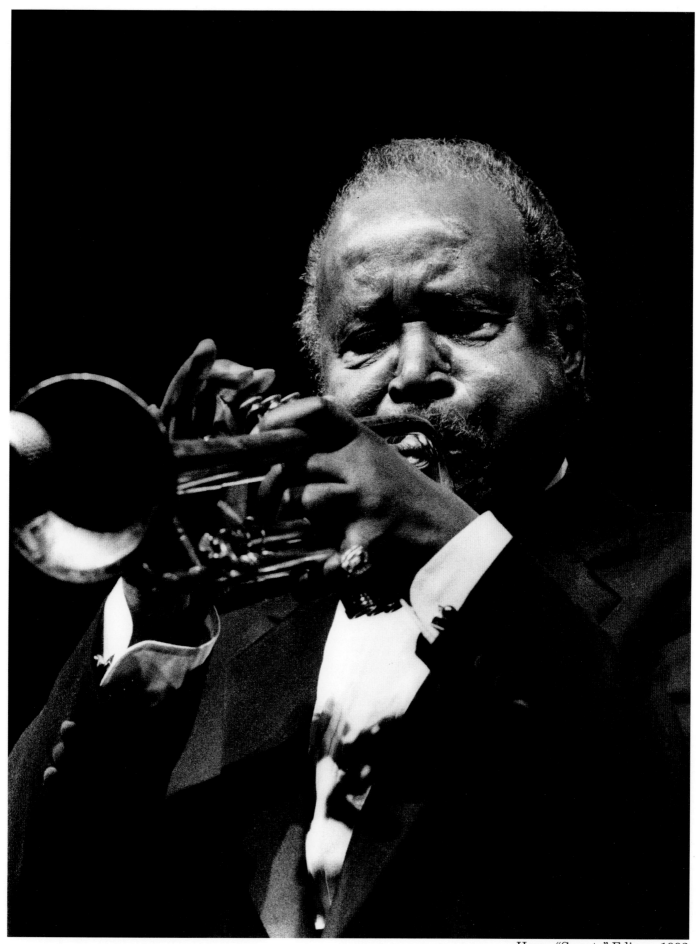

Harry "Sweets" Edison, 1992

"Basie never told you to play in a mute, never told you to play open, all he'd tell you to do was take four or five choruses. All he wanted you to do is be *swinging.*" —Harry "Sweets" Edison

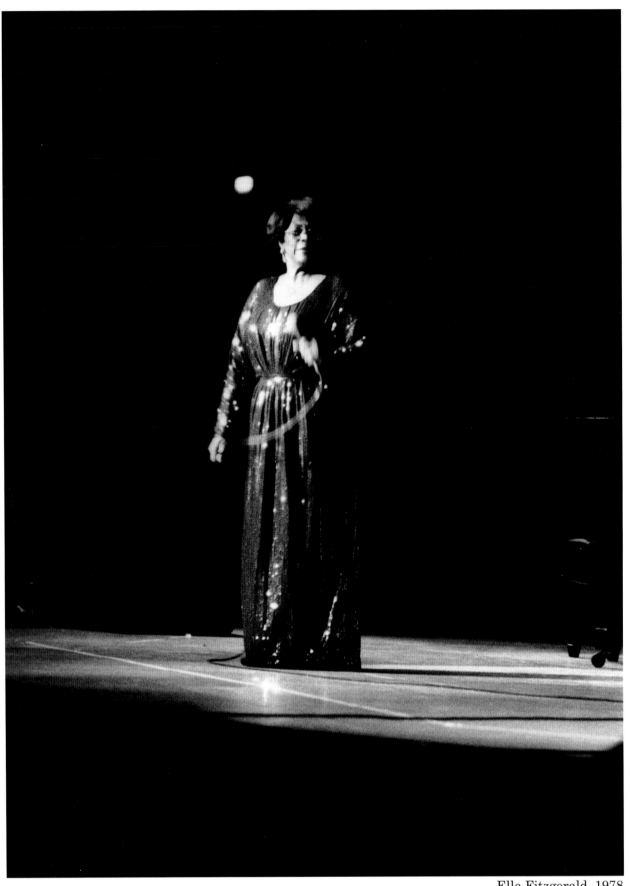

Ella Fitzgerald, 1978

"Sometimes when we're flying or in the hotel, I might run over songs, or in the bathroom. I think most people do that. That's how I get ideas." —Ella Fitzgerald

Dewey Redman, 1979

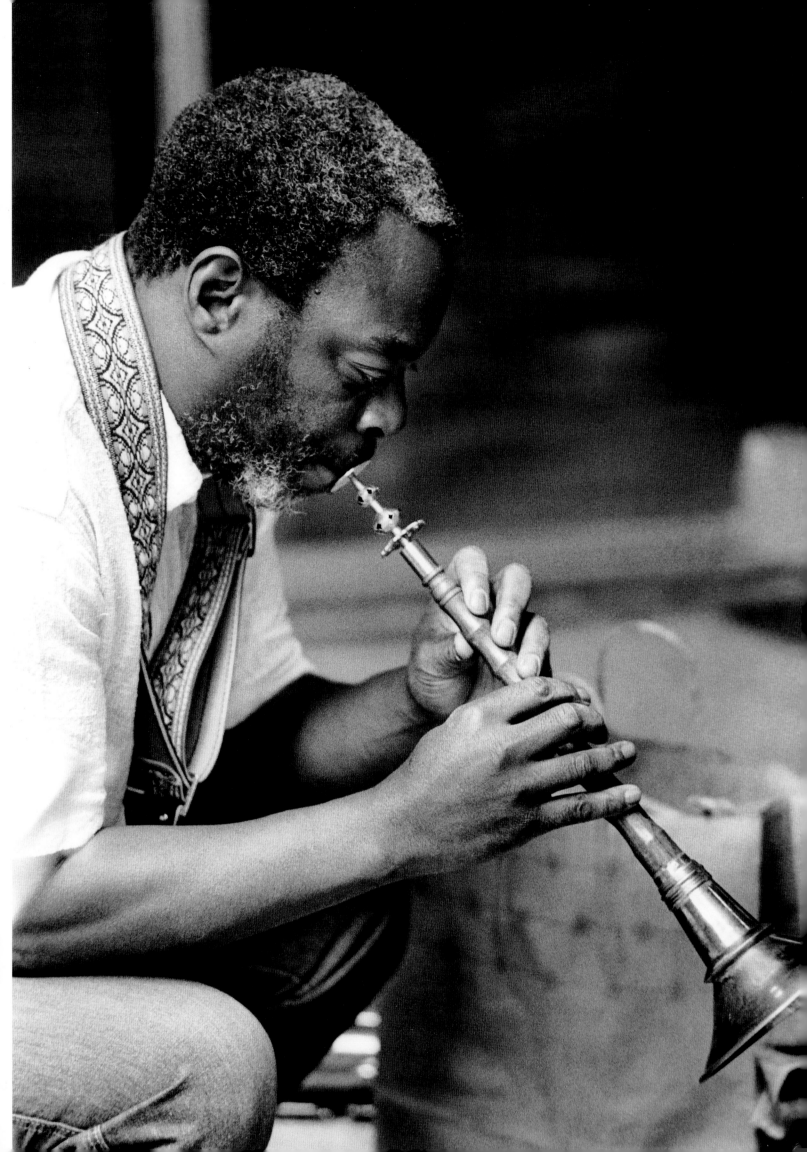

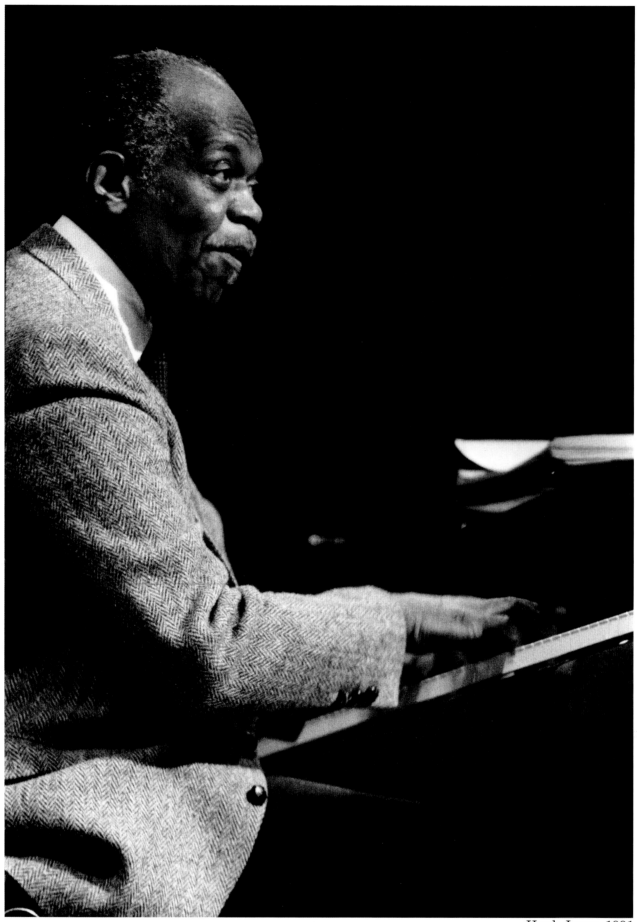

Hank Jones, 1991

"You don't go out and deliberately say, 'Well, I'm gonna cut somebody,'
you know, like play better. This is not part of it. What you do is, you do
the best that you can at that particular point in time, and then that's it.
In other words, you're competing against yourself." —Hank Jones

Jackie McLean, 1978

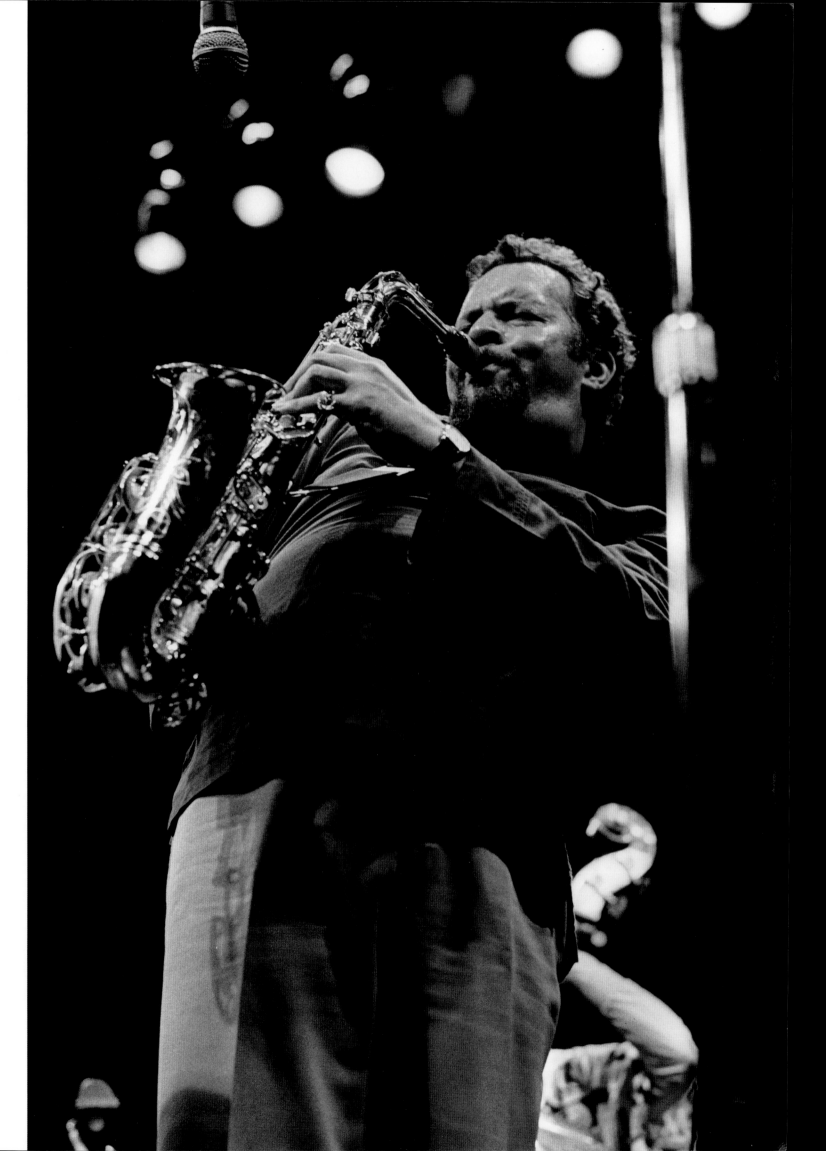

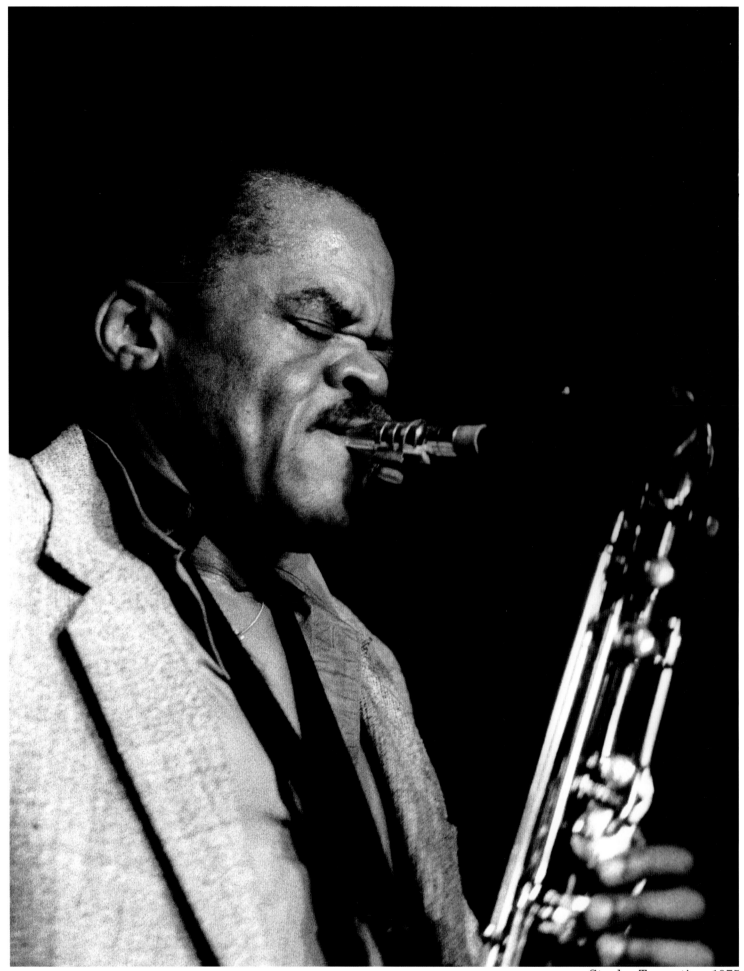

Stanley Turrentine, 1975

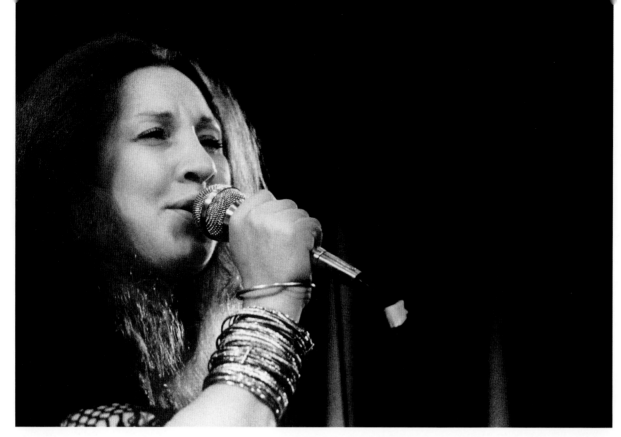

Flora Purim, 1976

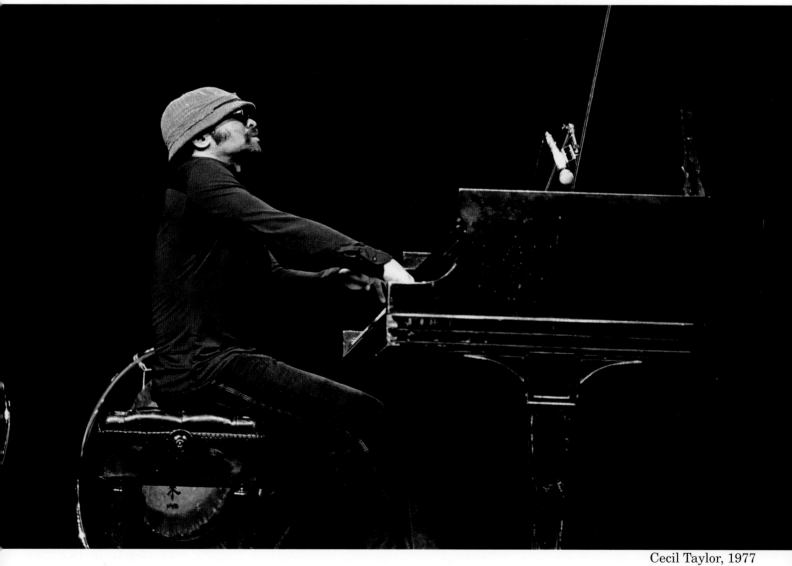

Cecil Taylor, 1977

"Improvisation is the ability to talk to one's self." —Cecil Taylor

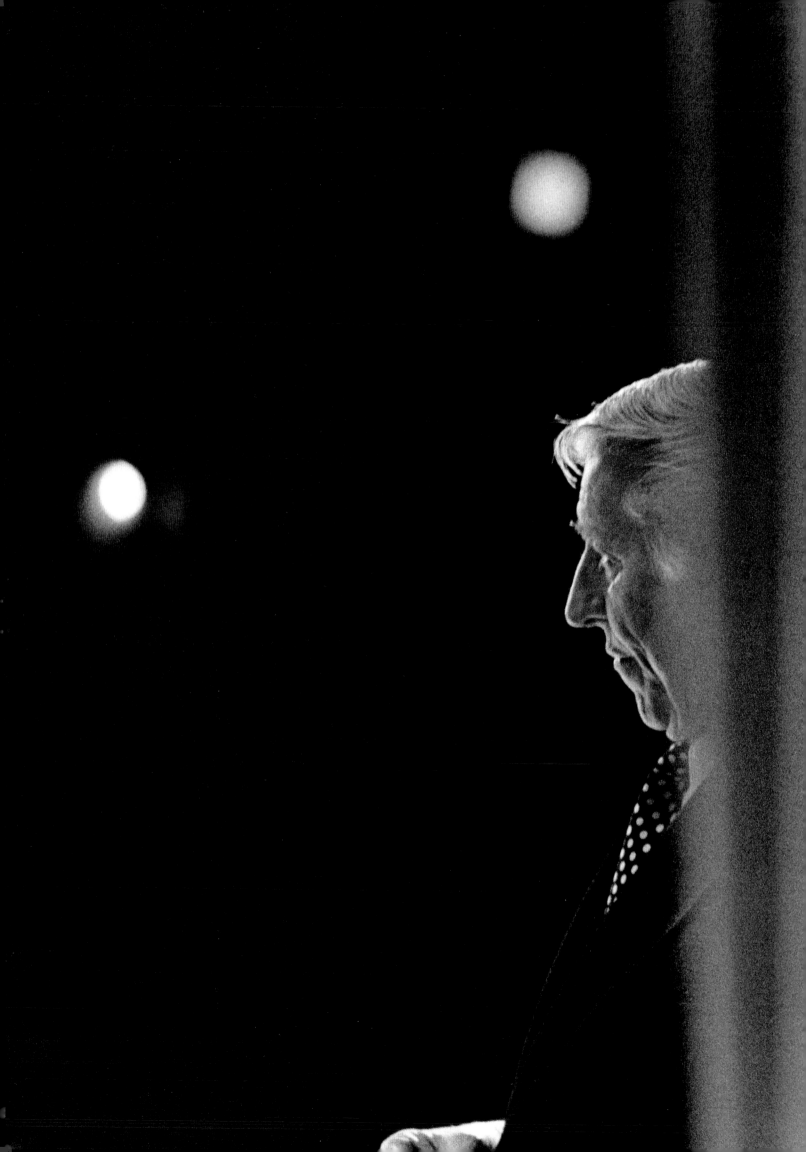

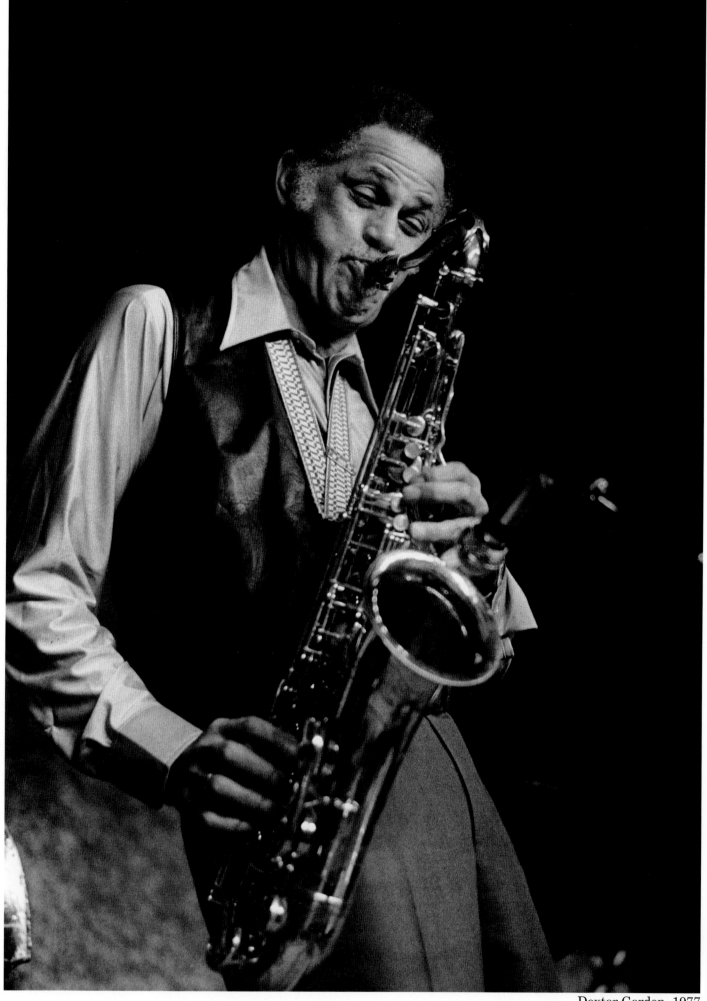

Dexter Gordon, 1977

"After you play with Charlie Parker, you don't have to worry about anything else. You've been through it." —Dexter Gordon

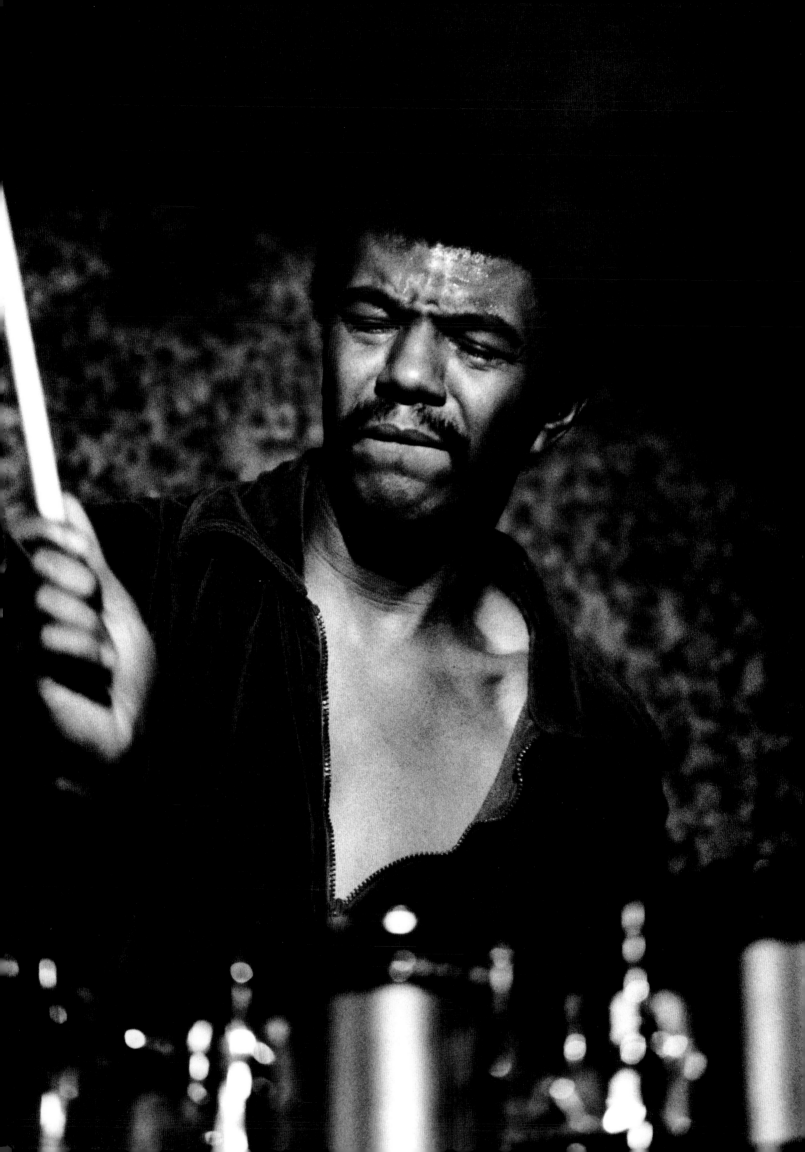

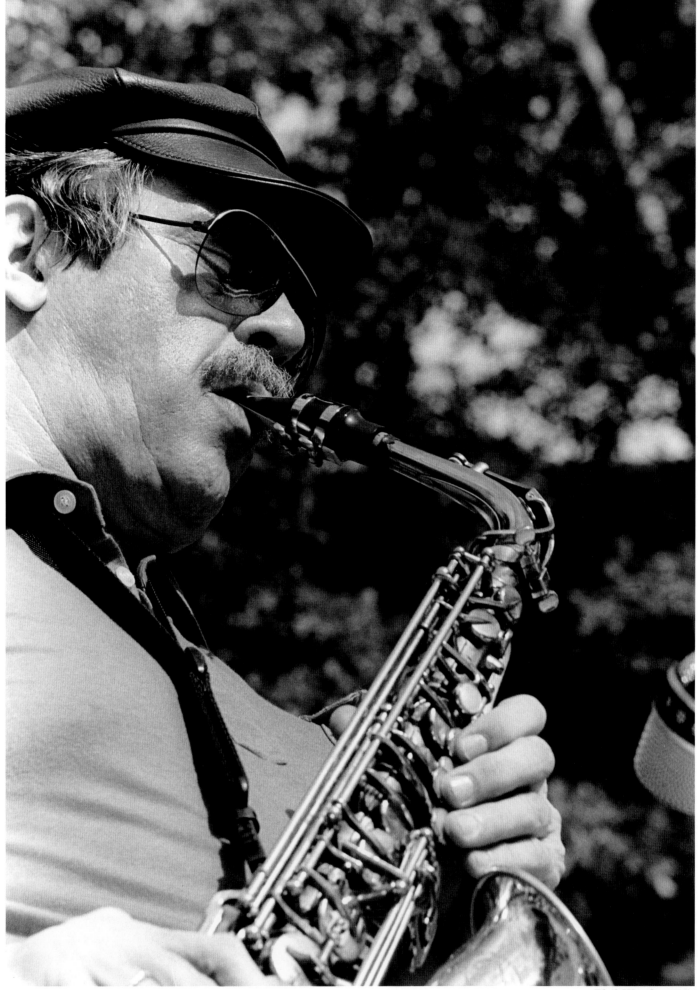

Phil Woods, 1985

"Bebop is the music of the future. I still hate the word. We Americans use such denigrating words about this music: Jazz or Bebop. These are not high-class words. But it's street music so you have to use the vernacular." —Phil Woods

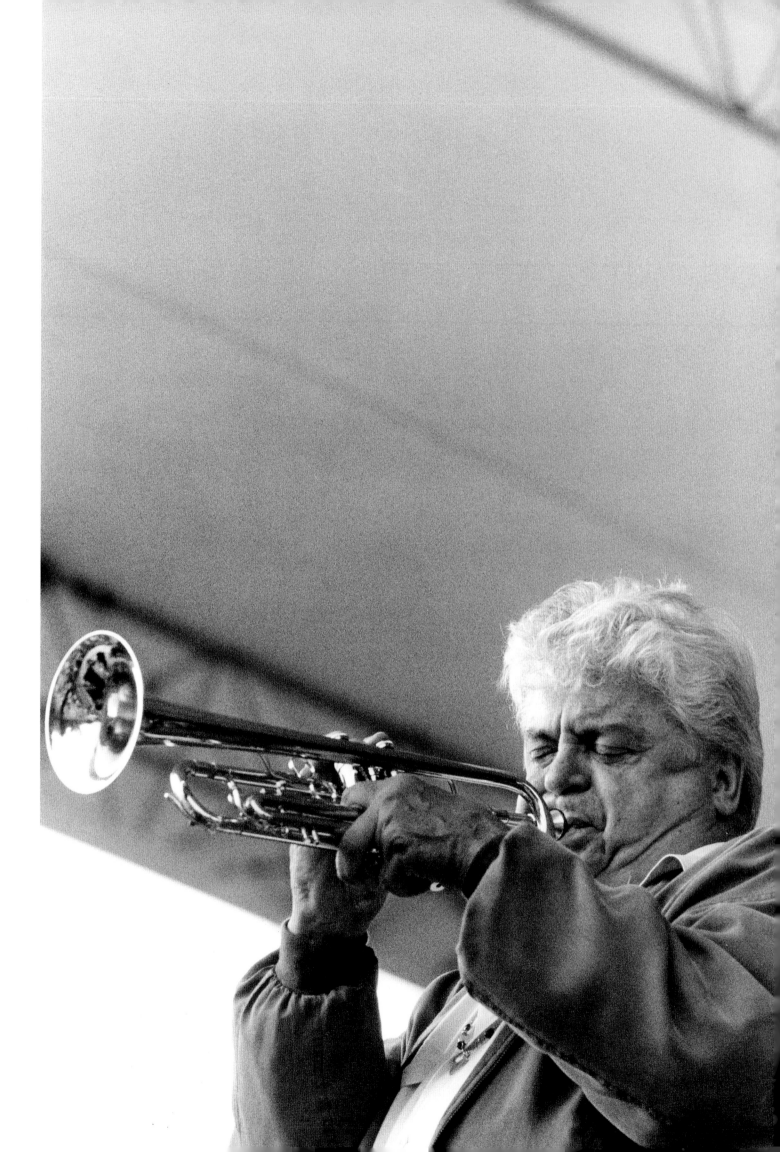

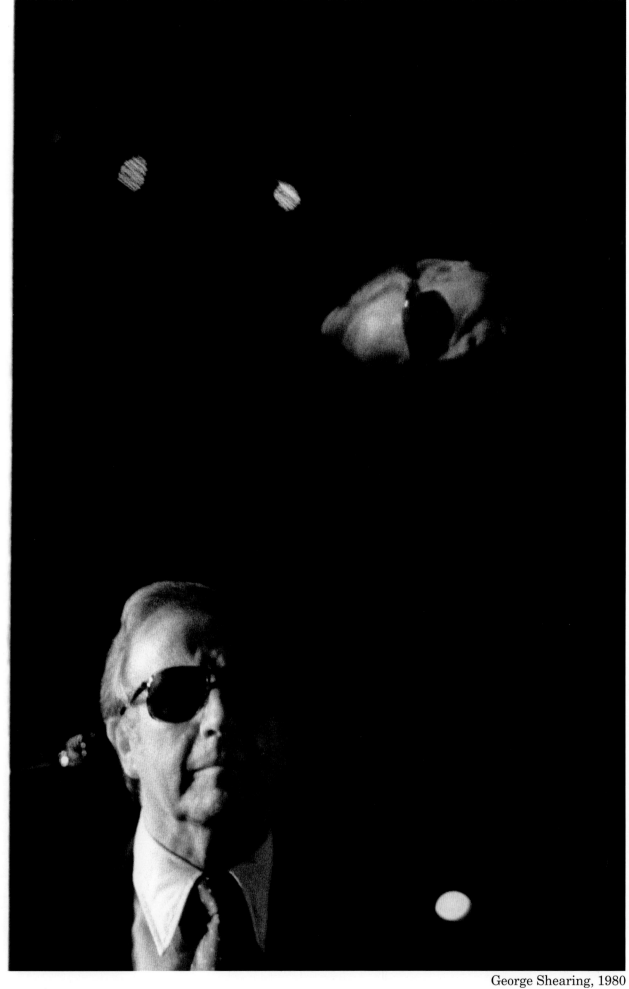

George Shearing, 1980

"I don't like being called a jazz pianist, just the same way I'm not a blind pianist. I'm a pianist." —George Shearing

Maynard Ferguson, 1991 35

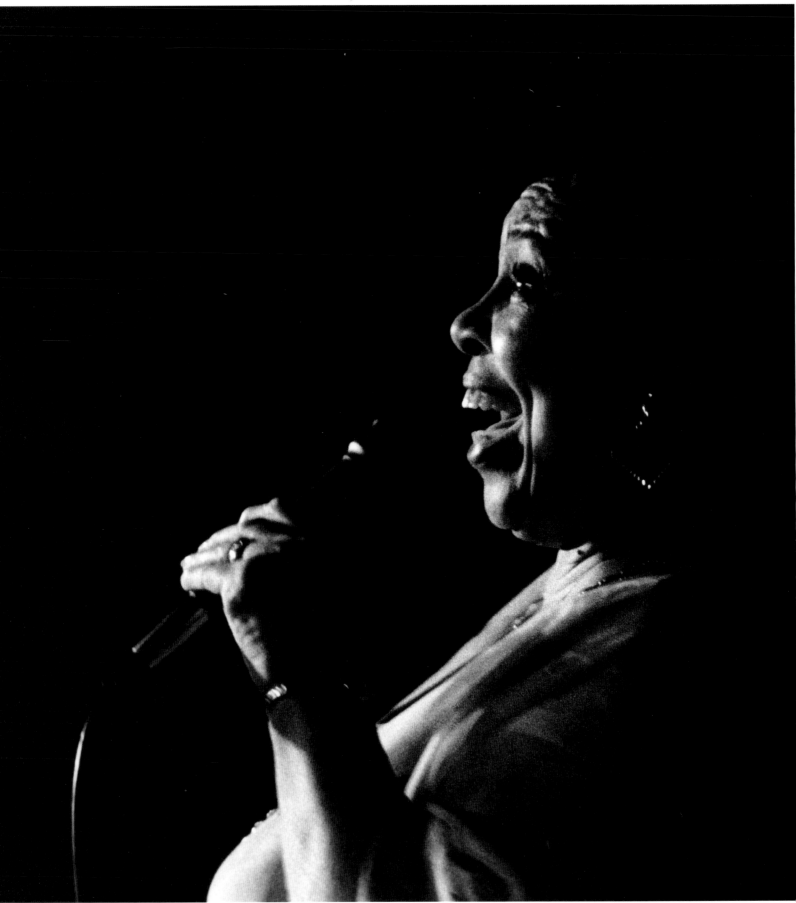

Helen Humes, 1978

"I went up to the Cotton Club and was singing with Al Sears' band and it was while I was singing there that Basie heard me and he wanted me to join his band. He said that Billie Holiday, she was leaving or had just left, and he was looking for a singer, and wanted to know if I'd be interested." —Helen Humes

Louis Hayes, 199

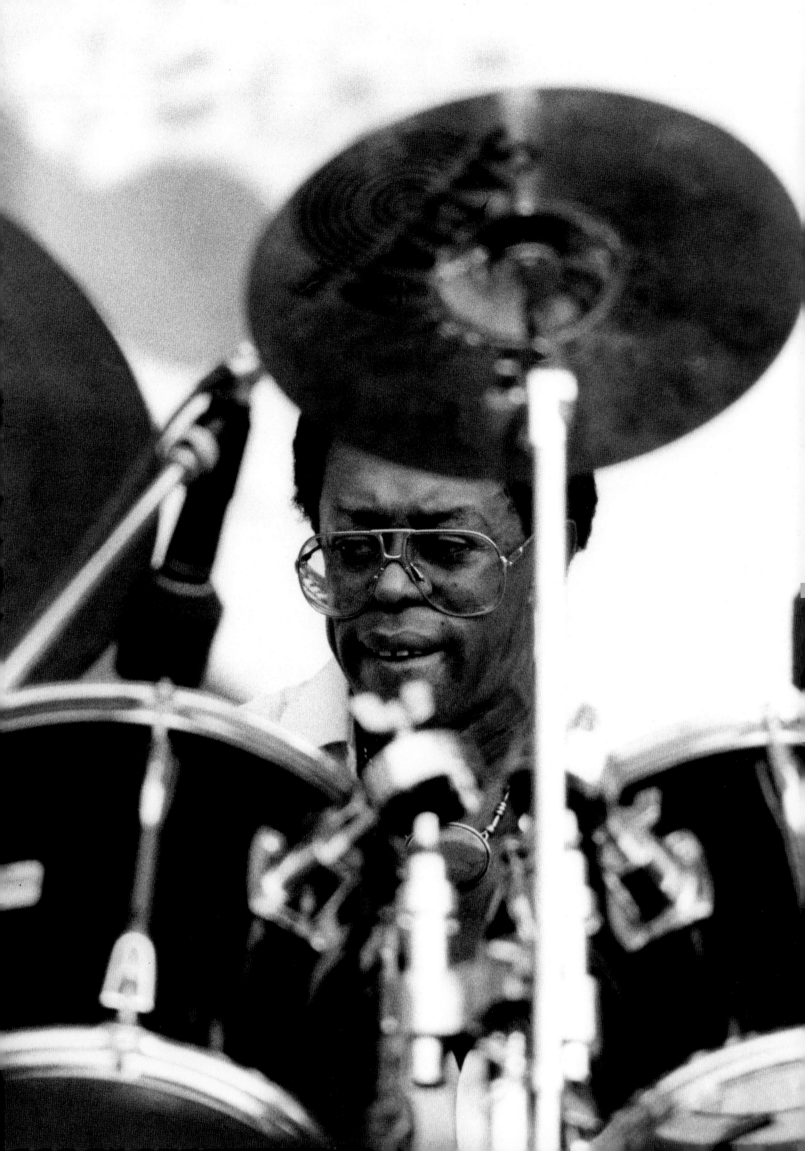

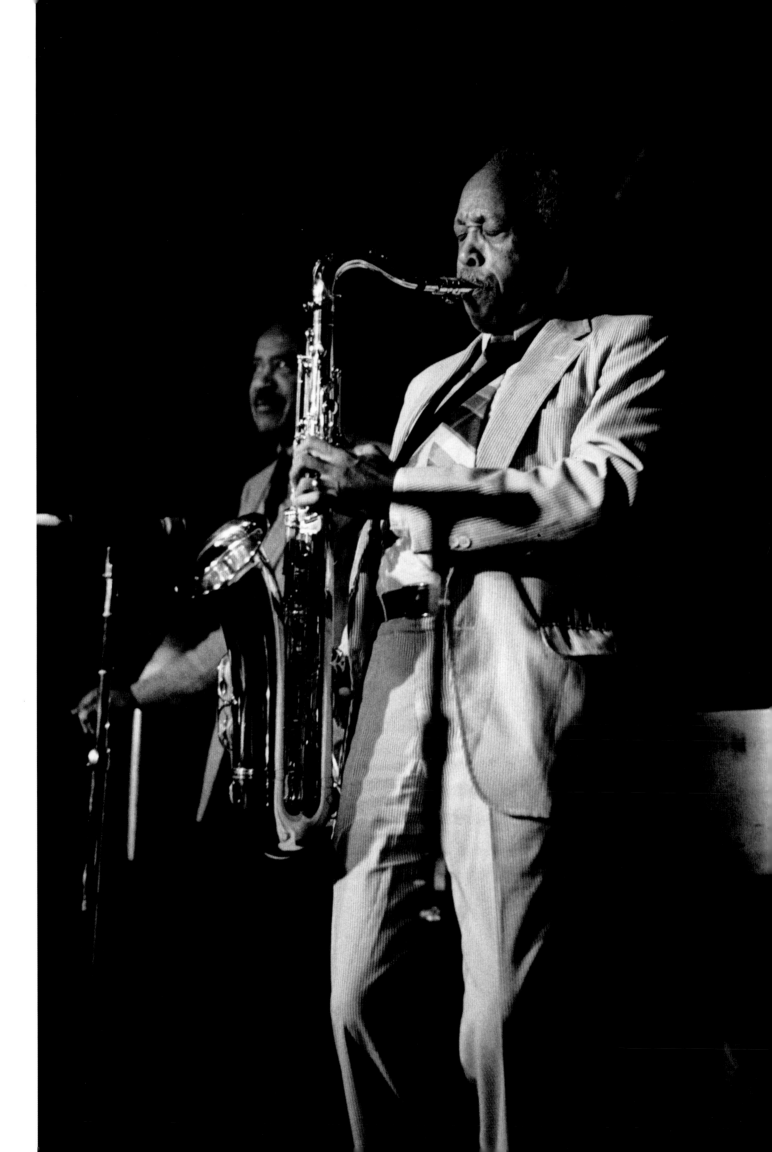

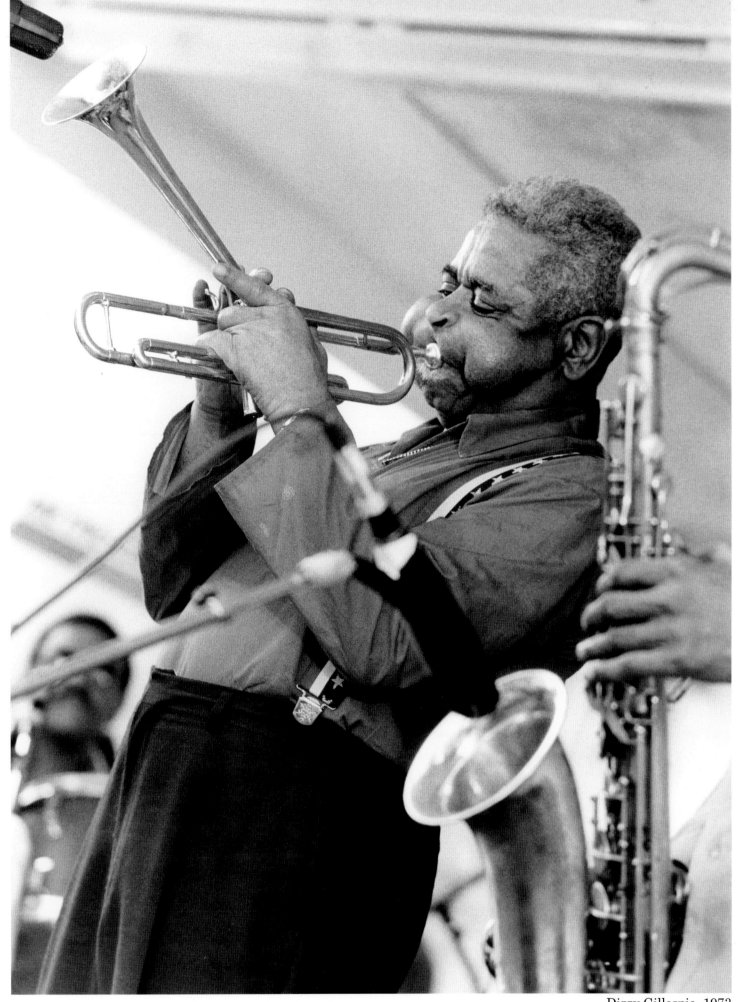

Dizzy Gillespie, 1973

"I don't think we have even tapped, even with all the great players that I have known, the masses of this music." —Dizzy Gillespie

Sonny Stitt, 1980 39

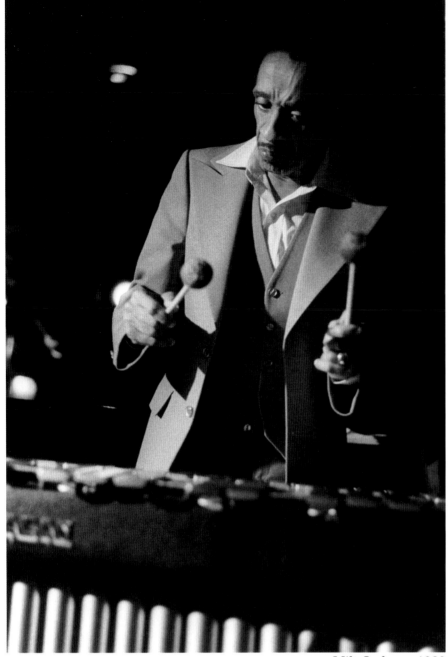

Milt Jackson, 1980

"The kids don't know why they go to the record
shop and buy Elton John records. That's because
they hear it all the time. They would respond to
Lester Young and Coleman Hawkins and all the
rest, but they have never been exposed to it."
 —Milt Jackson

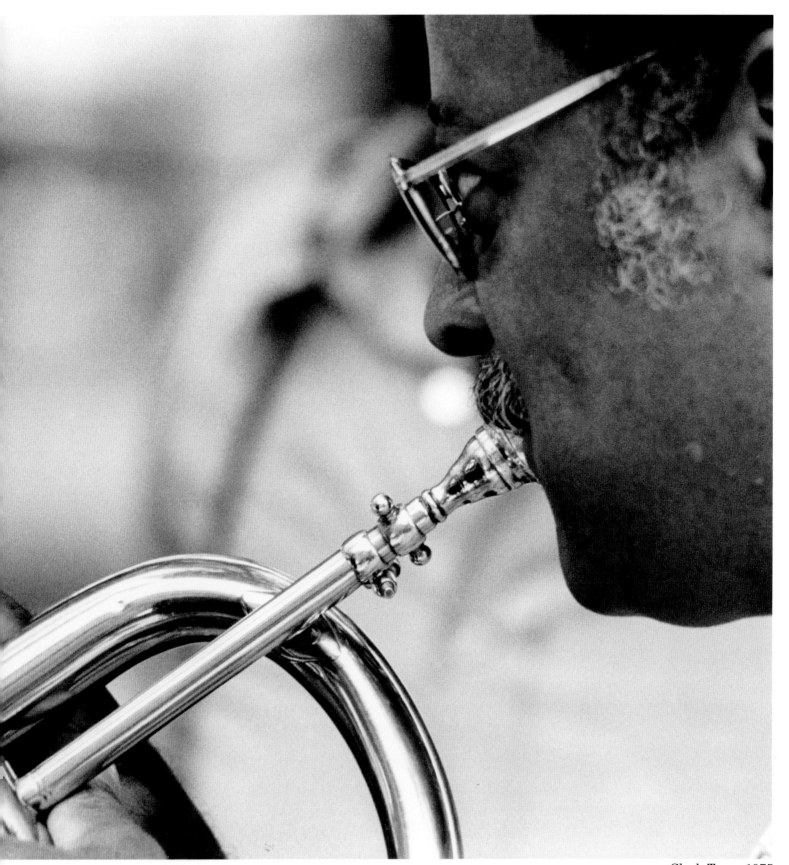

Clark Terry, 1975

"It's quite typical of some of our youth today that they want to get involved in jazz sort of like building a house. They want to start on the 15th floor and build a sky-scraper and forget all about the fact that you can't go up there unless you dig down there, you know. In order to go high, you've got to dig deep and go low. So you've got to have a good foundation." —Clark Terry

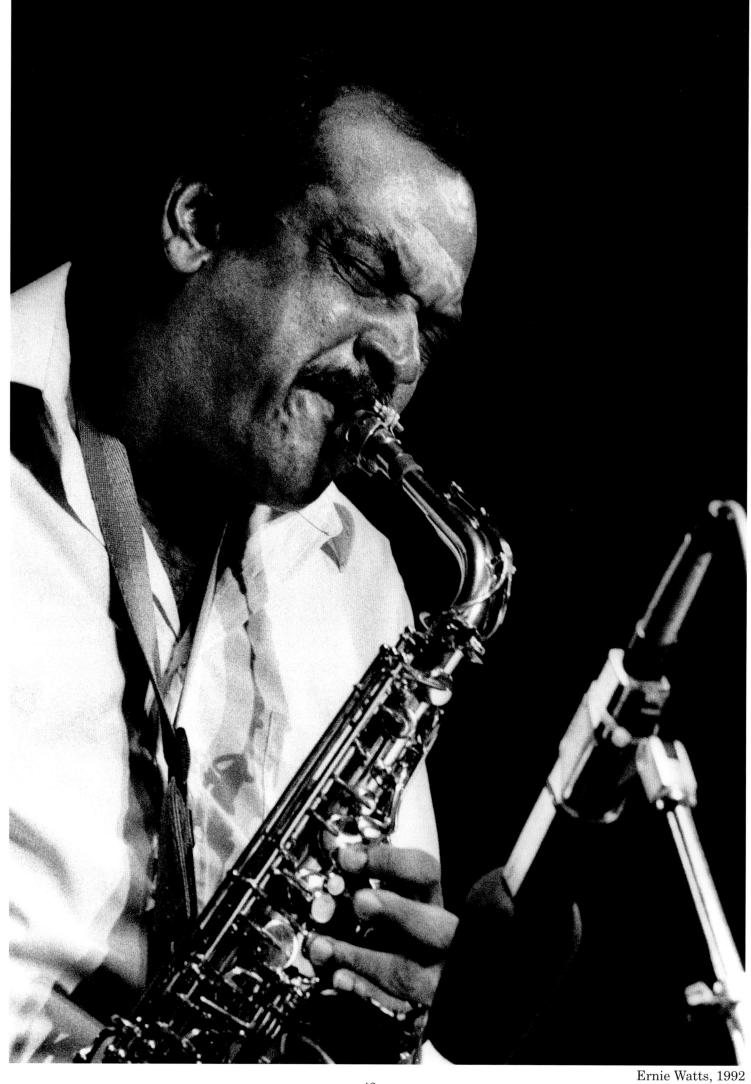

Ernie Watts, 1992

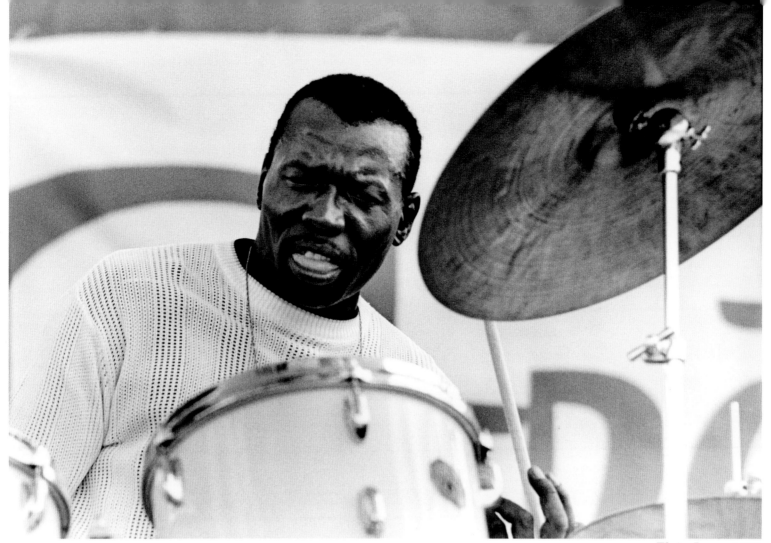

Elvin Jones, 1973

"My eyes can be wide open and I'll see different colors as a symbol of sound. Any sound has a corresponding color, any pitch or tone." —Elvin Jones

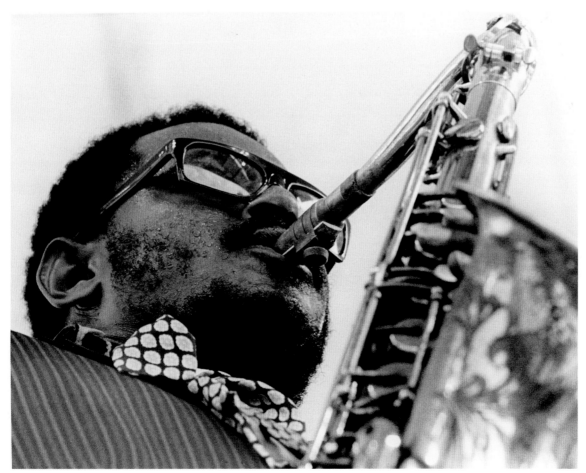

Archie Shepp, 1973

"Don't strive for complexity so much as you strive for simplicity. For years, that was a mistake of mine, that I strove so much for complexity. I wrote compositions that musicians could not possibly play well. You should write music that's singable."
 —Archie Shepp

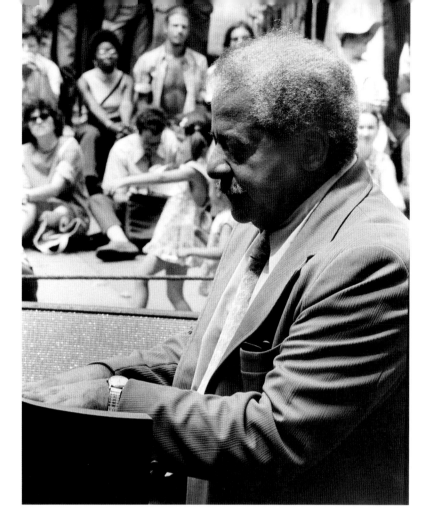

Teddy Wilson, 1973

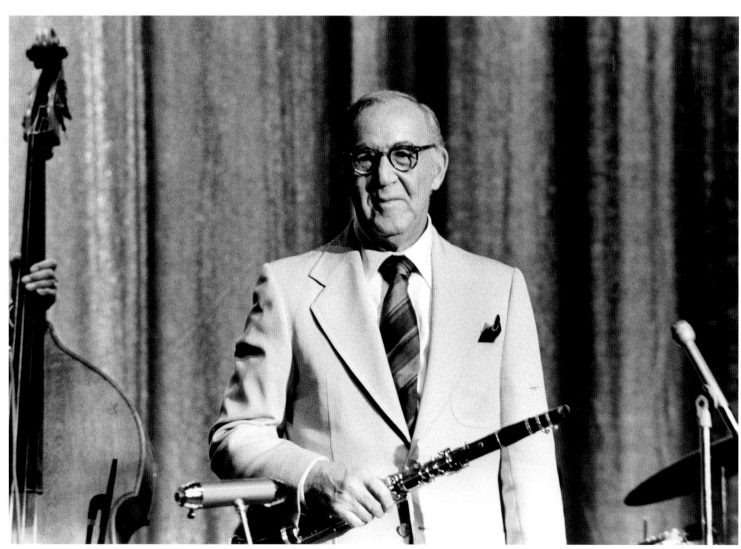

Benny Goodman, 1975

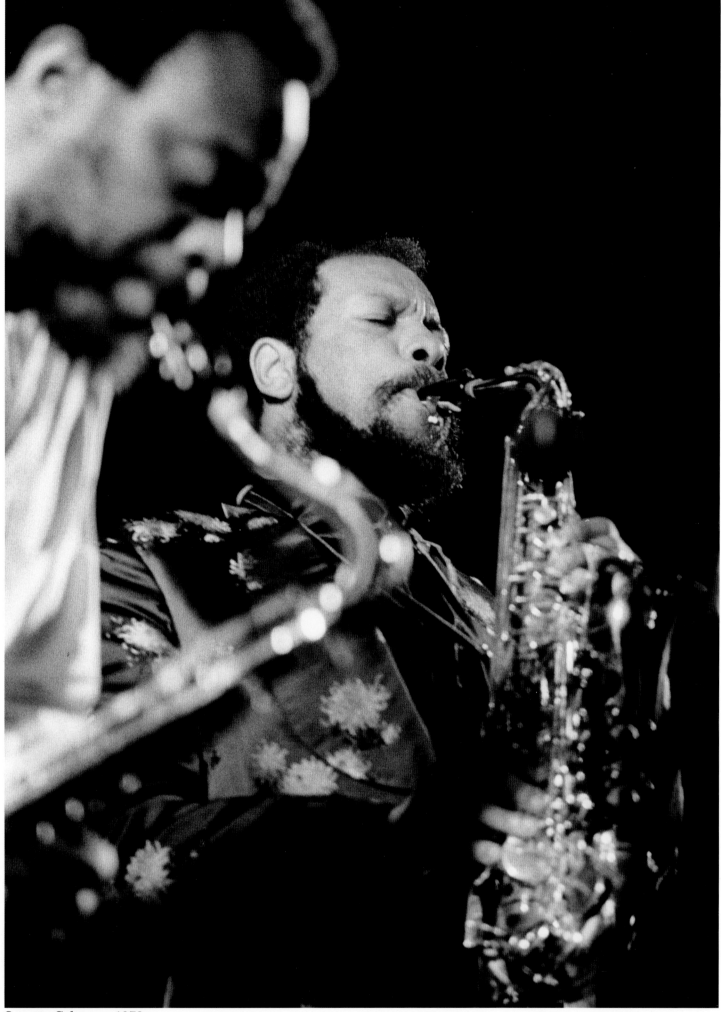

Ornette Coleman, 1972

"When I used to hear music it was always mostly sounding to me like it was all written out. I never thought anyone just played until I got an instrument myself and realized that you could do that."

—Ornette Coleman

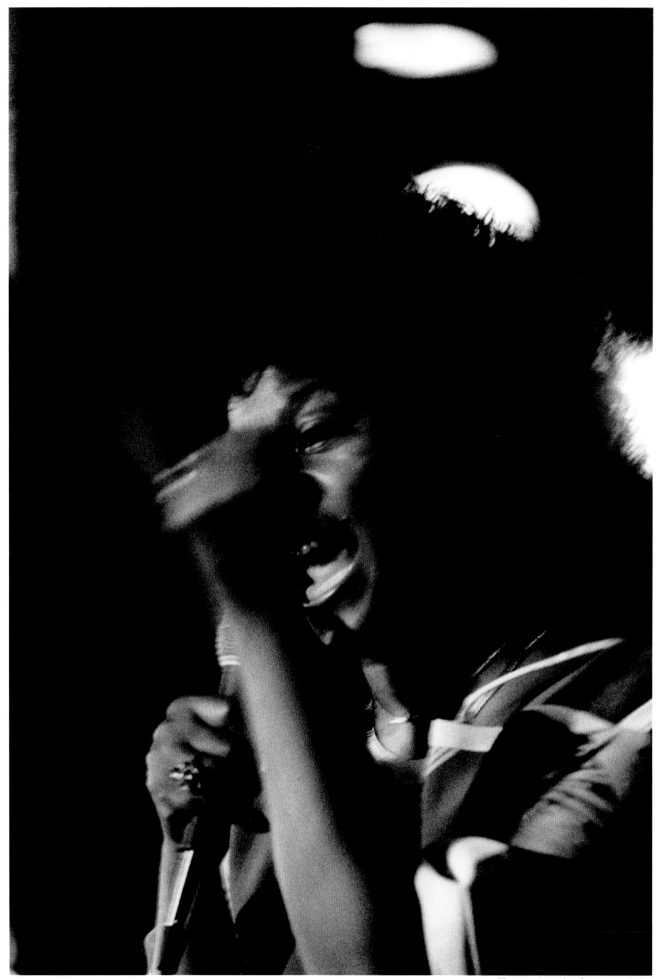

Ernestine Anderson, 1977

Mongo Santamaria, 1979

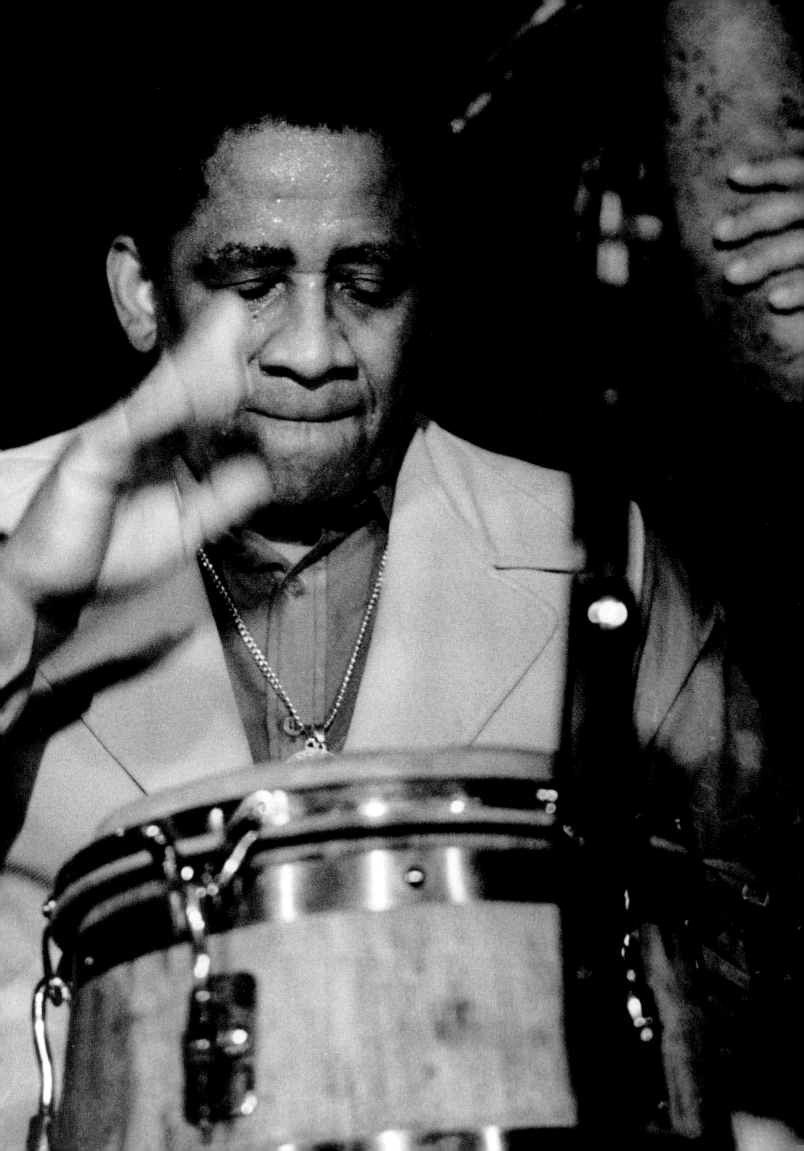

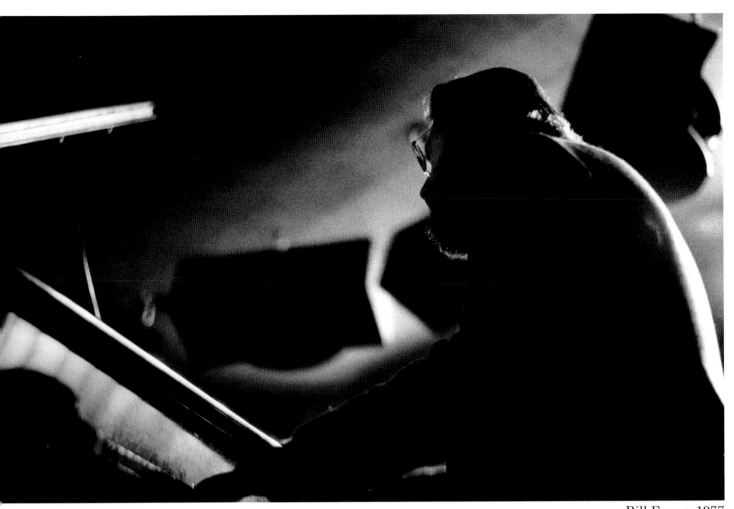

Bill Evans, 1977

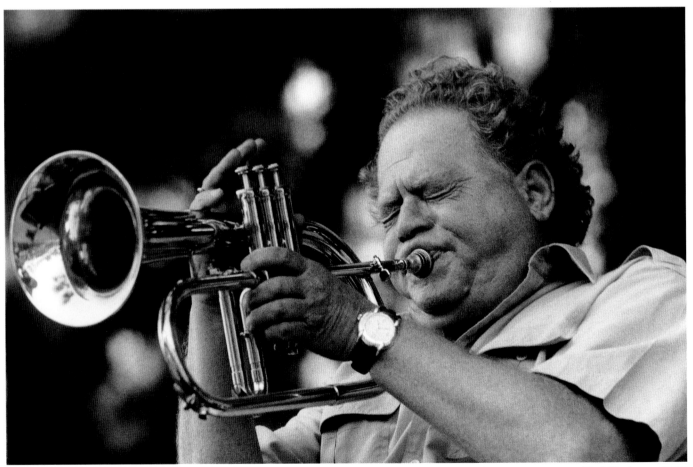

Red Rodney, 1989

"The moment I heard Charlie Parker, I understood everything. Sitting there,
I'll never forget the emotion I had." —Red Rodney

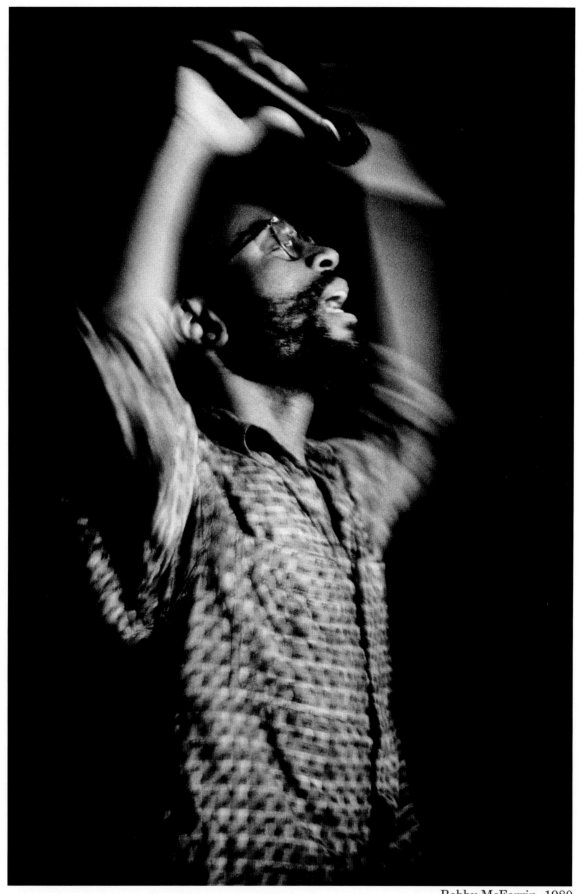

Bobby McFerrin, 1980

"I find it very insulting to be called an instrumental *impersonator*. Because I feel I am an instrument." —Bobby McFerrin

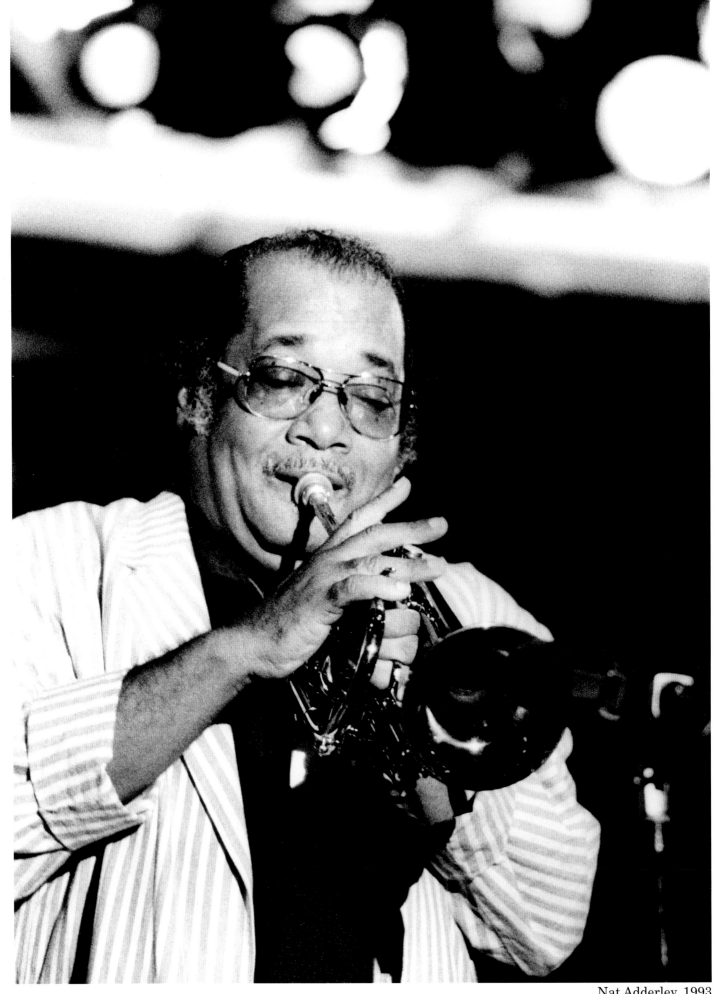

Nat Adderley, 1993

"I never heard of a jazz musician who retired. You love what you do, so if you retire, what are you going to do, play for the walls?" —Nat Adderley

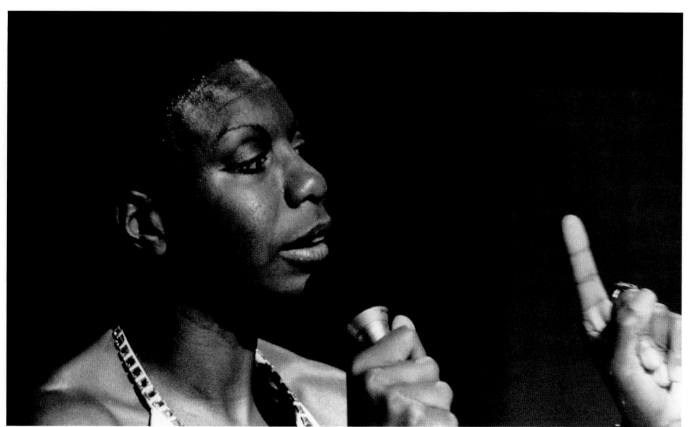

Nina Simone, 1977

Billy Taylor, 1993

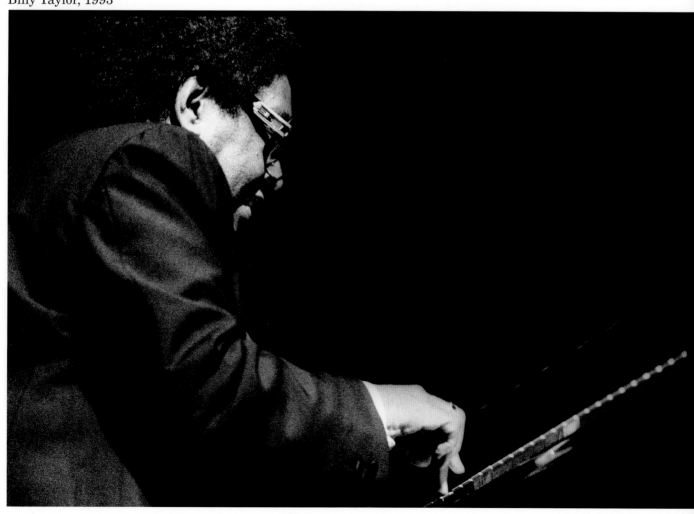

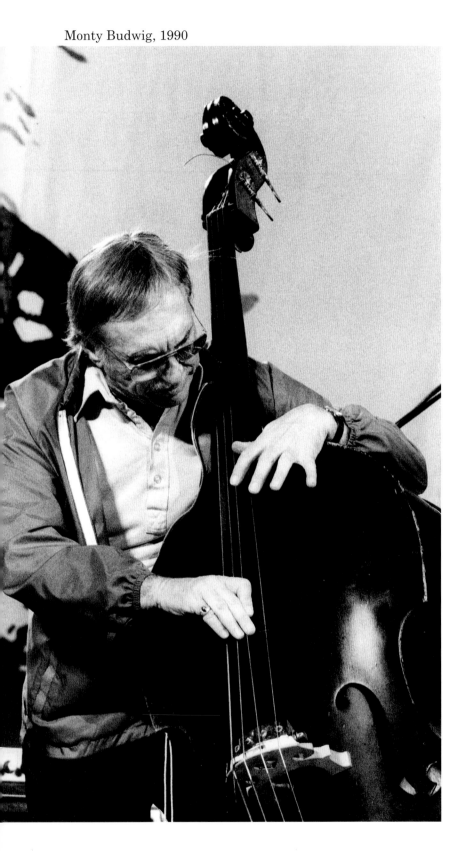

Monty Budwig, 1990

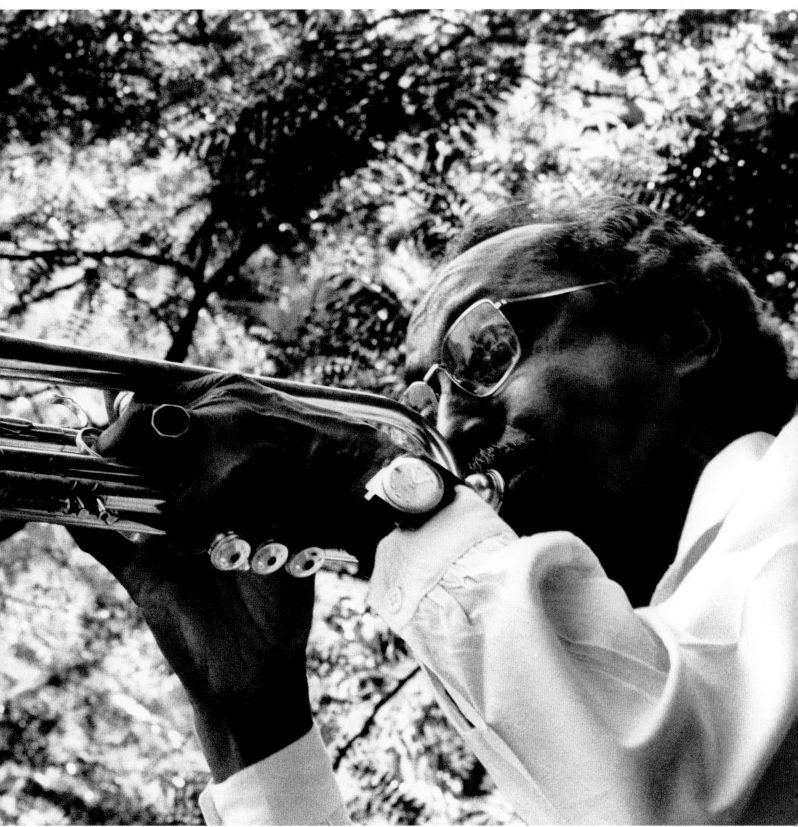

Joe Newman, 1977

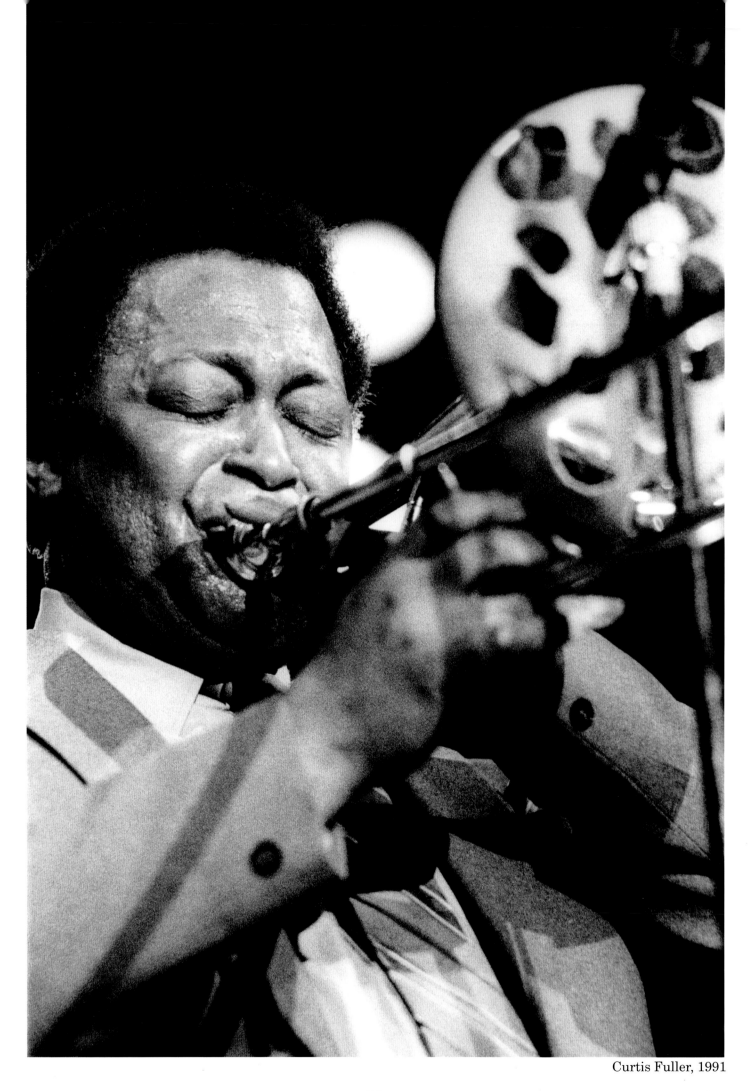

Curtis Fuller, 1991

"Prior to what we call jazz, musicians were almost in slavery, except for the conductor and composer. When this music came out, the musicians became an integral part of the music."
—Max Roach

Max Roach, 1973

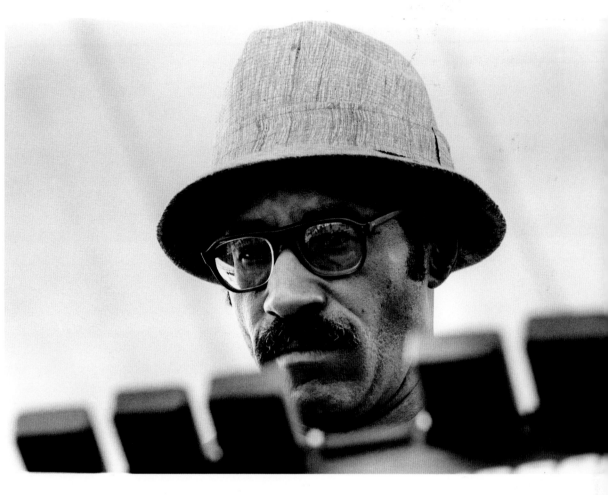

"I prefer that nobody teach me. I prefer to swing on my own."
—Stephane Grappelli

Stephane Grappelli, 1978

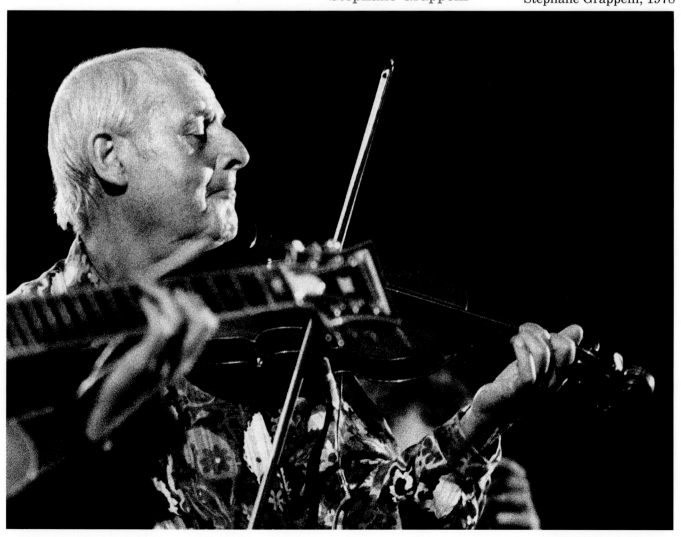

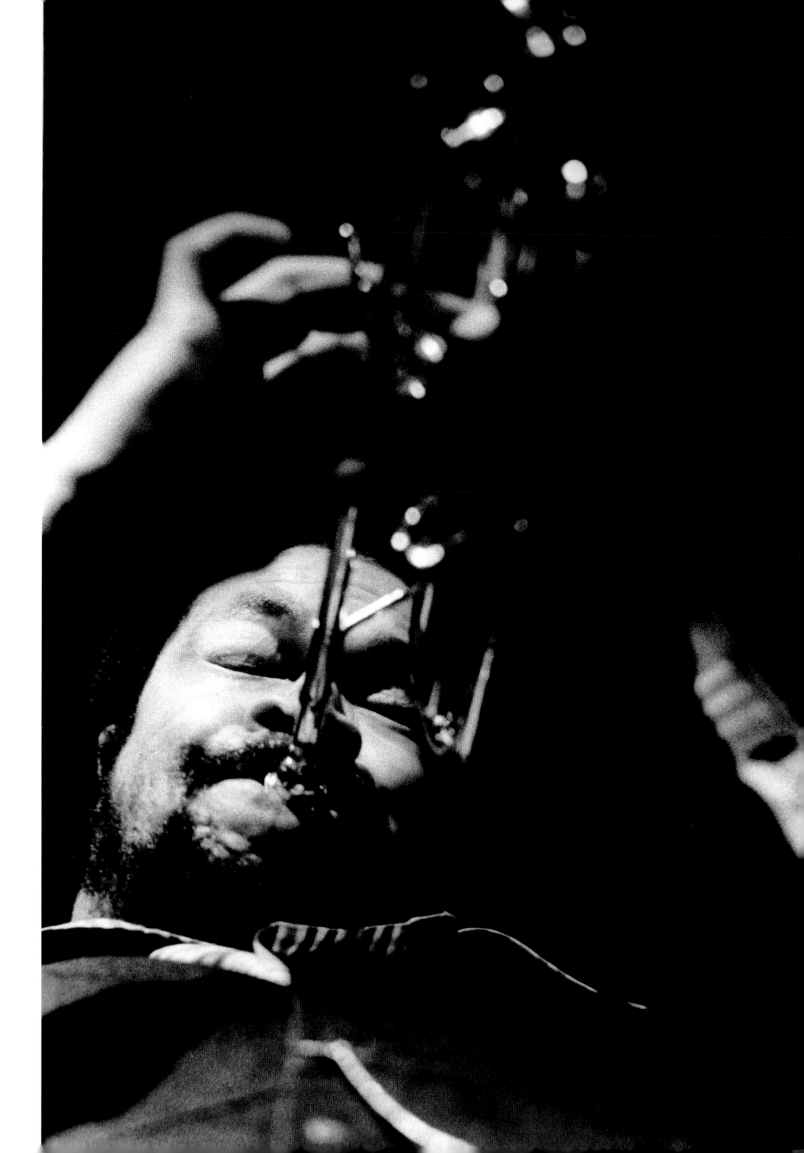

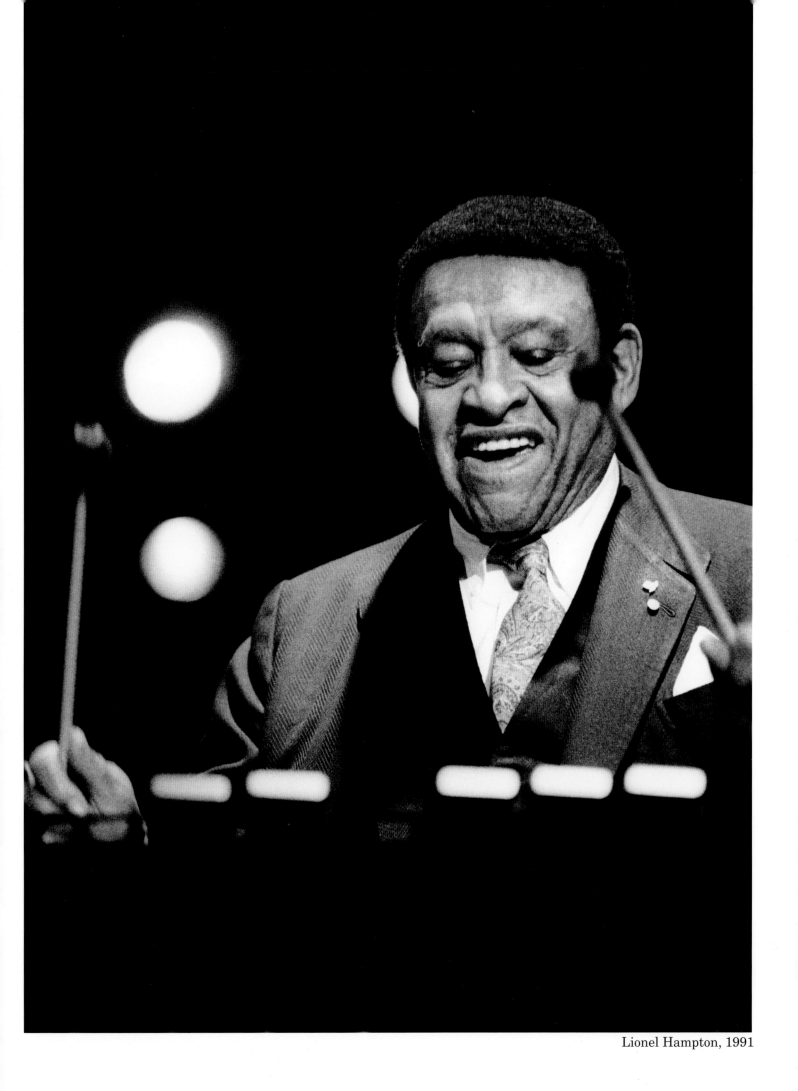

Lionel Hampton, 1991

"A black man asked me why I played complex, avant-garde music instead of straight-ahead black jazz, during a break in a festival performance. When I returned to the stage to play the next set, I remembered his question and performed a short pygmy chant, taking it through many interesting developments." —Charles Austin

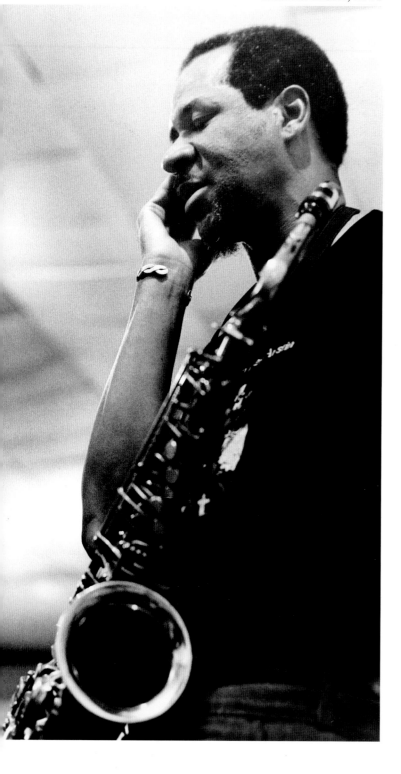

Charles Austin, 1976

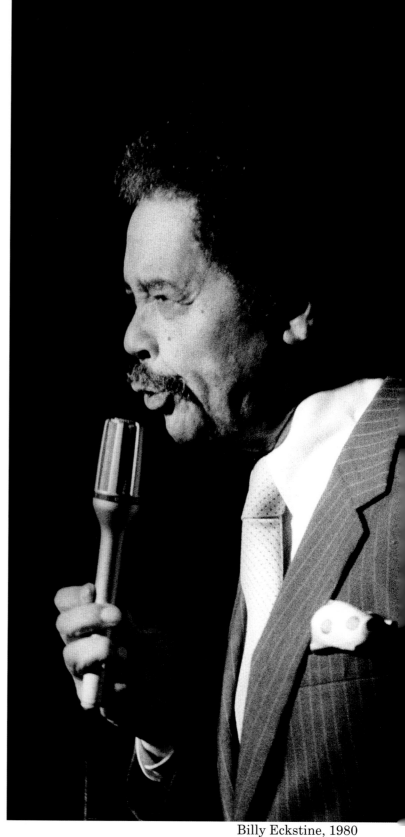

Billy Eckstine, 1980

"I used to have old cats tell me, 'You're going to be a great player in time.' A young guy don't want to hear that crap, but you know they're right."
—Nick Brignola

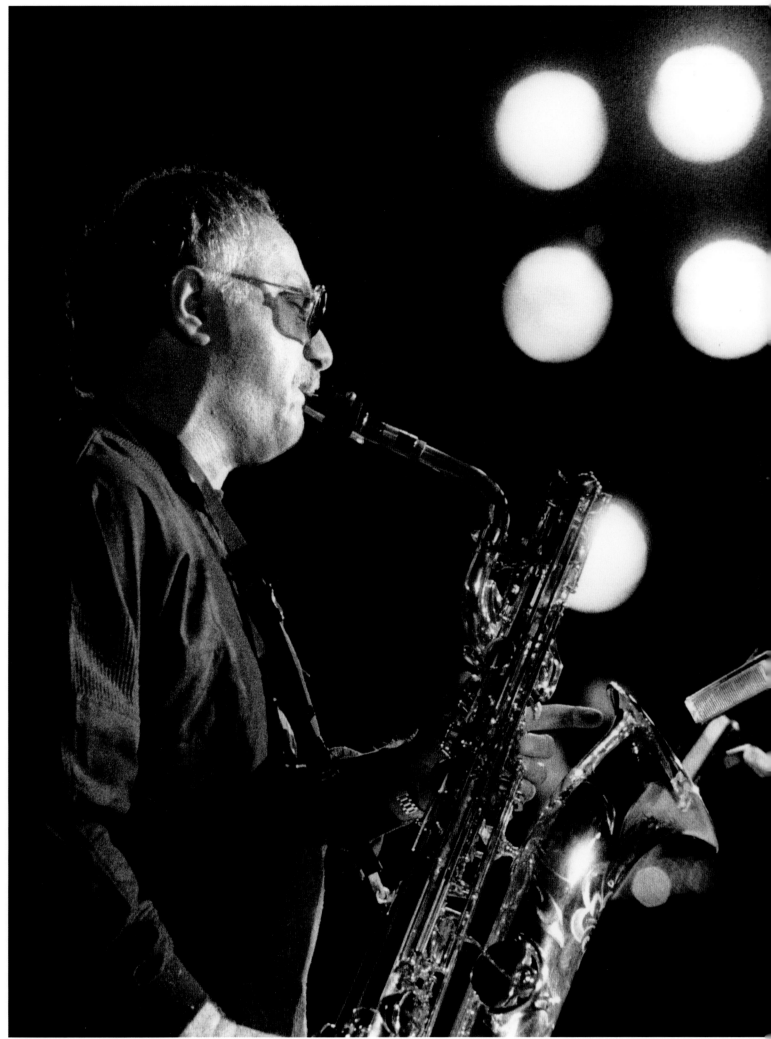

Nick Brignola, 1990

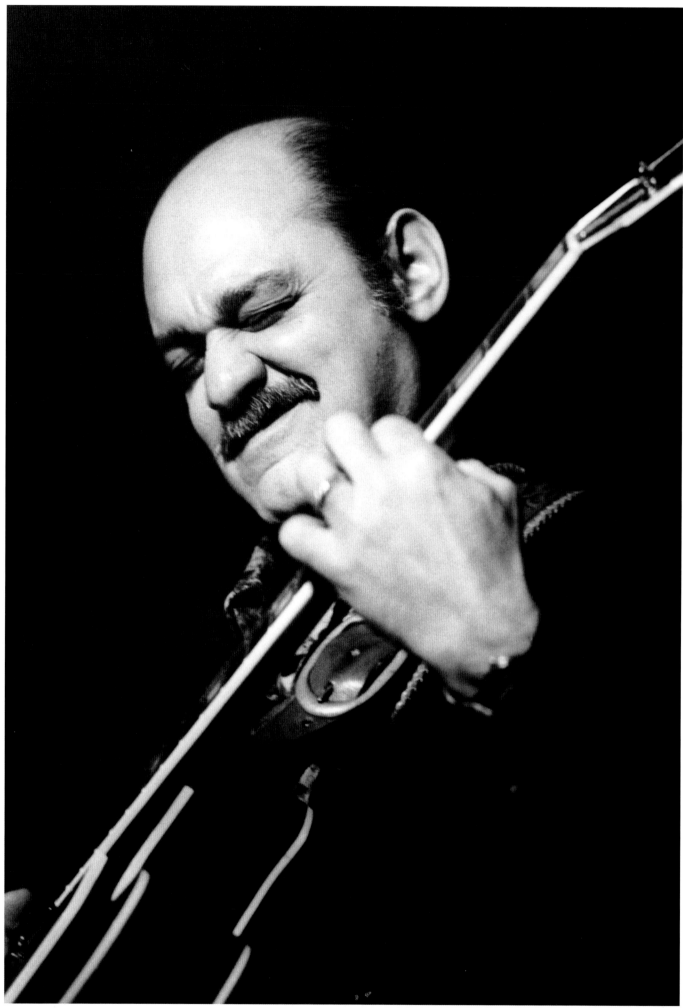

Joe Pass, 1976

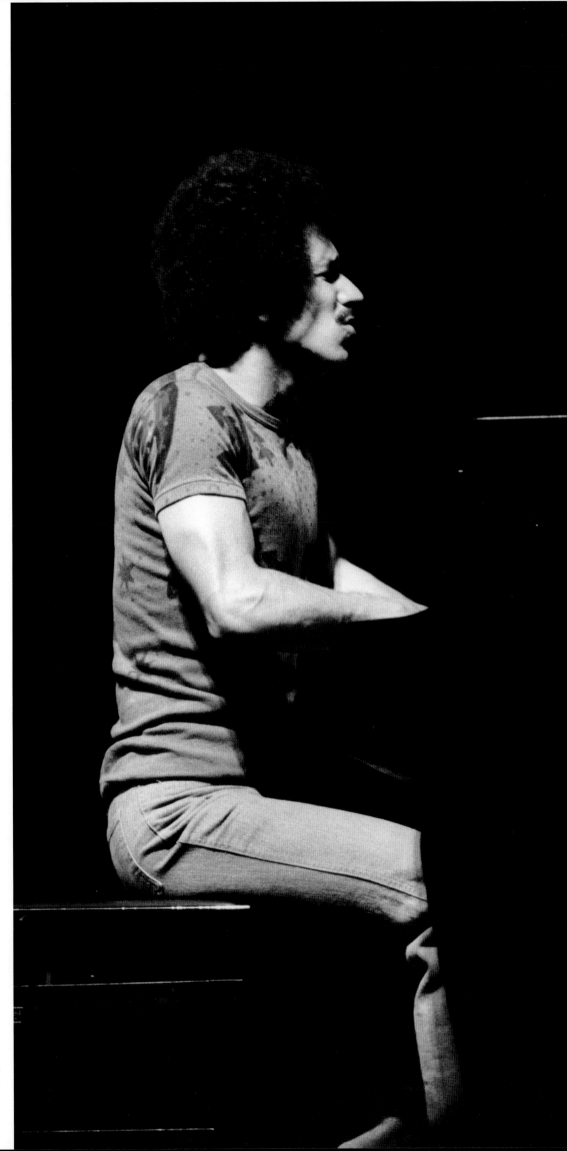

"Music means the presence of possibility. To me, what music should do, at its most potent, is make the listener question himself."
—Keith Jarrett

Keith Jarrett
1975

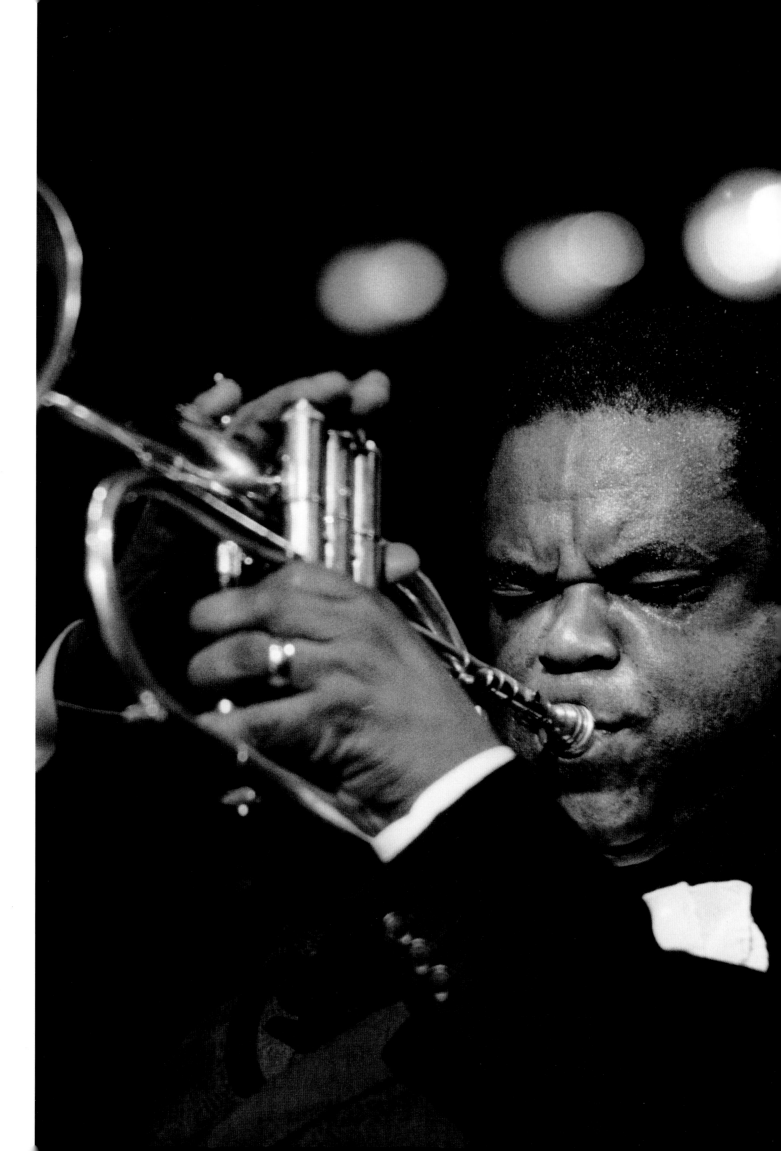

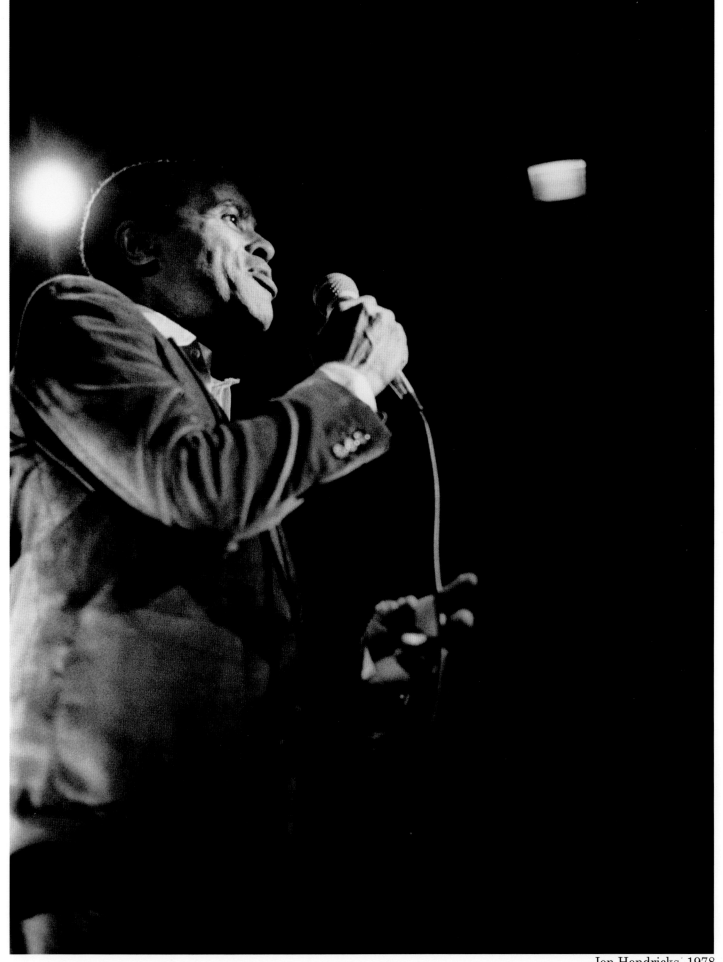

Jon Hendricks, 1978

"A person with a superficial knowledge about jazz is dangerous because they take away the cultural flow, they don't connect Louis Armstrong and Miles Davis, they think that's two different schools; that's the evolutions of the same thing. The two are bound together." —Jon Hendricks

Freddie Hubbard, 1991

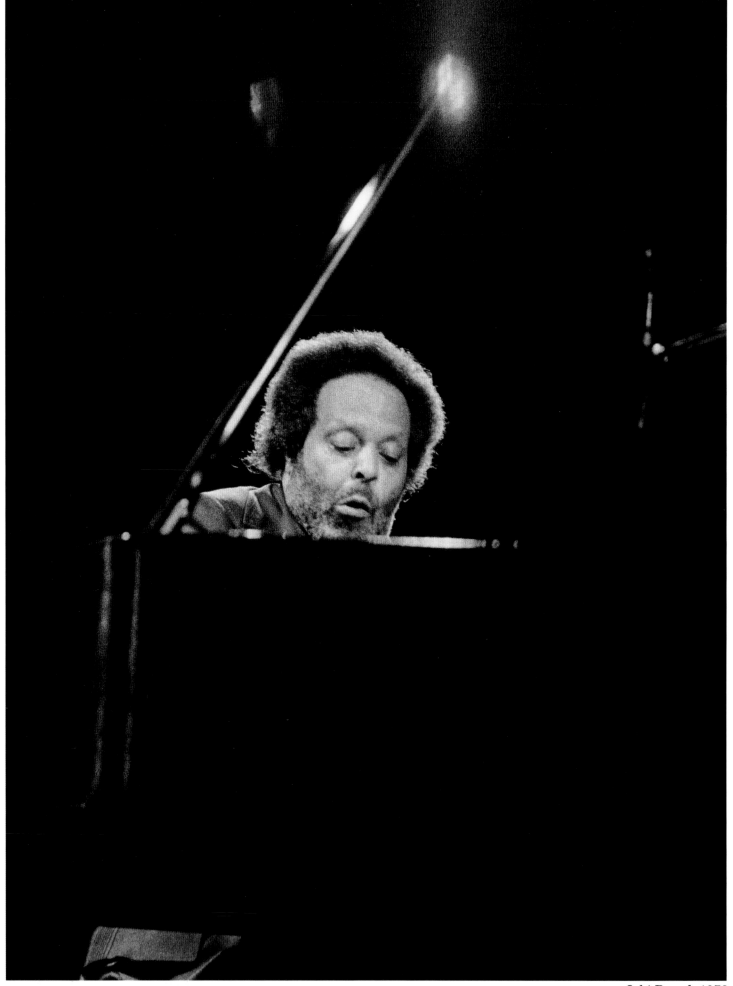

Jaki Byard, 1978

"The music business stinks. The only thing that saves us is the beauty that we bring out of it and the beautiful people that are involved in it." —Jaki Byard

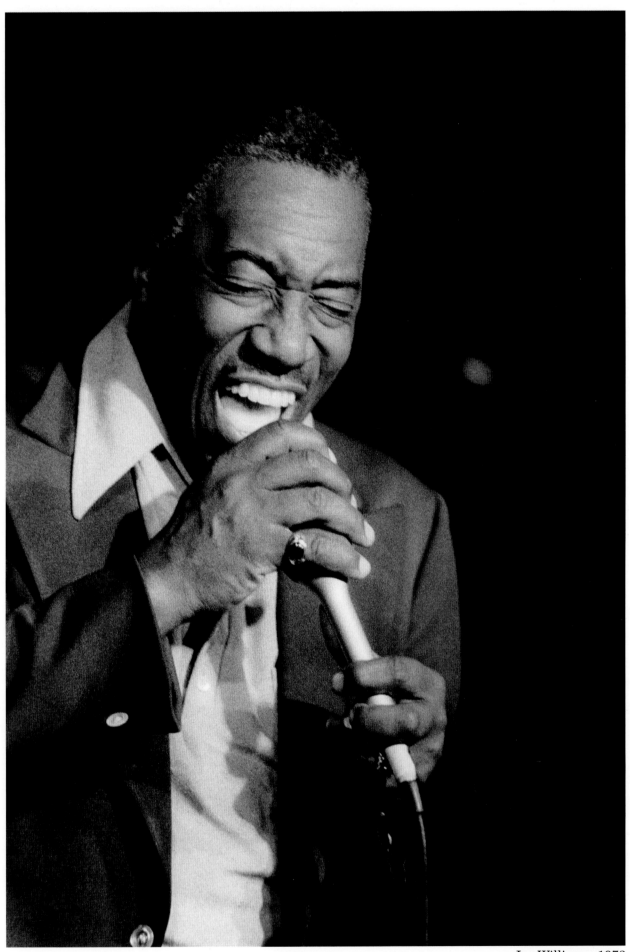

Joe Williams, 1973

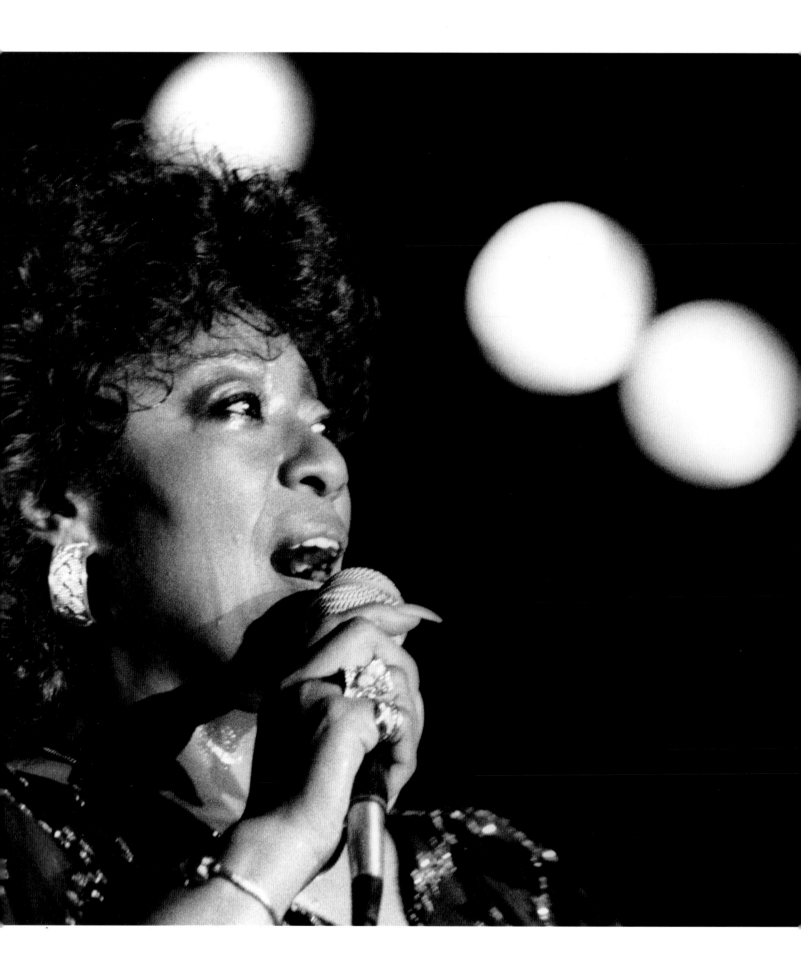

Marlena Shaw, 1990

"I first heard Parker in the mid-1940s. It was uptown at some club. He borrowed a horn and sat in. I was completely turned around. I couldn't sleep for two days. I decided immediately that that was it: I was determined to articulate like that on the clarinet." —Buddy DeFranco

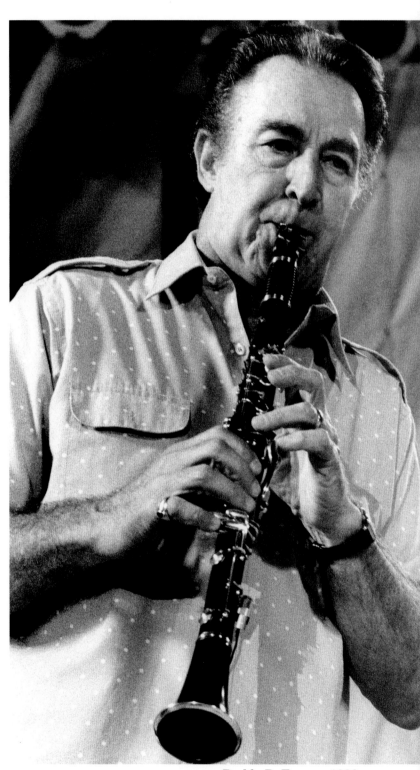

Buddy DeFranco, 1990

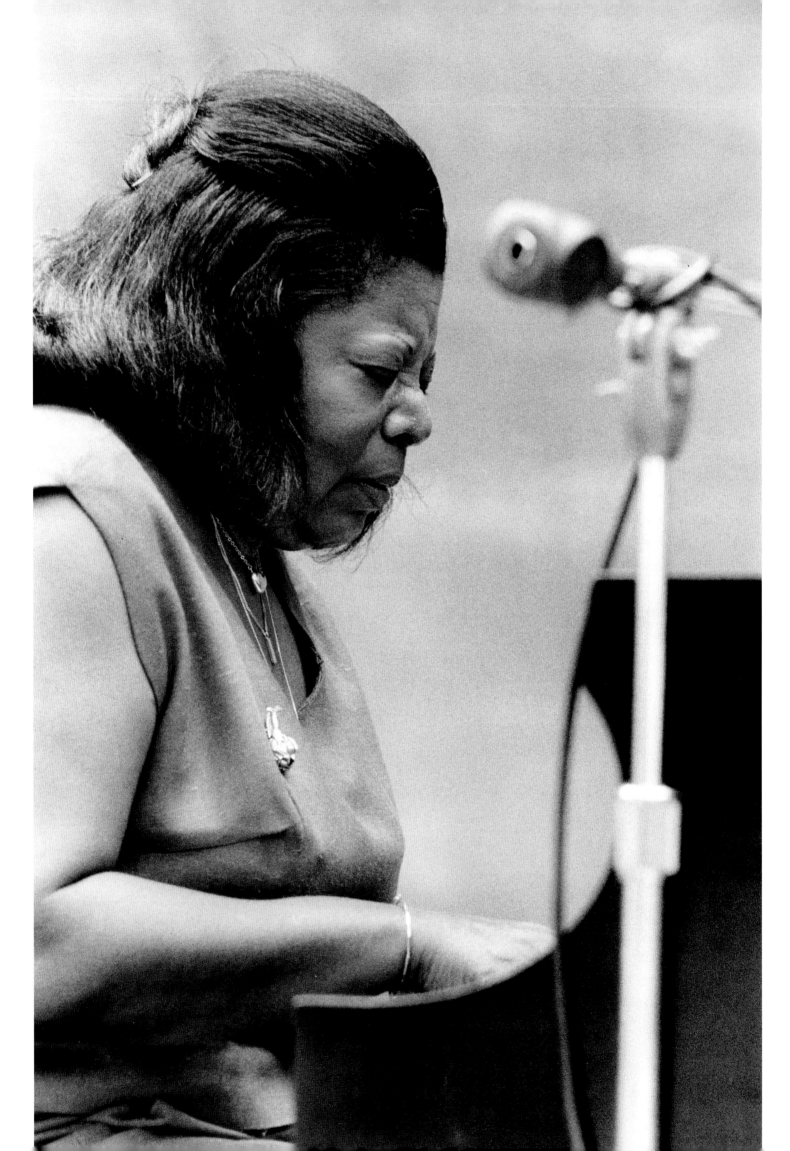

"The music has healing powers in it. Everything about you is in it, healing the soul and all that, and people have forgotten to listen to it as a conversation. If you listen to it, you'll find that it tells a story."
 —Mary Lou Williams

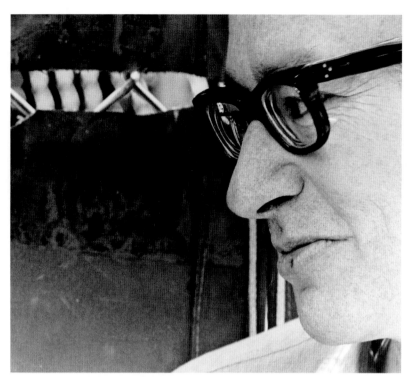

Paul Desmond, 1973

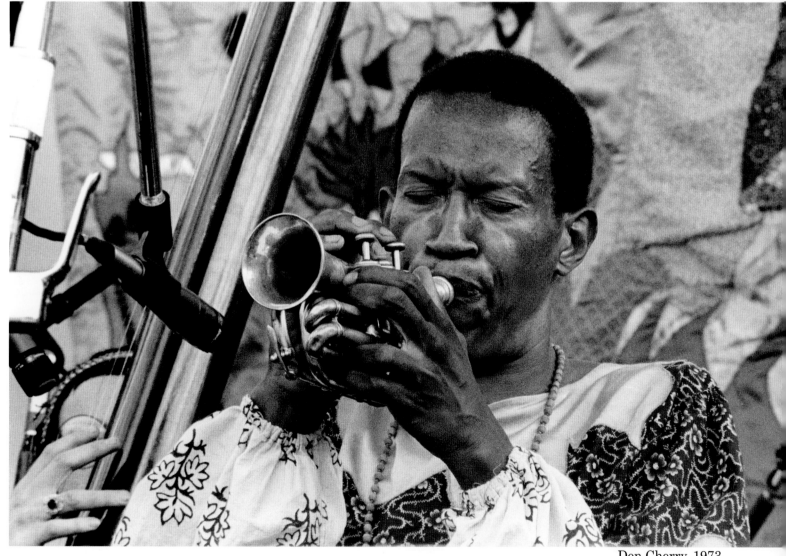

Don Cherry, 1973

Mary Lou Williams, 1977 69

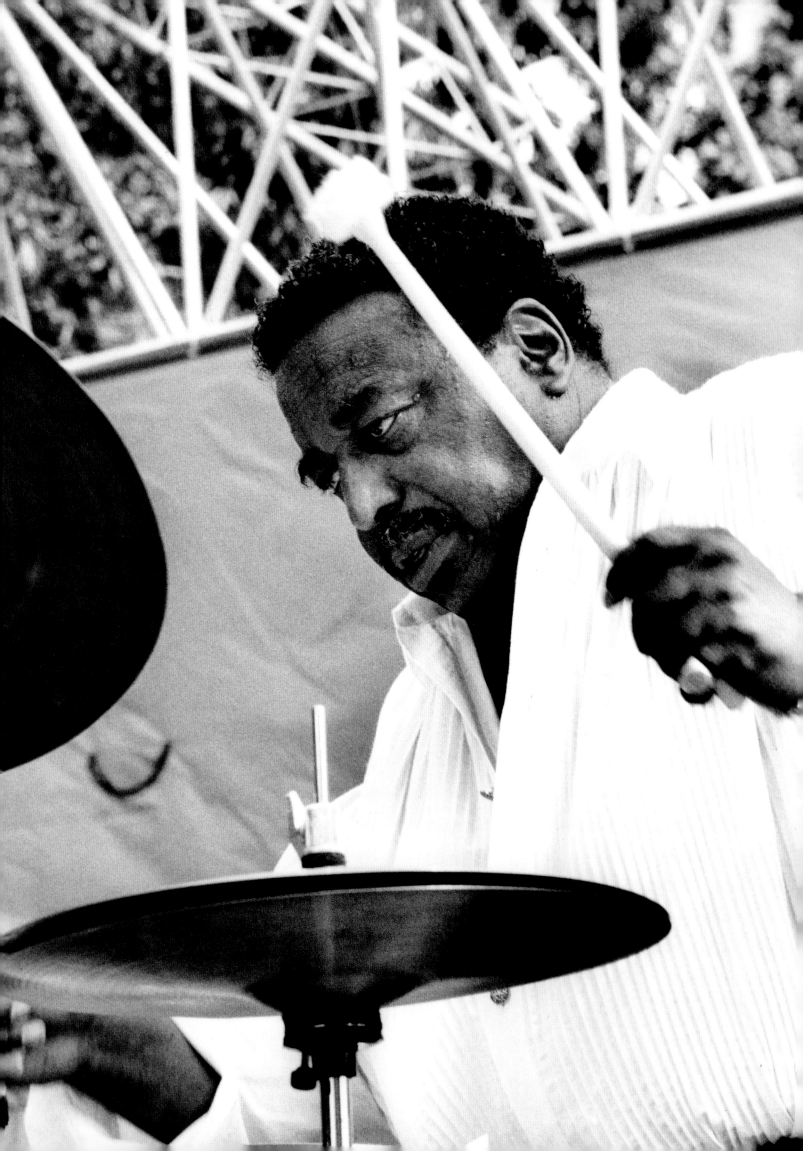

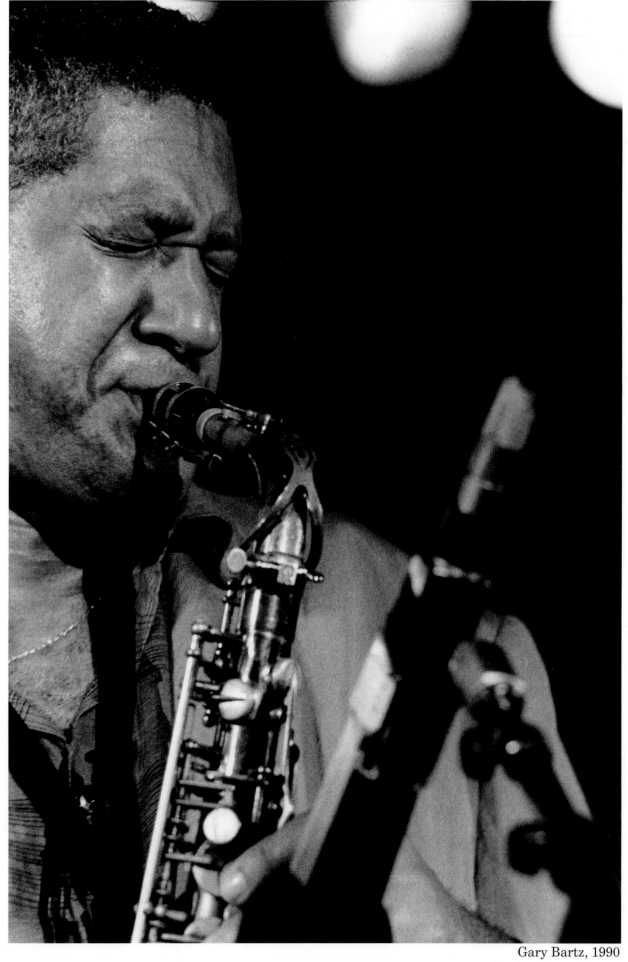

Gary Bartz, 1990

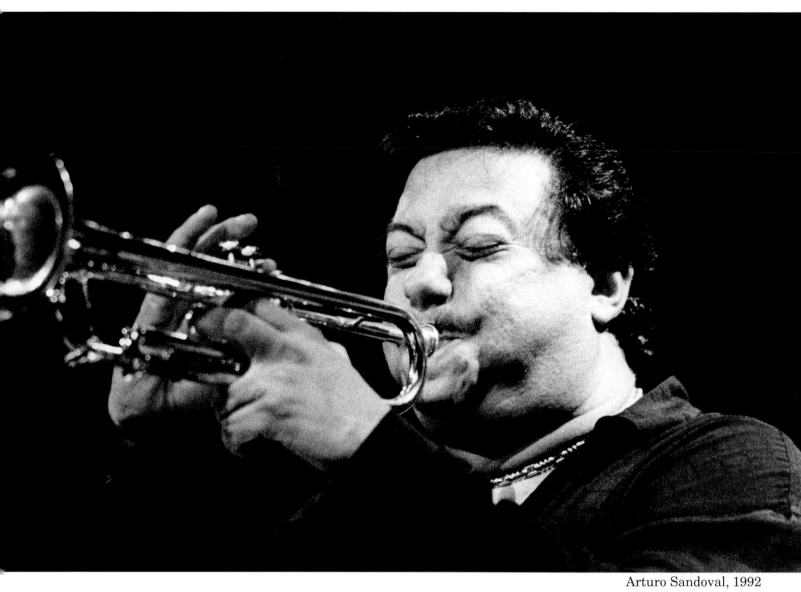

Arturo Sandoval, 1992

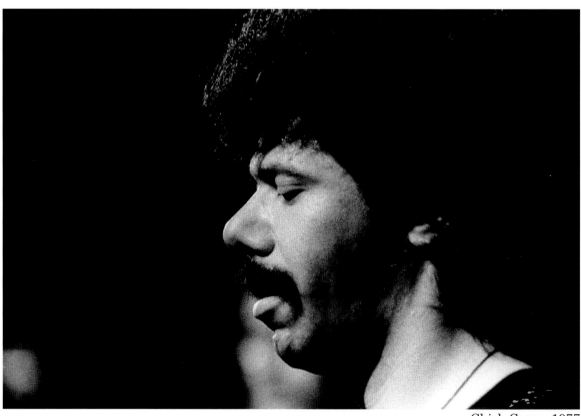

Chick Corea, 1977

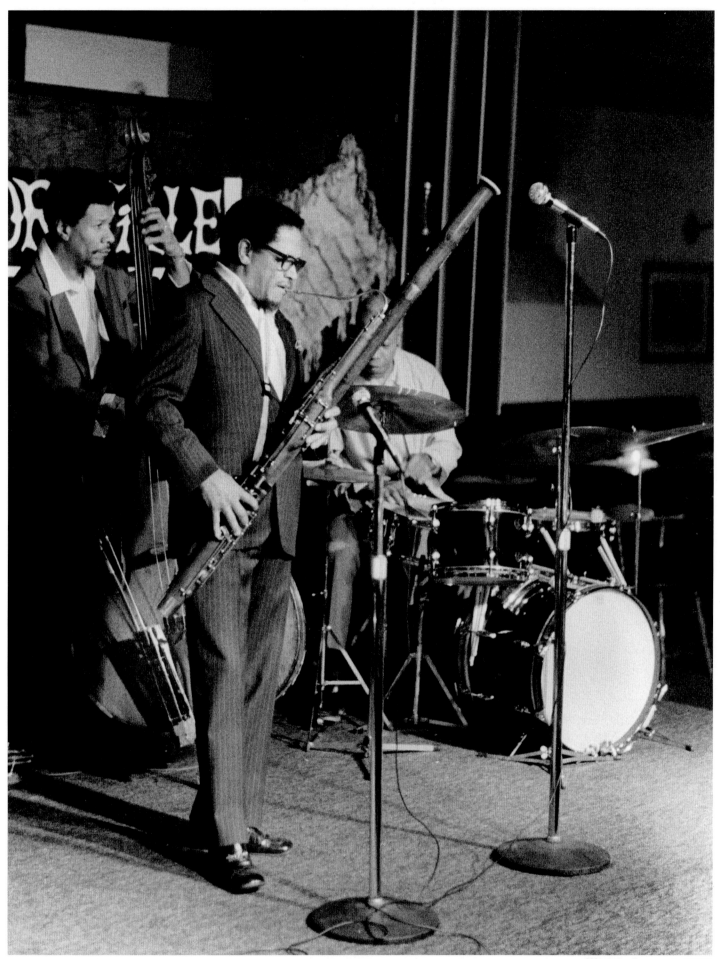

Illinois Jacquet, 1976

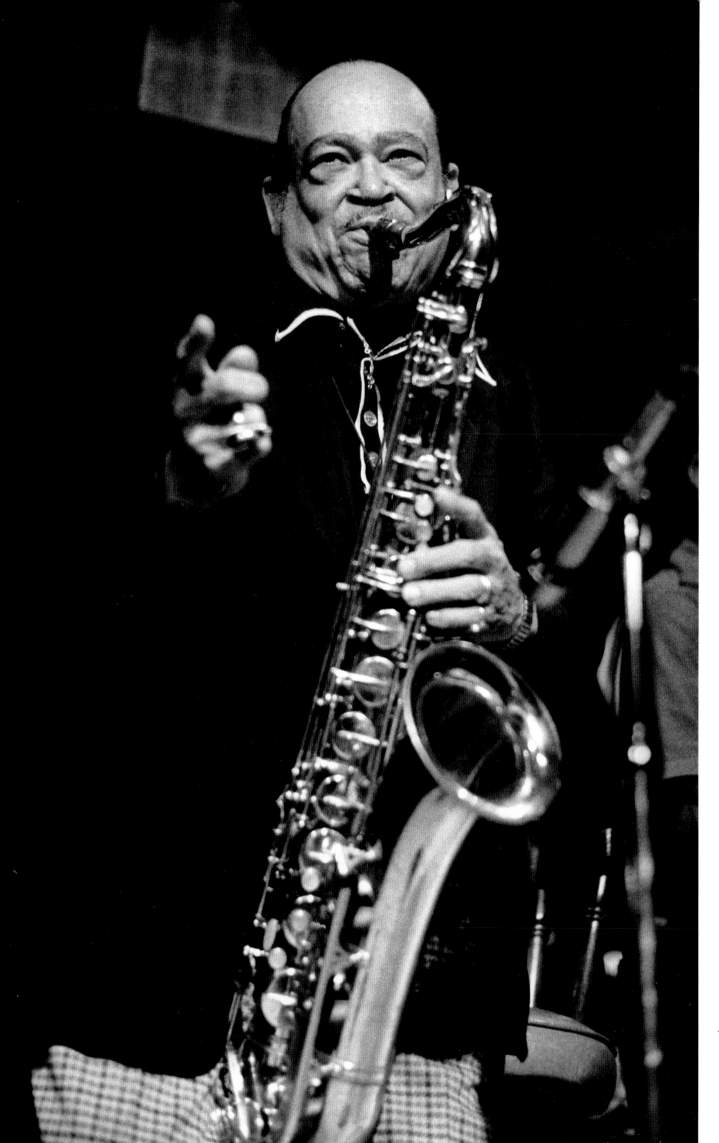

Arnett Cobb
1978

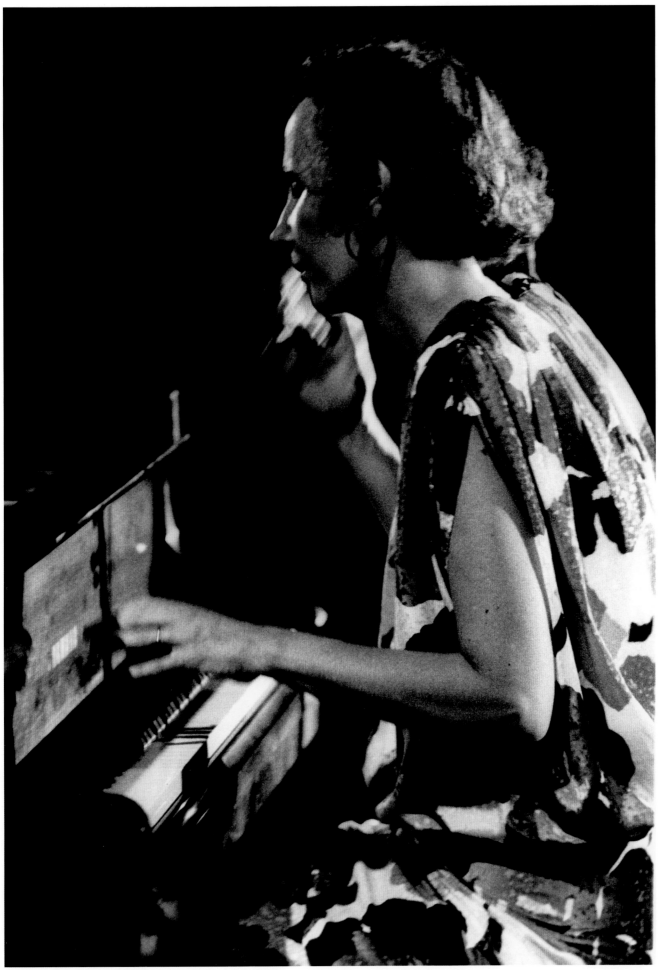

Joanne Brackeen, 1990

"To me, all music is one music. People just want to put names on it. Music to me is the dance." —Joanne Brackeen

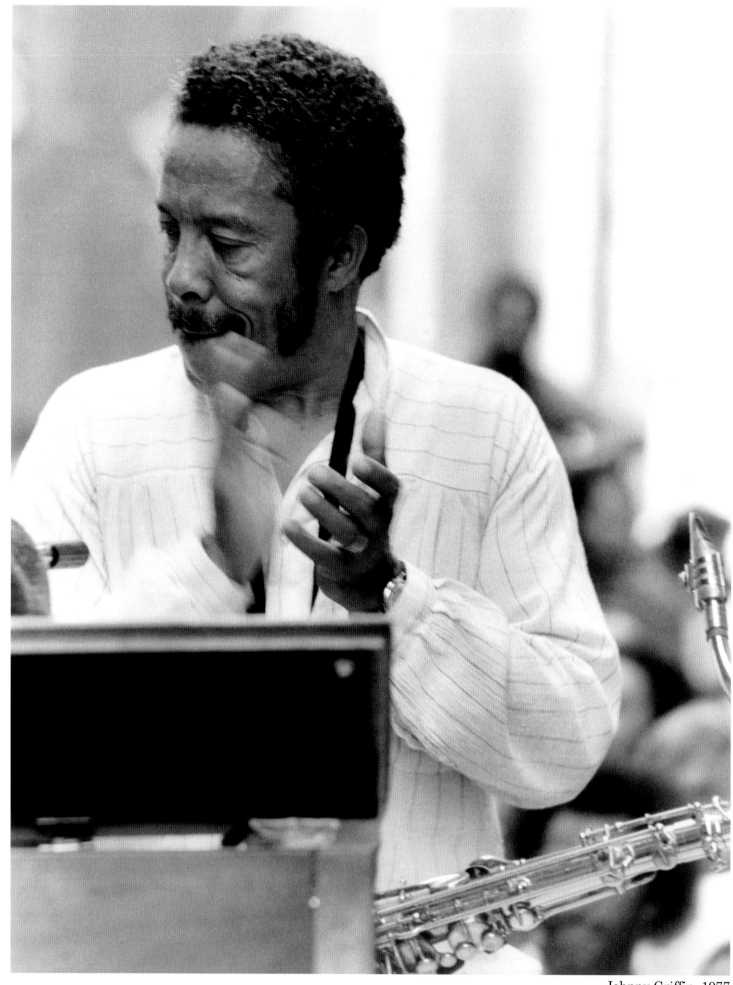

Johnny Griffin, 1977

"Jazz isn't just a music, it's a way of life, a philosophy for living.
It's having a good time when you are feeling bad." —Johnny Griffin

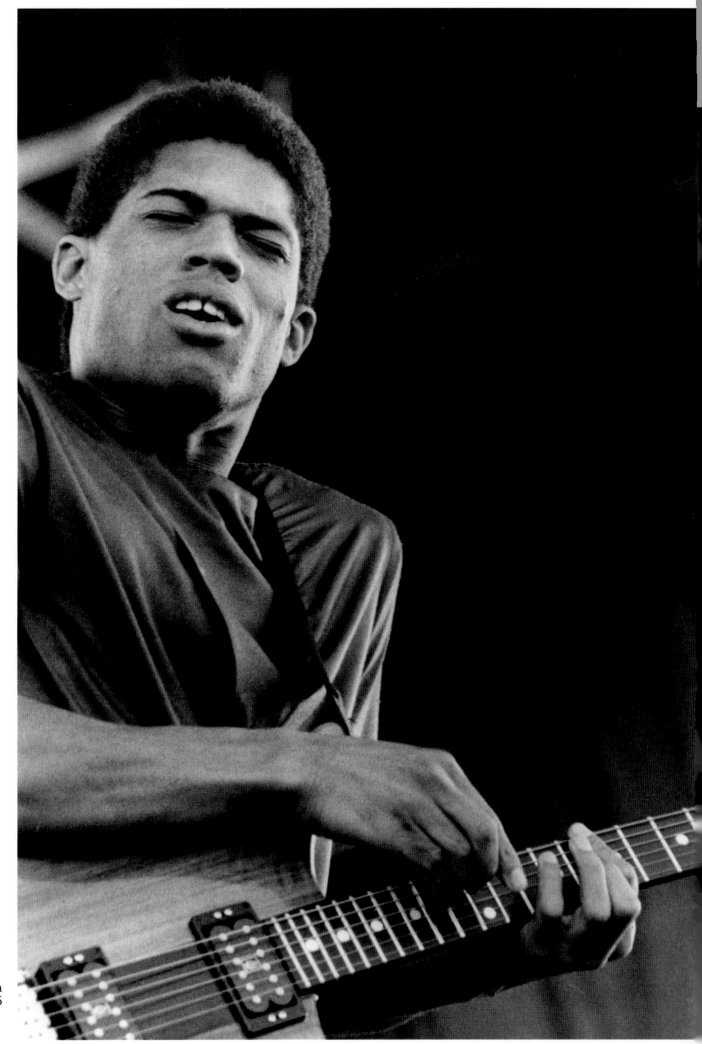

Stanley Jordan
1985

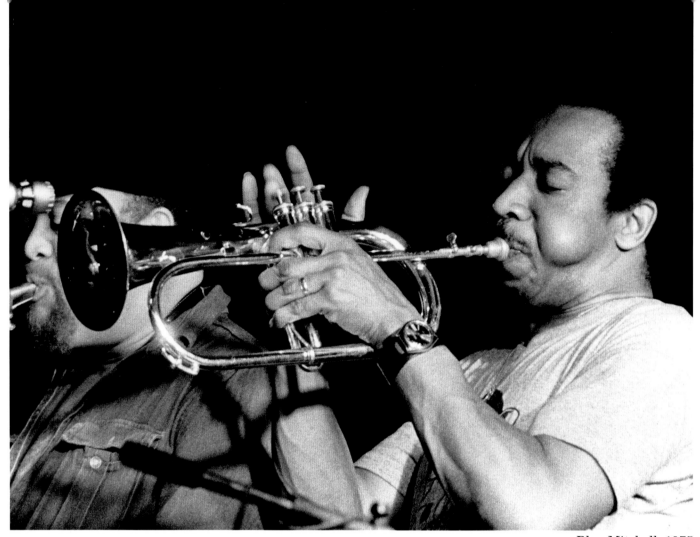

Blue Mitchell, 1975

Jane Ira Bloom, 1990

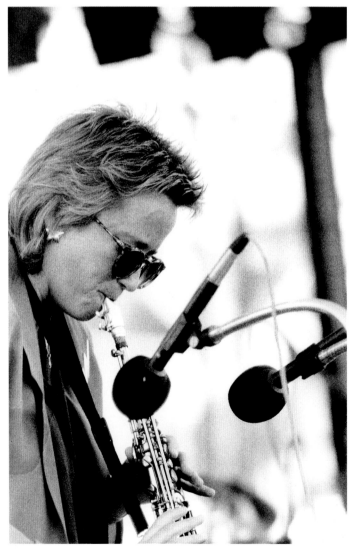

"I am not trying to sound like a guitar or trying to interface with a synthesizer. I'm still a saxophonist trying to sound like a saxophonist."

—Jane Ira Bloom

Poncho Sanchez, 1989

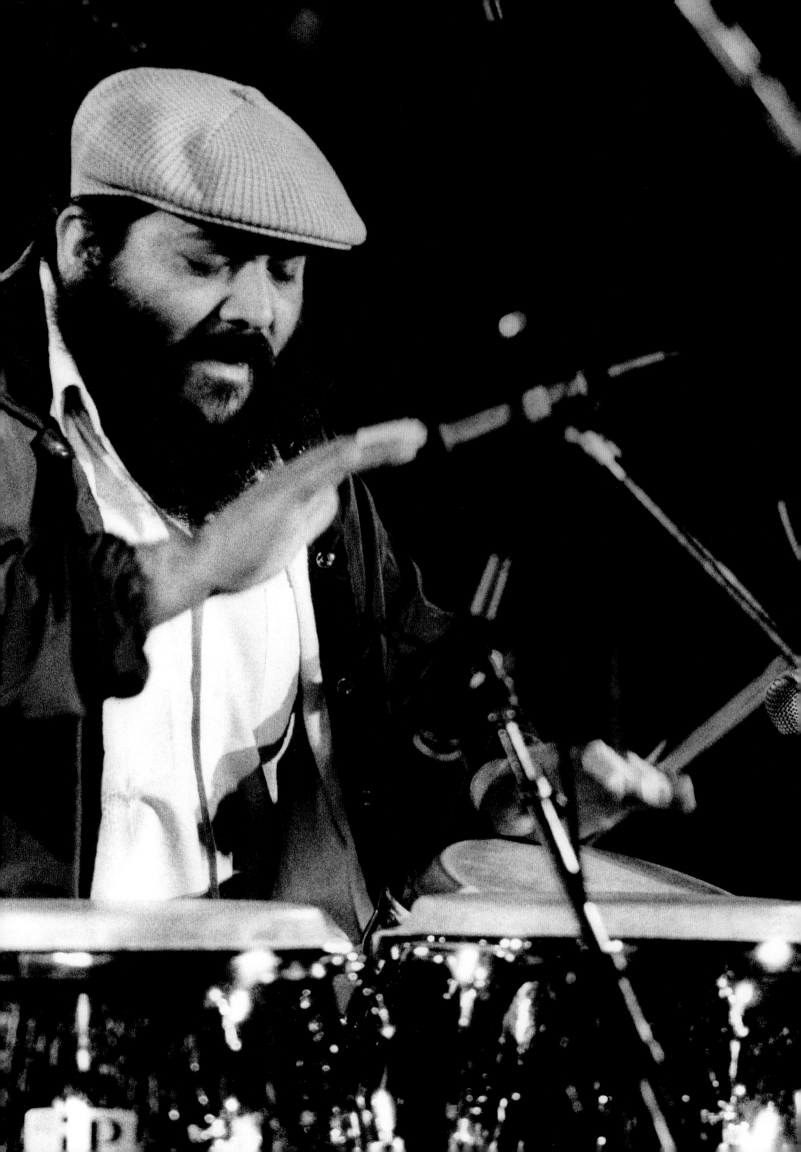

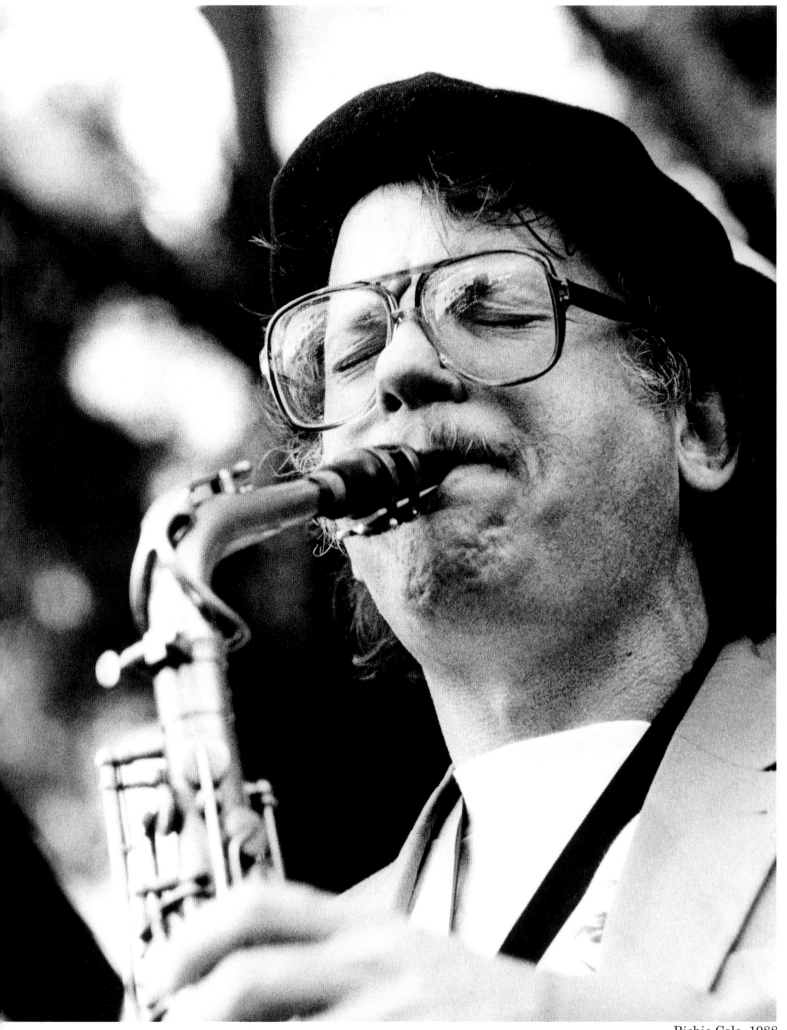

Richie Cole, 1988

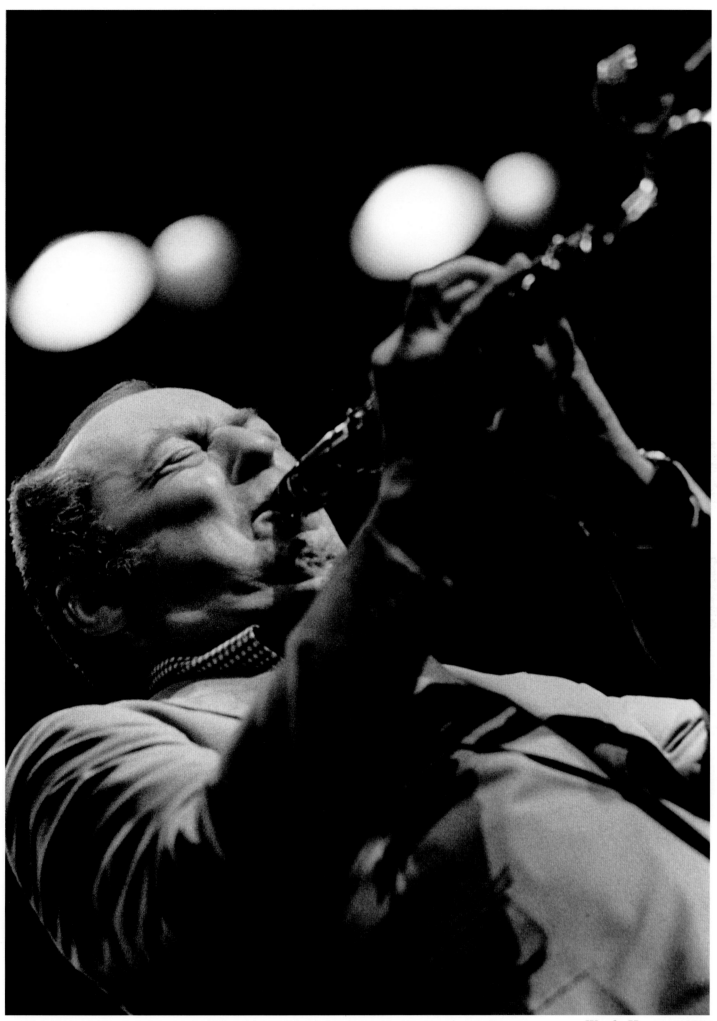

Woody Herman, 1974

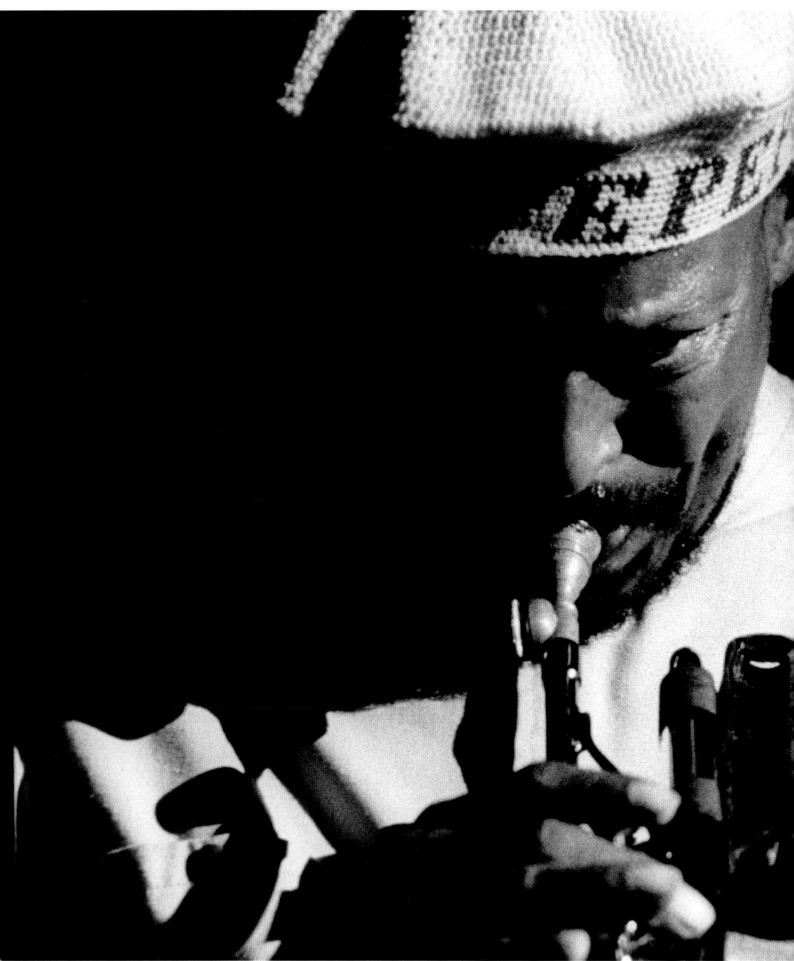

Miles Davis, 1981

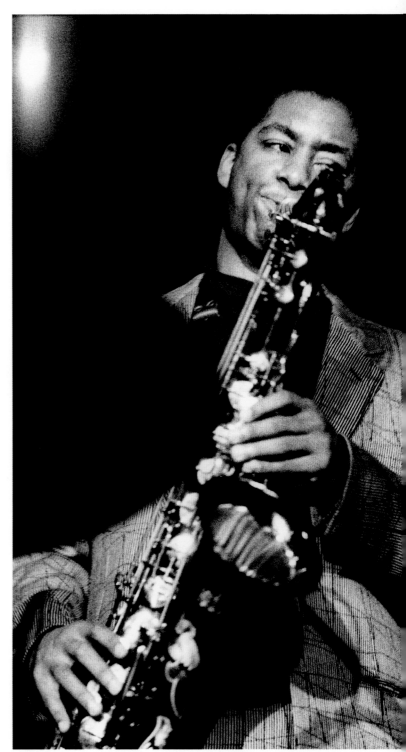

Branford Marsalis, 1991

"Music is about timing and getting everything in rhythm. It can sound great if it's Chinese as long as the right things are in place. But as complex as people try to make my music out to be, I like it simple. That's the way I hear it even if it's complex to them." —Miles Davis

83

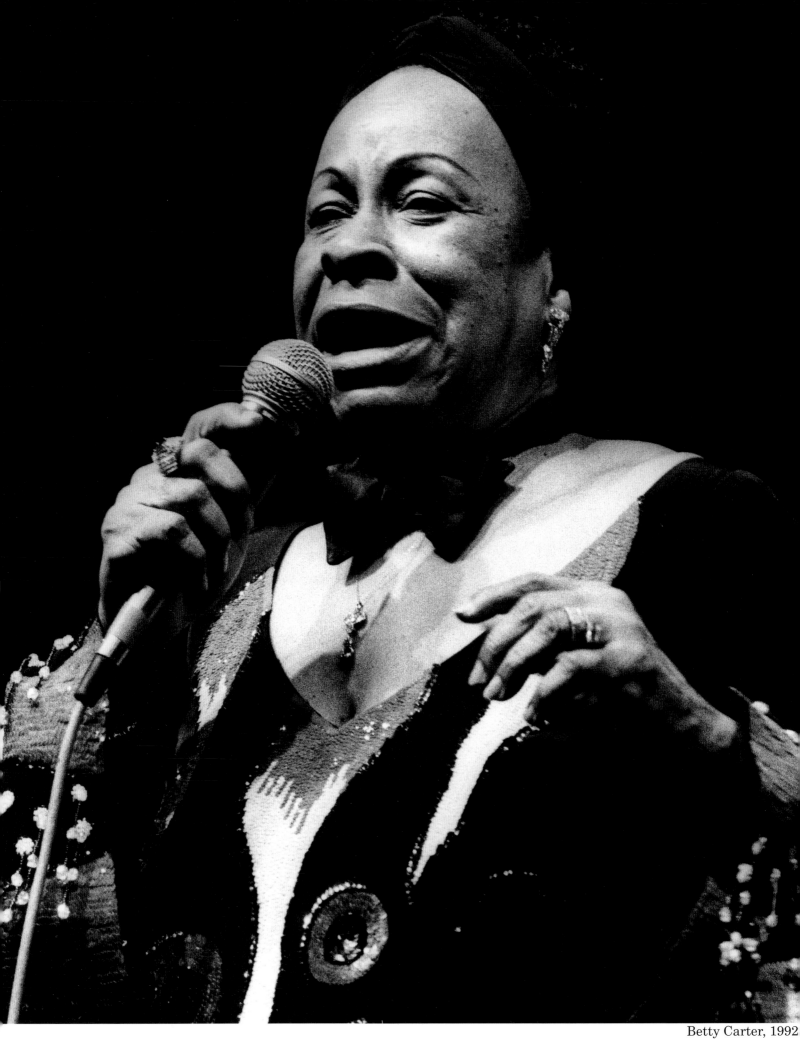

Betty Carter, 1992

"I don't usually listen to jazz at home. I don't want to absorb my head with it. So
when you hear me, you hear me fresh; whatever comes out is mine." —Betty Carter

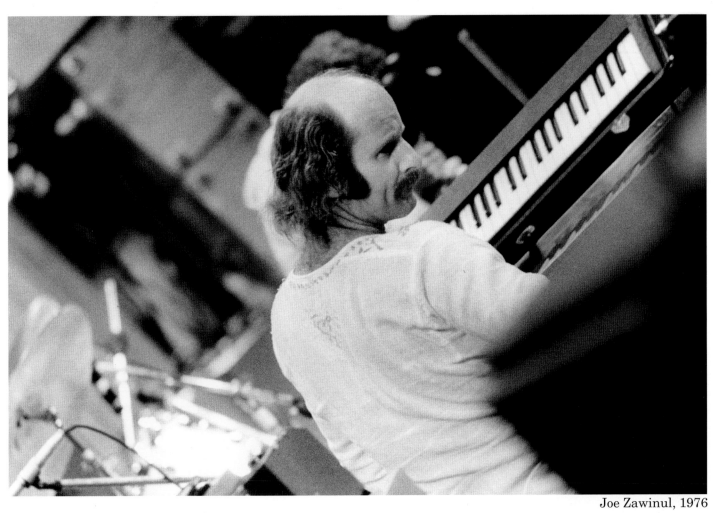

Joe Zawinul, 1976

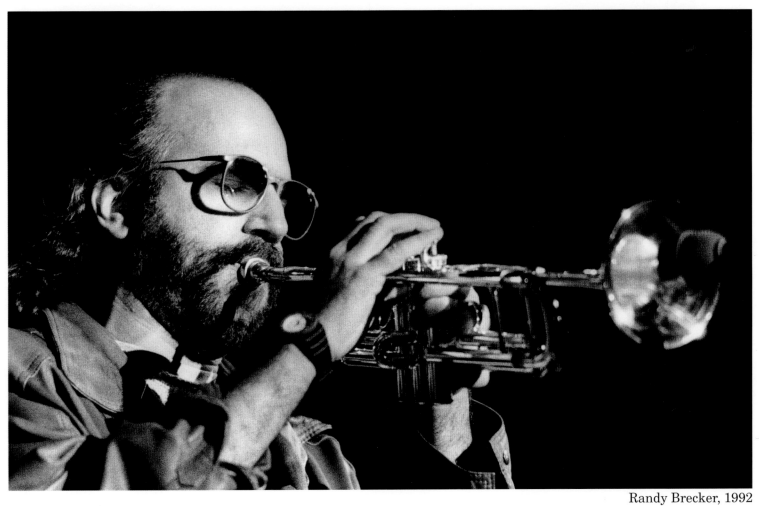

Randy Brecker, 1992

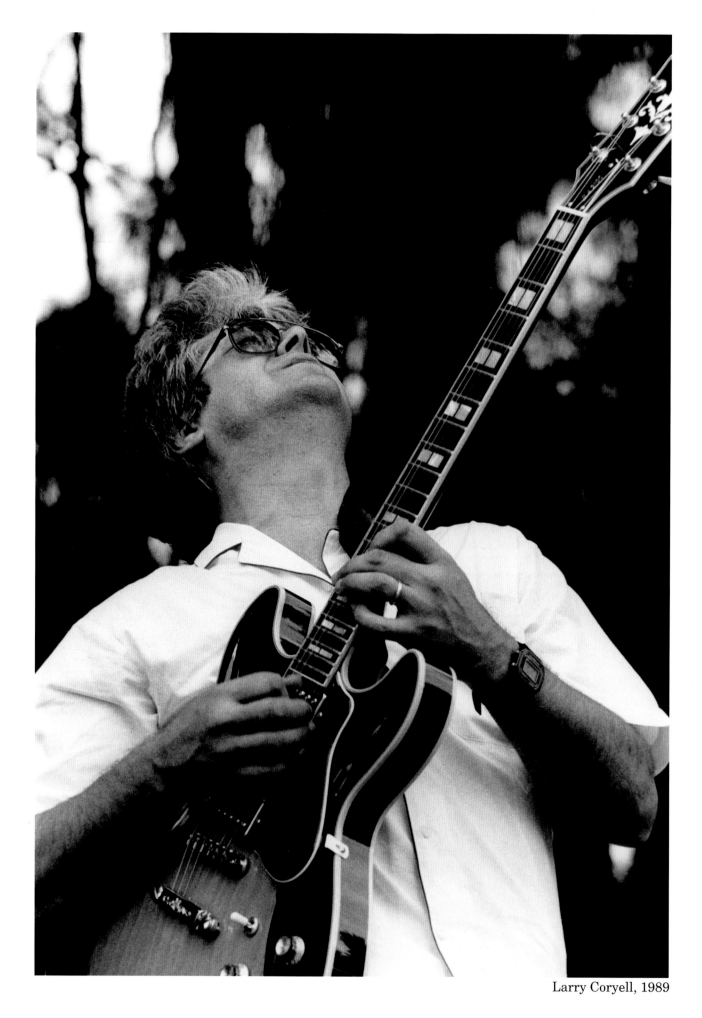

Larry Coryell, 1989

"I could say the music has given me everything that I have so I feel obligated to give back everything I have to music." —Larry Coryell

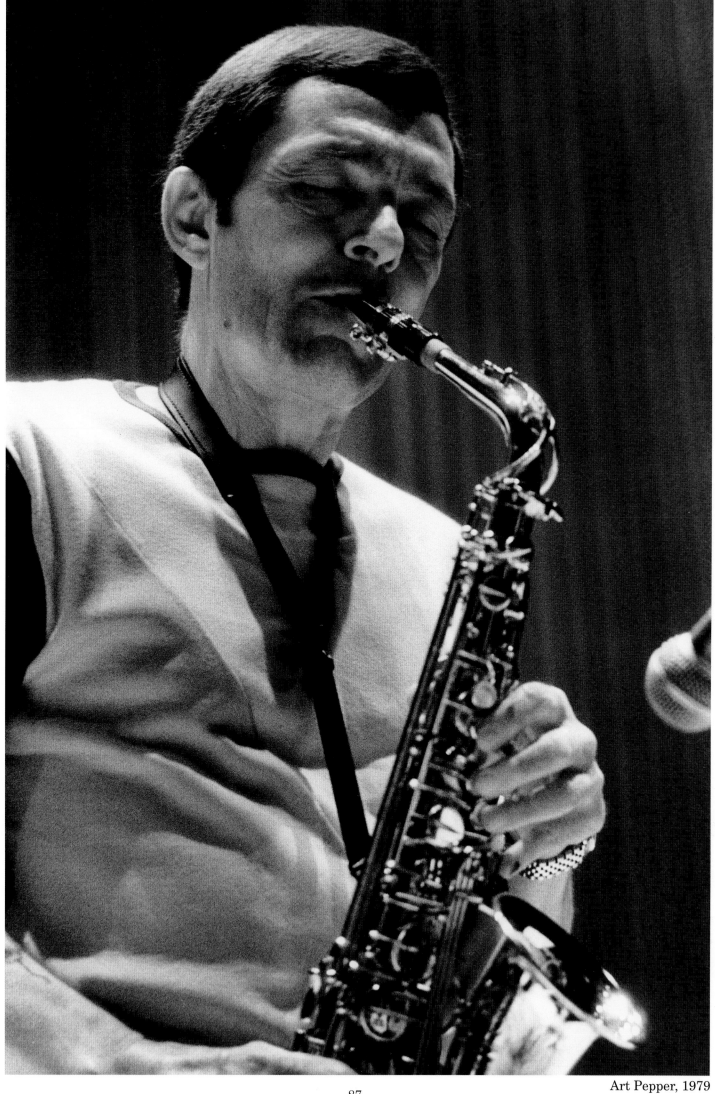

Art Pepper, 1979

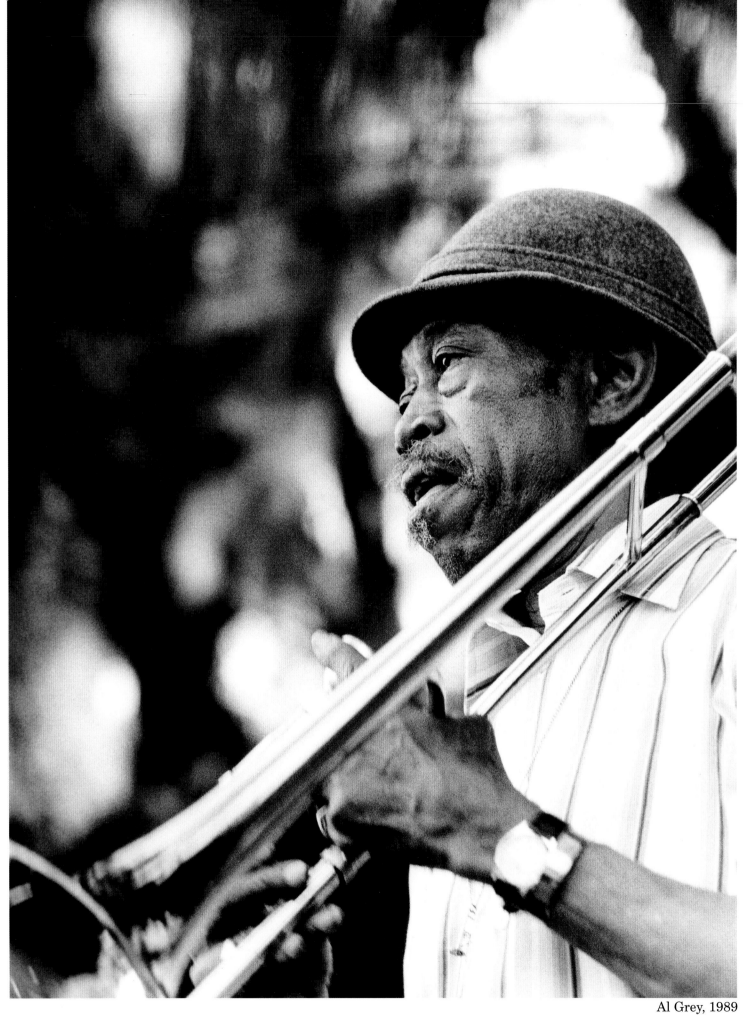

Al Grey, 1989

"You have to deal with the public who are listening to the music. You can't play for yourself, you have to play for the people that come to hear you." —Al Grey

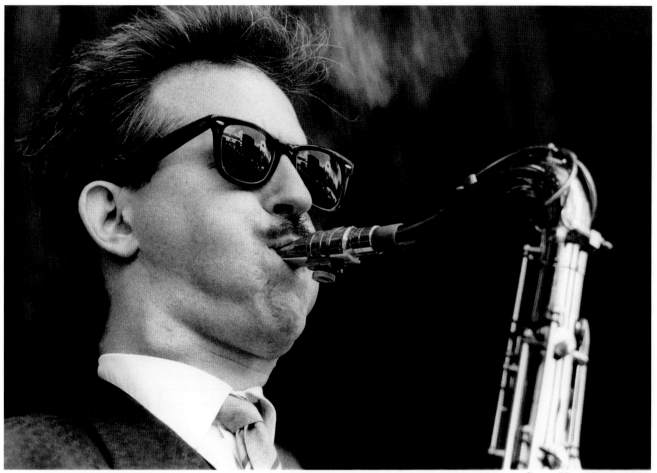

Scott Hamilton, 1988

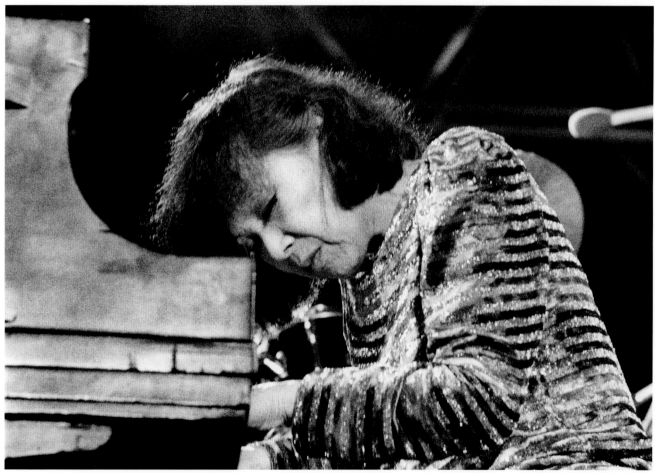

Toshiko Akiyoshi, 1989

"I like to have my music approach cultural attitudes and problems. When people listen I want them to identify with their own lives." —Toshiko Akiyoshi

89

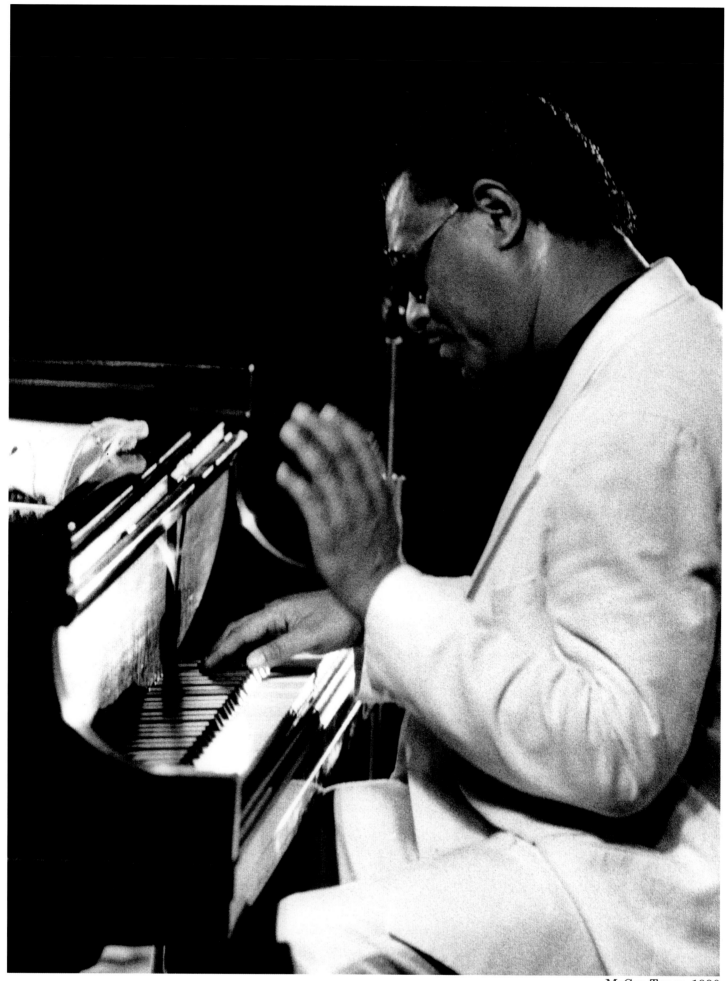

McCoy Tyner, 1990

"When all the elements are there the music takes the forefront. It's not egos,
you should be submerged totally and the music will take you." —McCoy Tyner

Rahsaan Roland Kirk, 1977

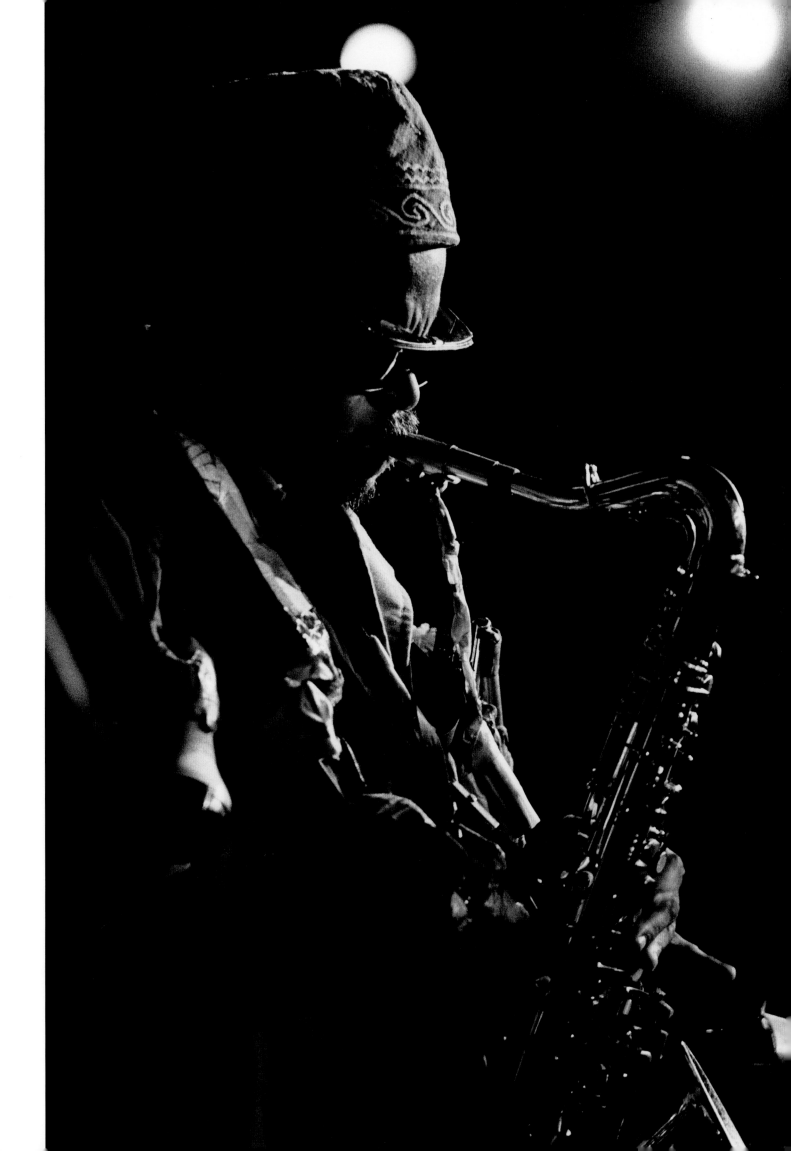

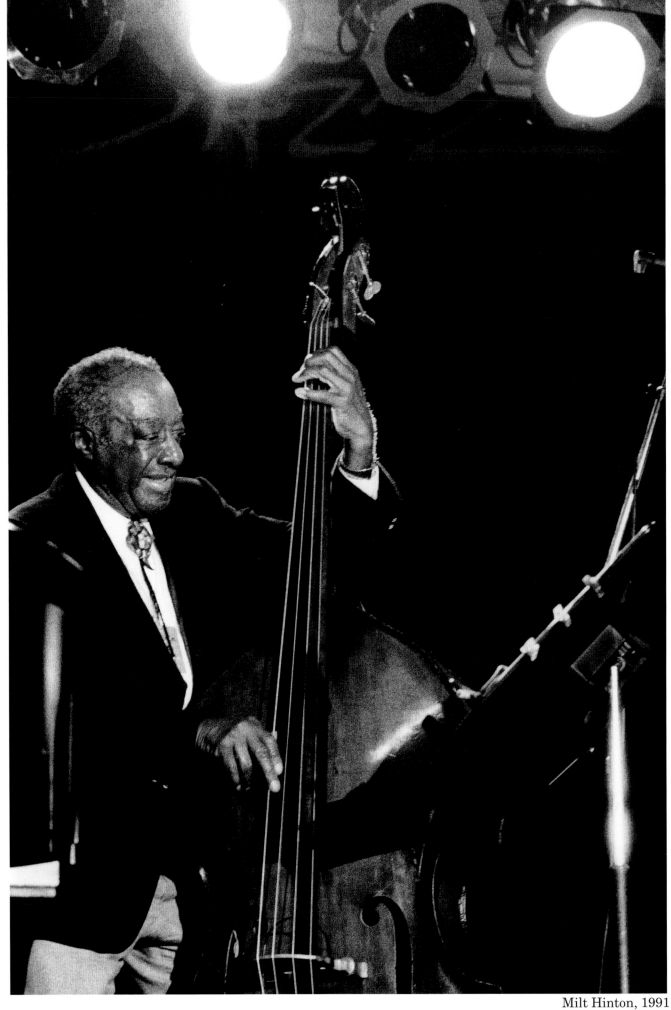

Milt Hinton, 1991

"I'm a very sad tuba player. My very first recording in 1930 was with Tiny Parham and I'm playing tuba on this record. If you want to know why I'm playing bass now, just listen to that record. It's just ridiculous." —Milt Hinton

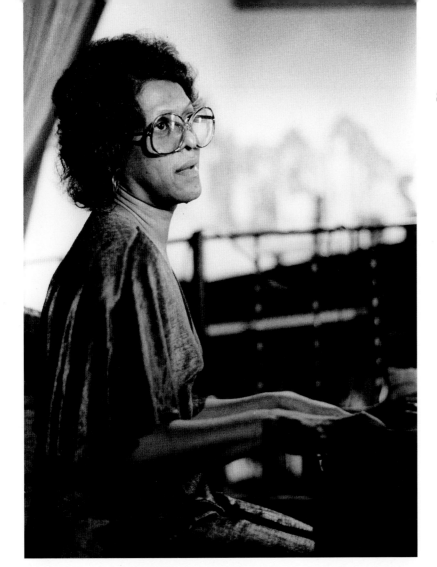

Shirley Scott, 1976

"Musicians are playing so many different electric instruments today. They don't focus on one instrument." —Shirley Scott

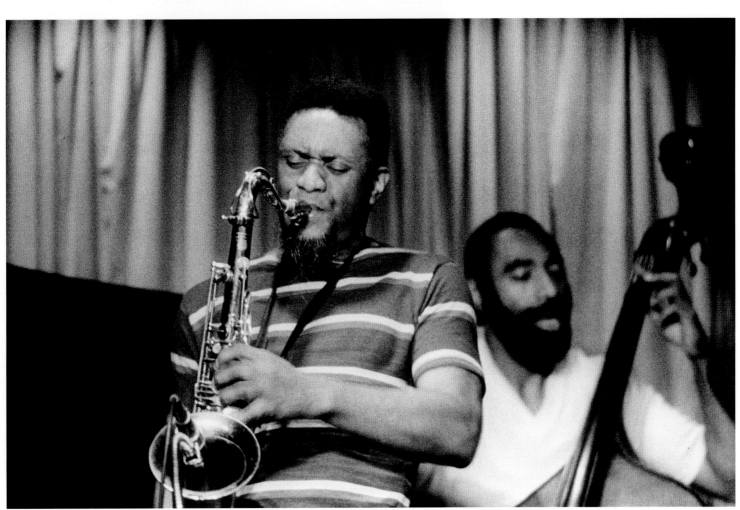

93

Pharoah Sanders, 1980

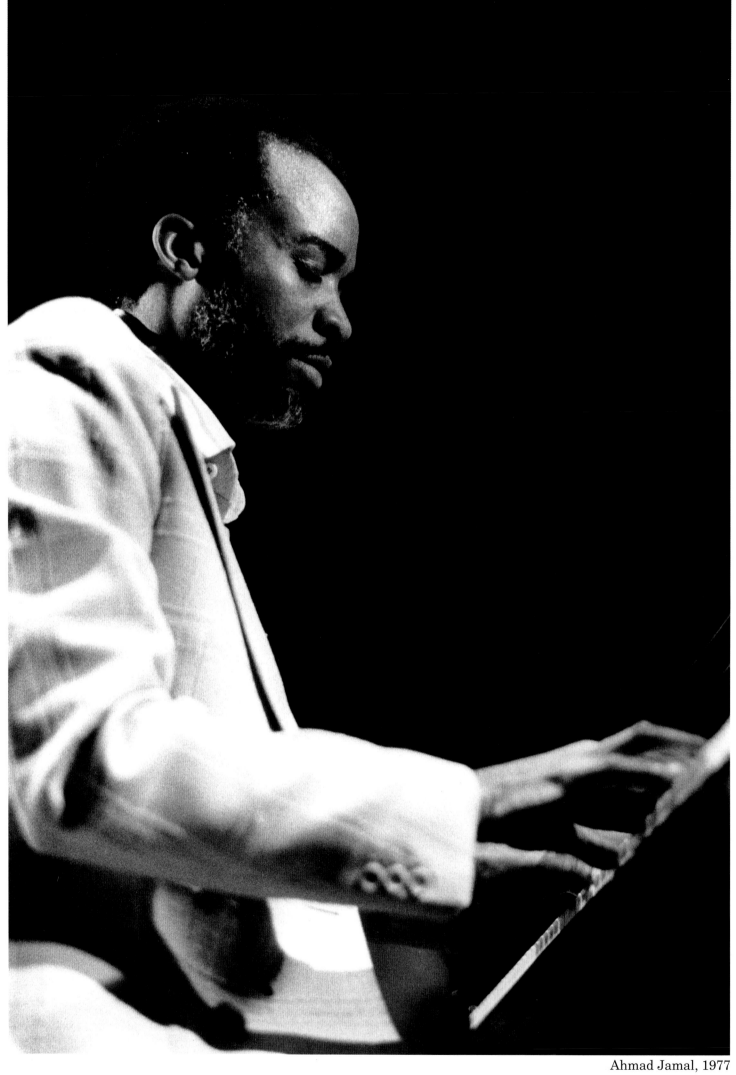

Ahmad Jamal, 1977

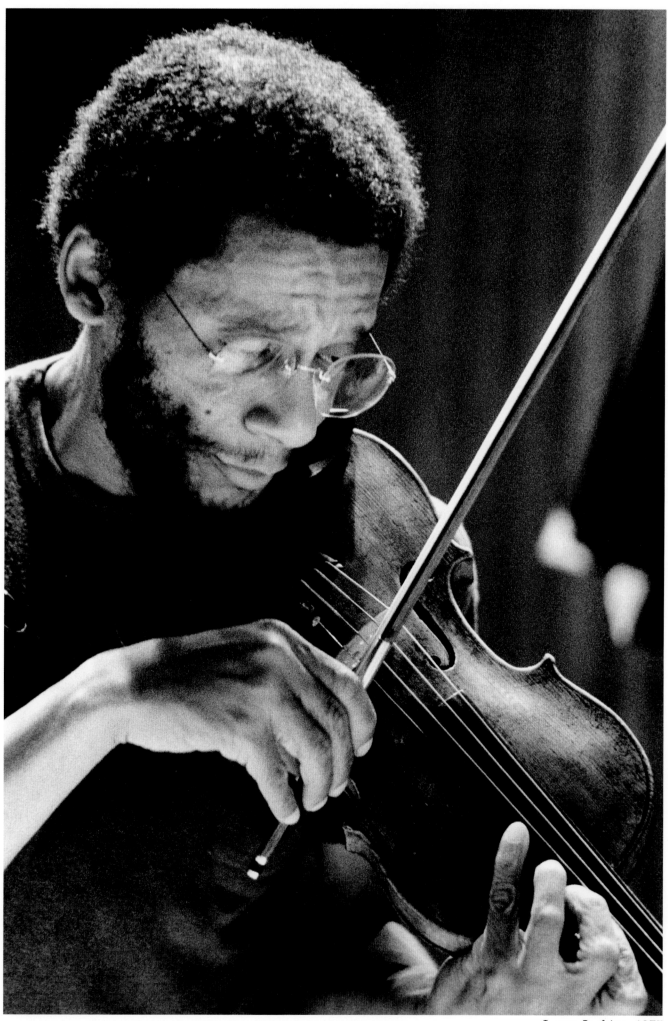

Leroy Jenkins, 1975

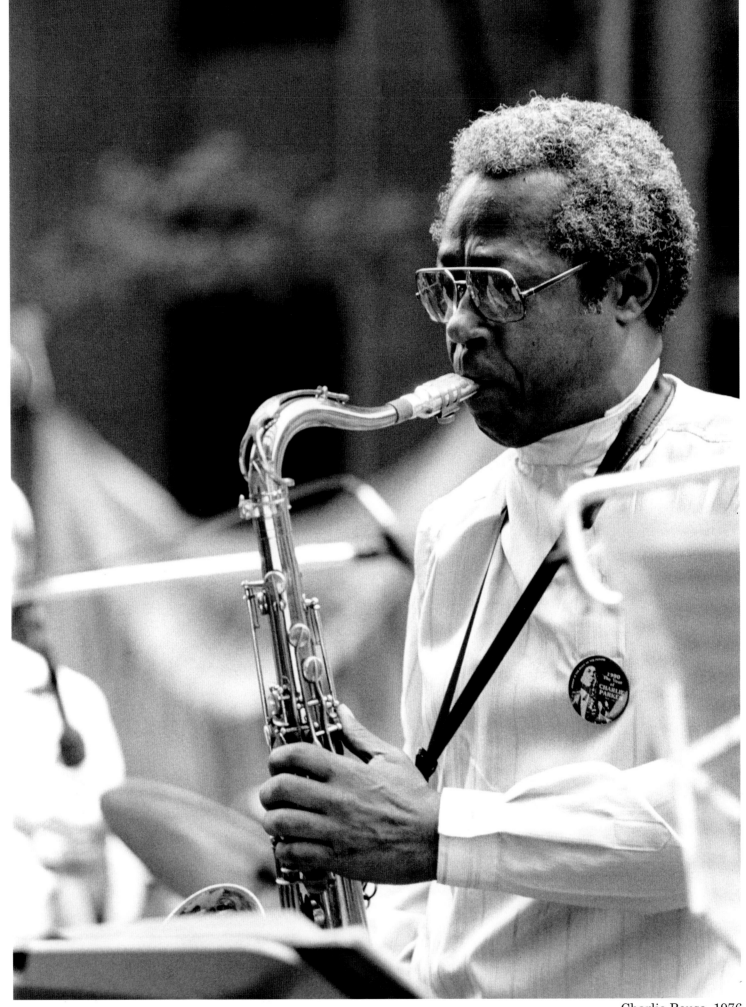

Charlie Rouse, 1976

"I hope that the music will stay alive instead of going electric or some other thing. I feel good because there are some very good young kids beginning to be serious about the music." —Charlie Rouse

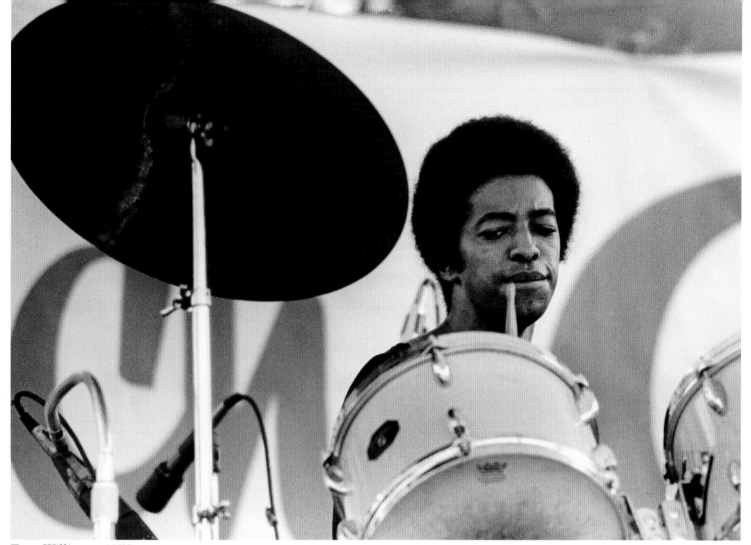

Tony Williams, 1973

Herbie Mann, 1974

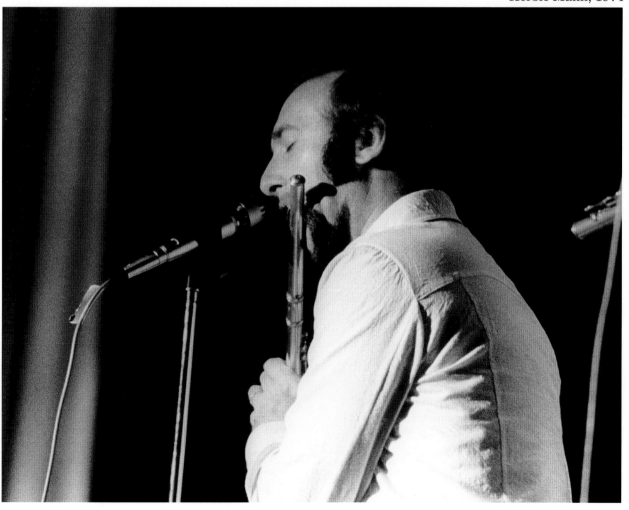

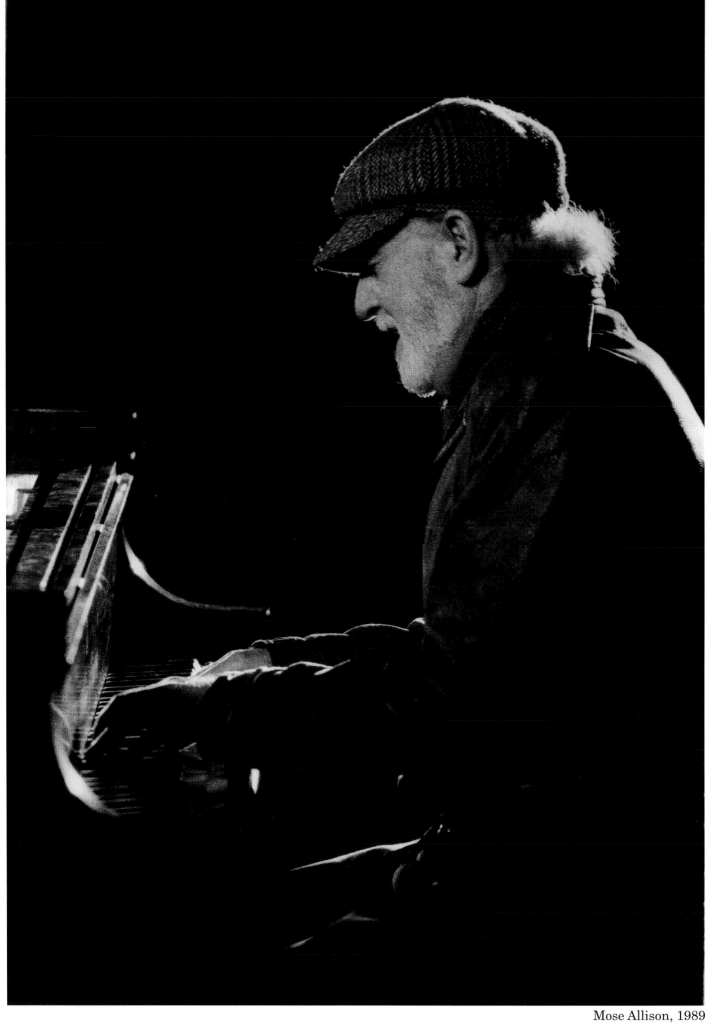

Mose Allison, 1989

"I usually start the set with certain chord structures that I improvise on.
I visualize them as sort of boogie-woogie sonatas." —Mose Allison

"The idea of cool is to be able to be in control of what's happening." —Lee Konitz

Lee Konitz, 1989

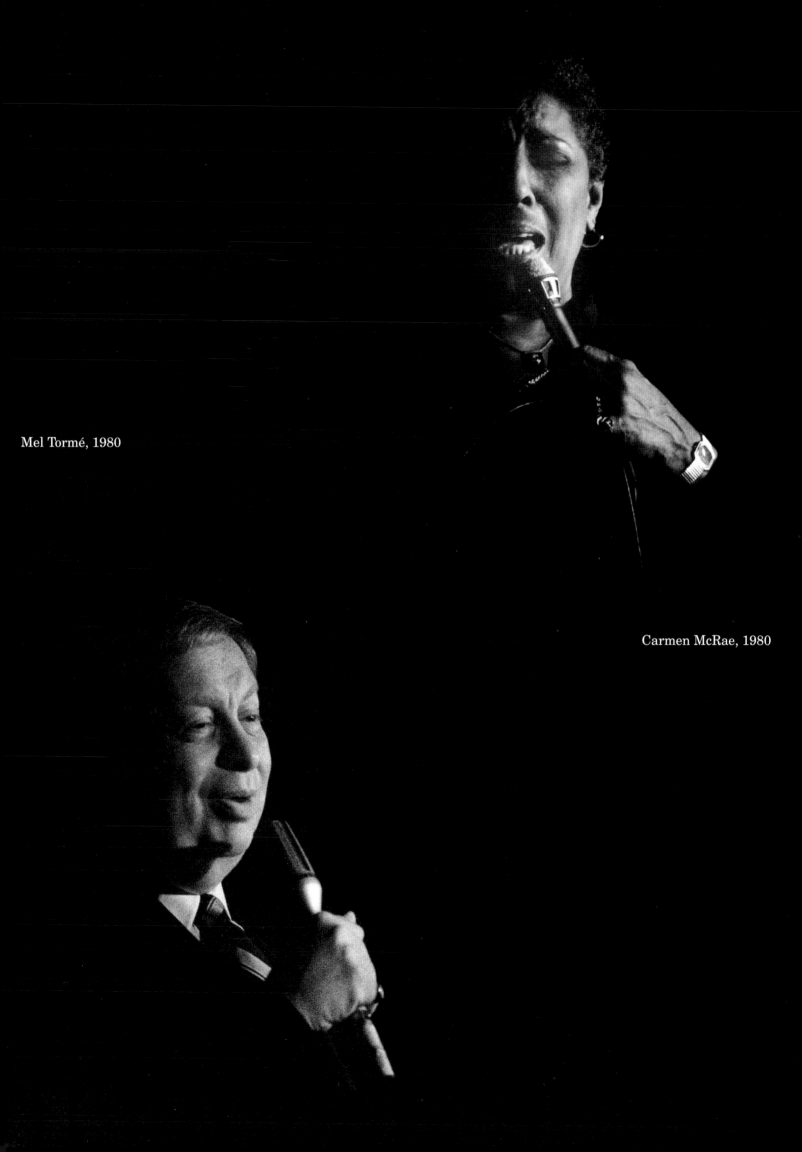

Mel Tormé, 1980

Carmen McRae, 1980

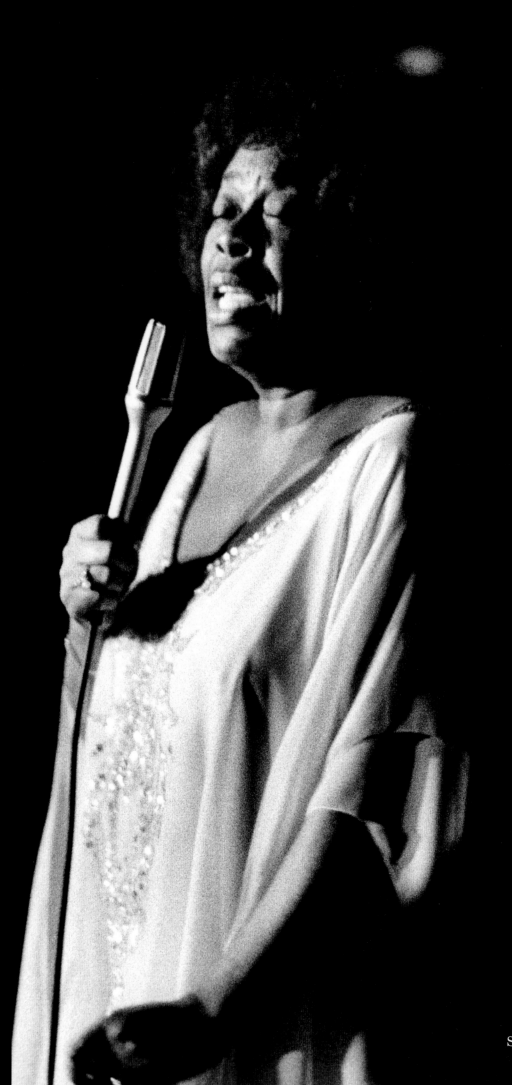

Sarah Vaughan, 1980

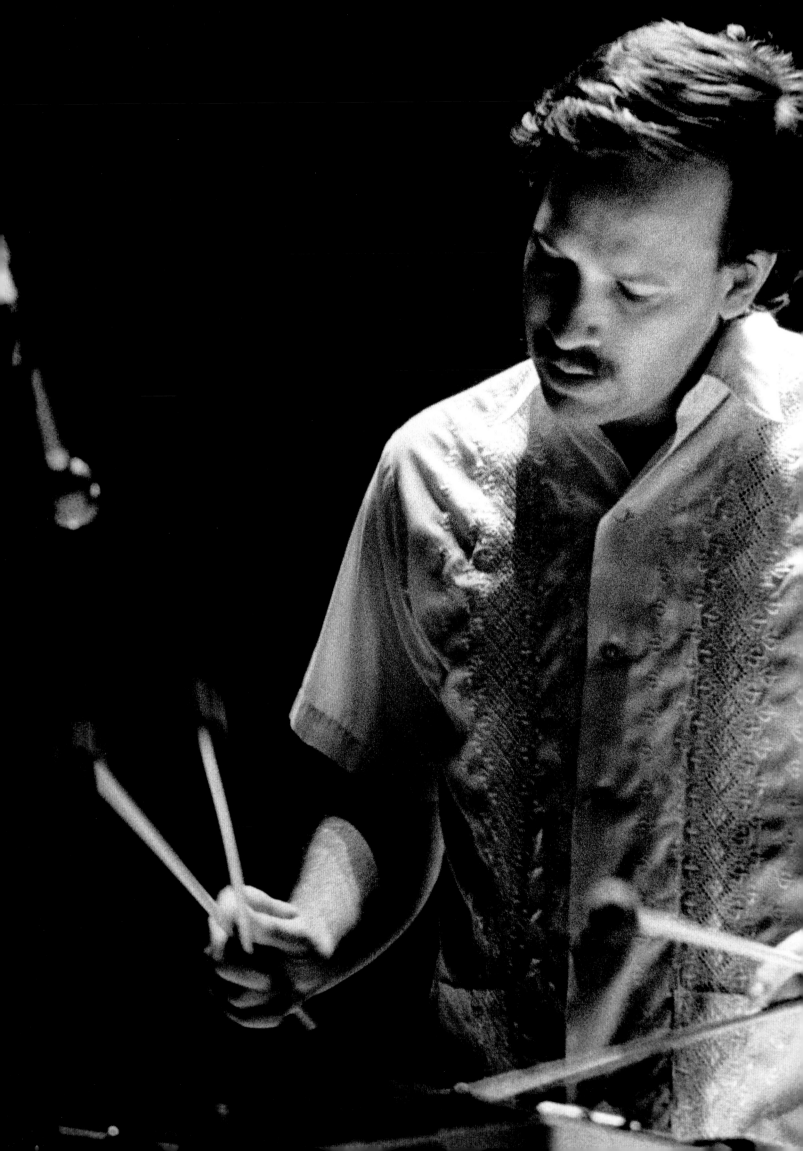

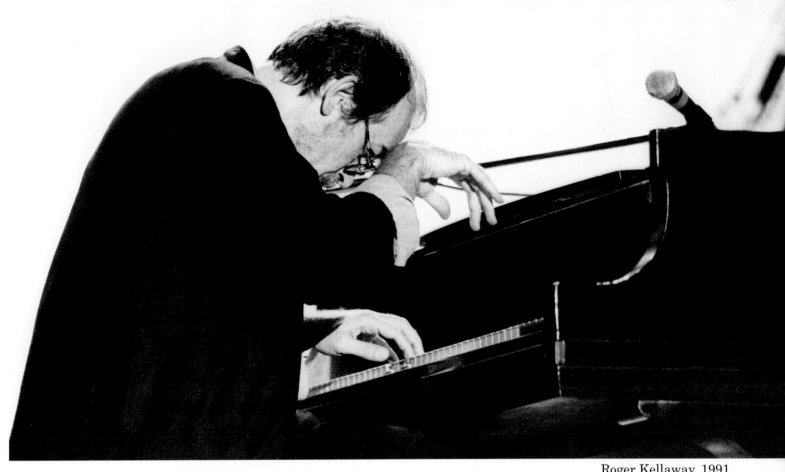

Roger Kellaway, 1991

"I try to use the whole spectrum of language that's available which I think is the most rewarding way to play if you're trying to satisfy yourself."
—Pepper Adams

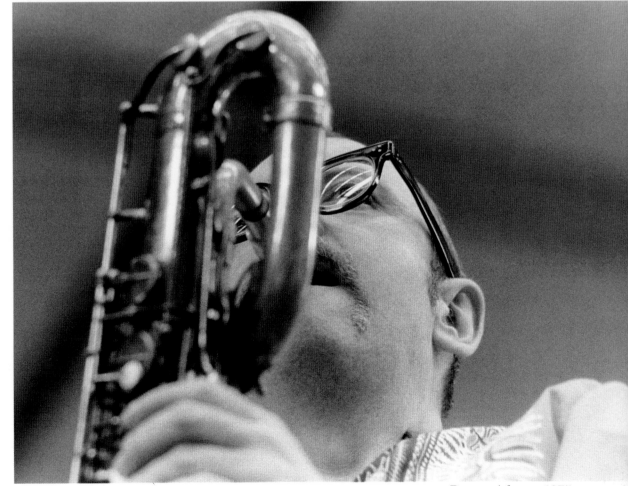

Gary Burton, 1985

Pepper Adams, 1975

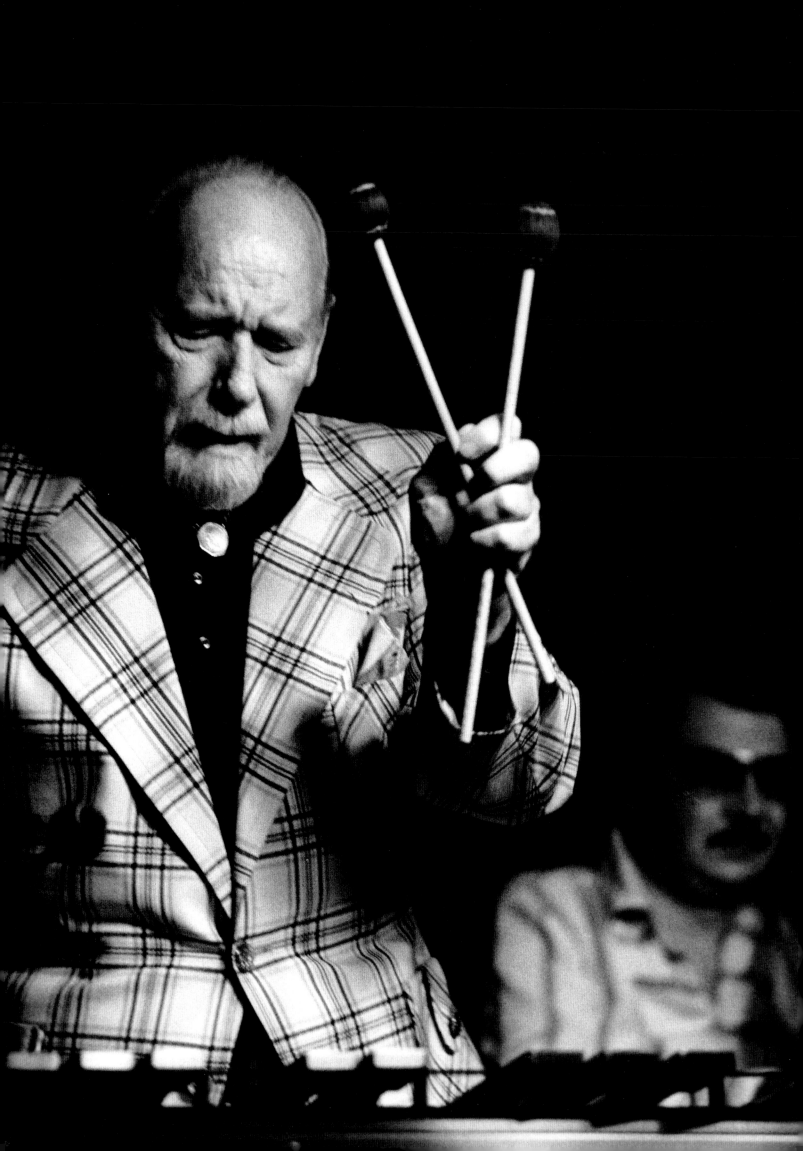

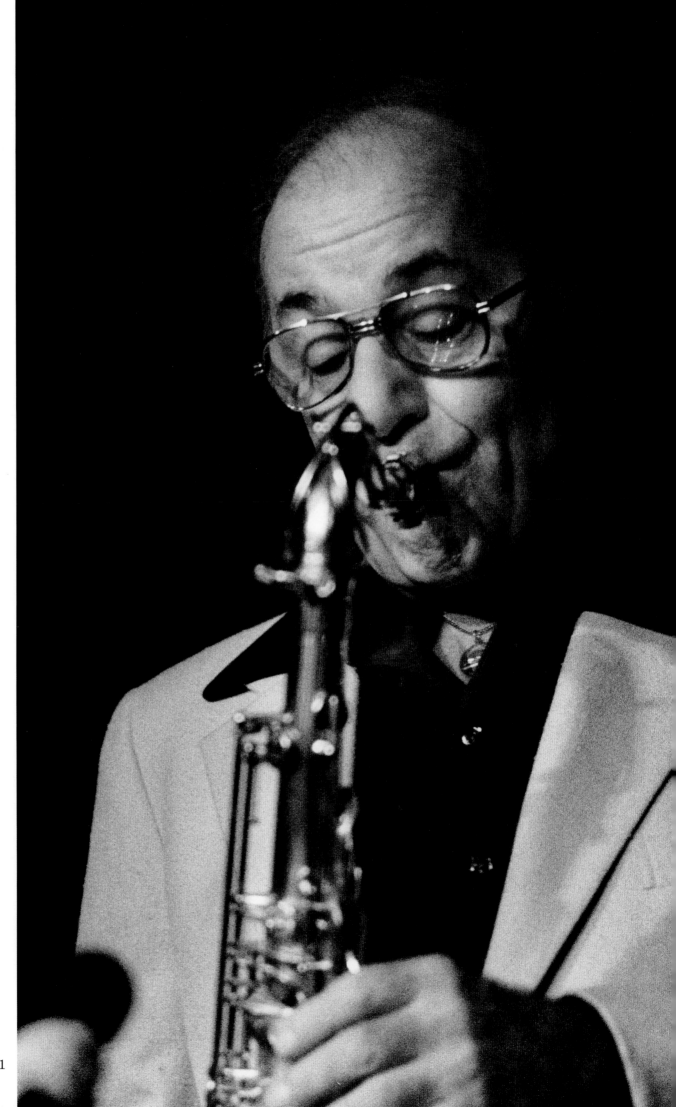

"I don't care what you think about my saxophone playing, I'm still the greatest fisherman in the world."
—Flip Phillips

Flip Phillips, 1981

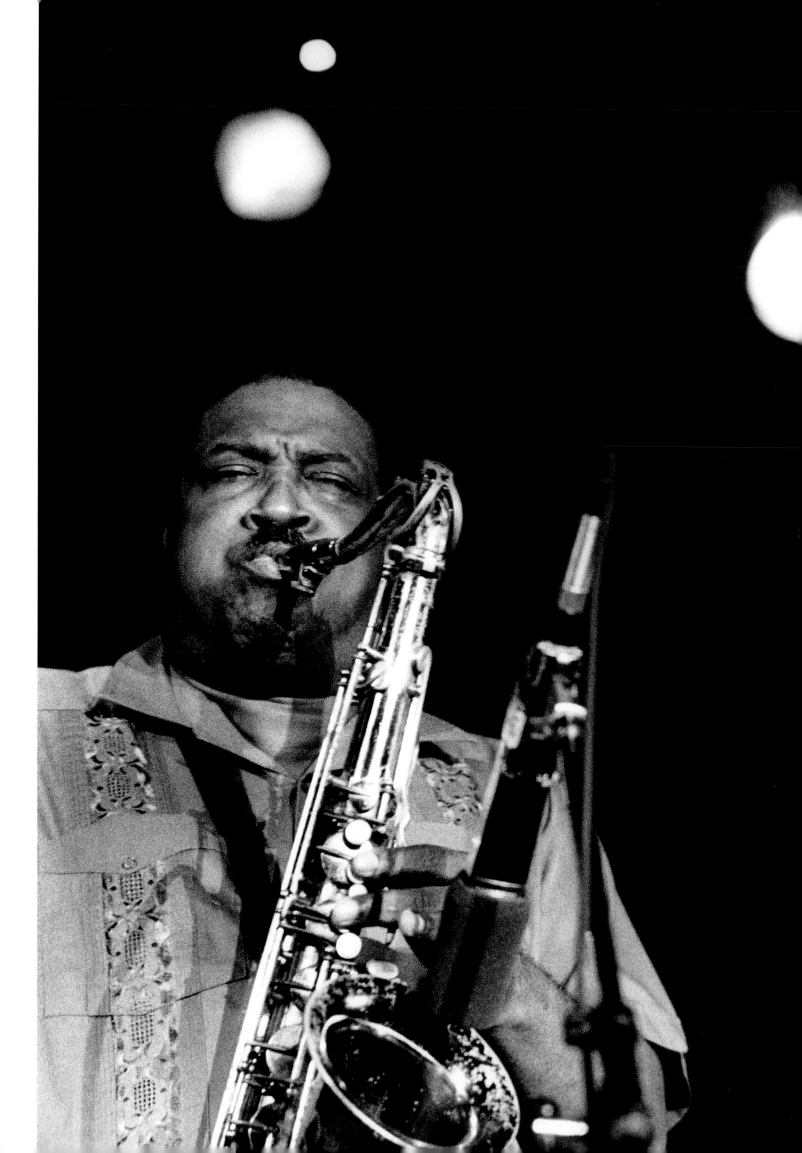

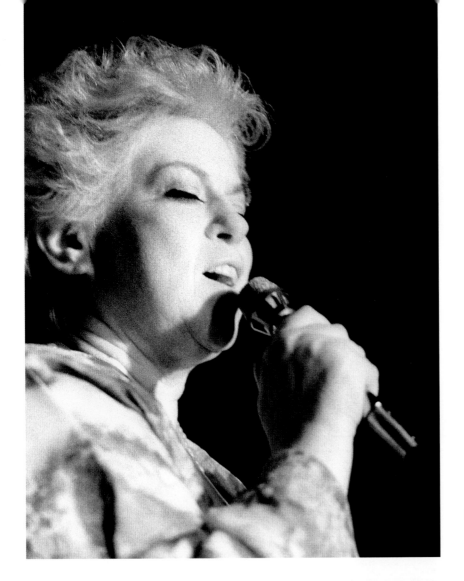

"We'd have two or three hundred miles to make every day on the bus and you'd get to the job, if you were lucky, about six in the evening and you'd have maybe an hour and a half to grab a hamburger at the White Tower and check in a hotel. Then we'd go immediately to the job and we'd be there for two or three hours and then get back on the bus and travel all night. It did me in and I was in my early 20s then."
—Chris Connor

Chris Connor, 1979

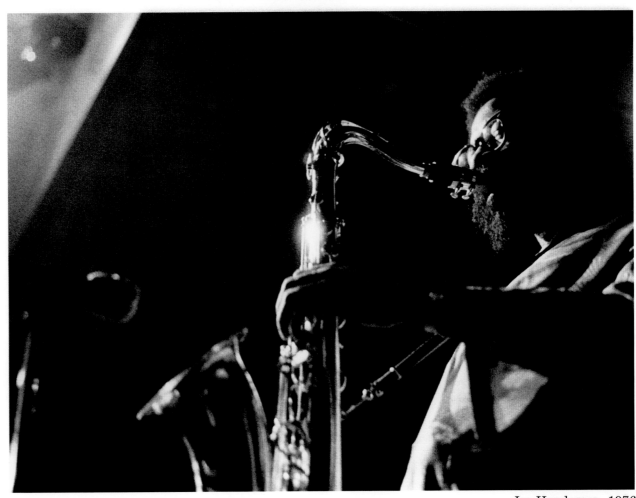

Houston Person, 1990

Joe Henderson, 1976

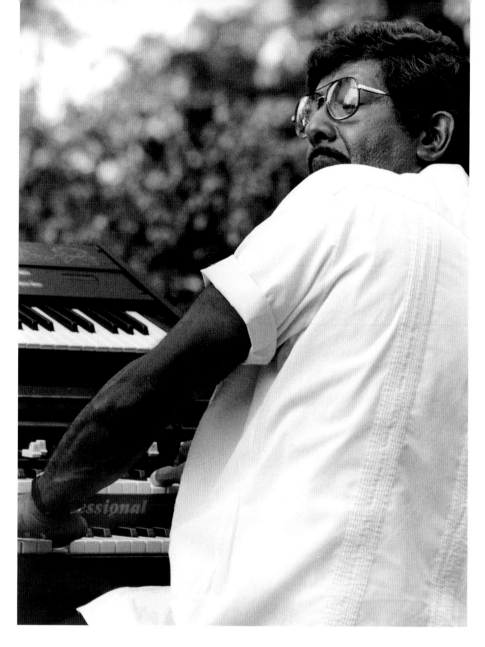

Jimmy McGriff, 1992

Ron Carter, 1976

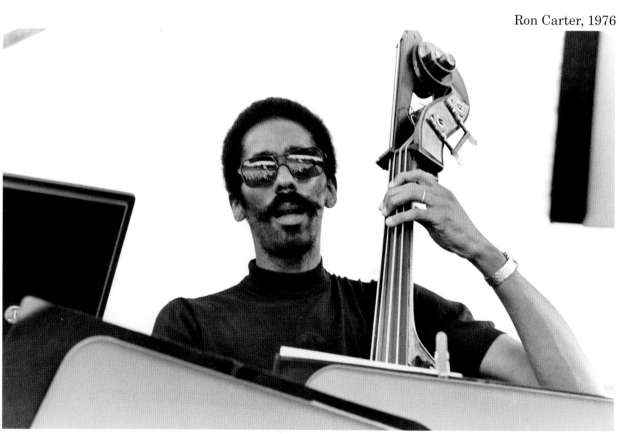

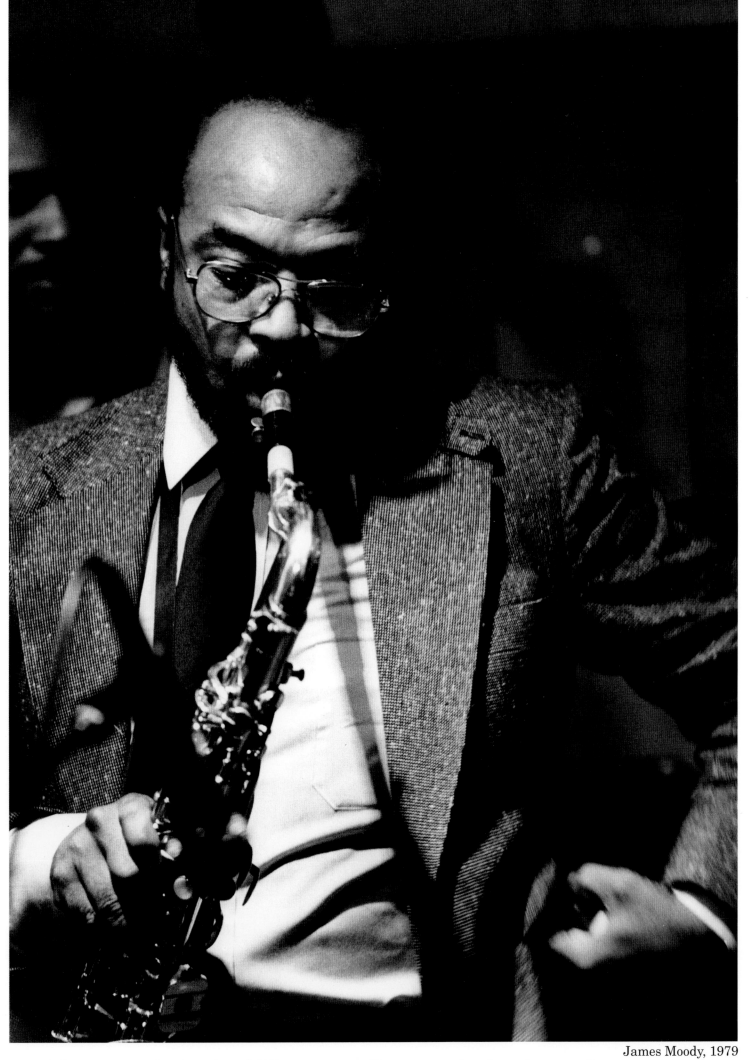

James Moody, 1979

"Things can swing in a lot of different ways. To me, as swing is, swing goes."

—James Moody

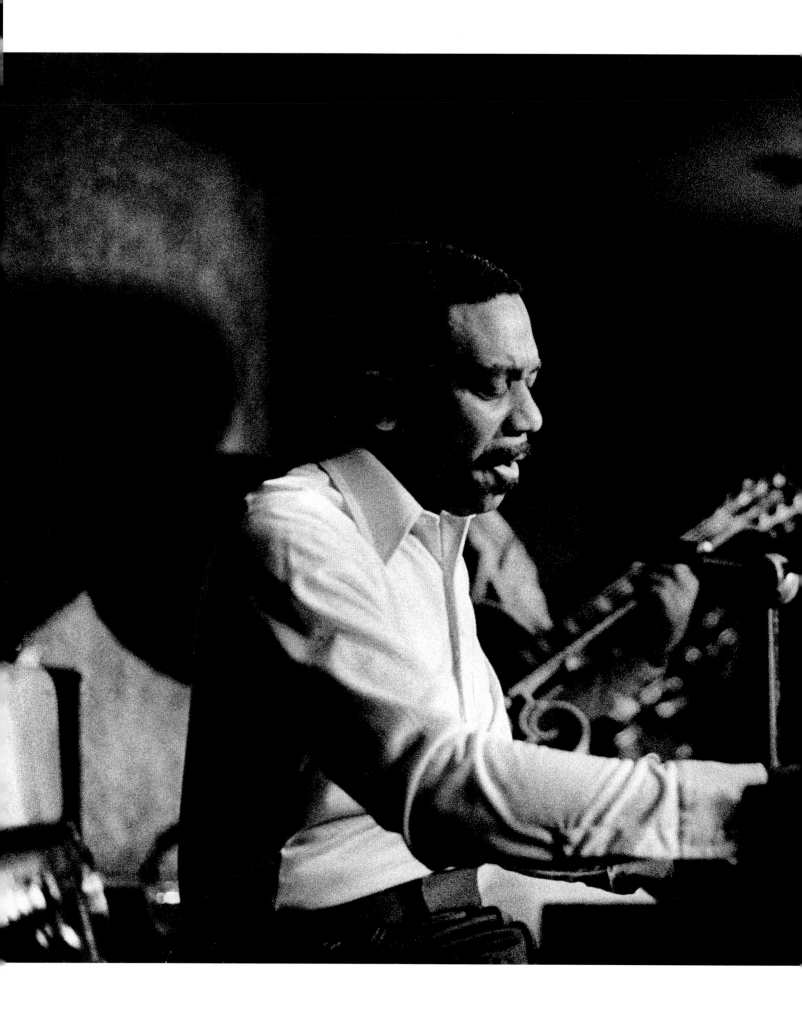

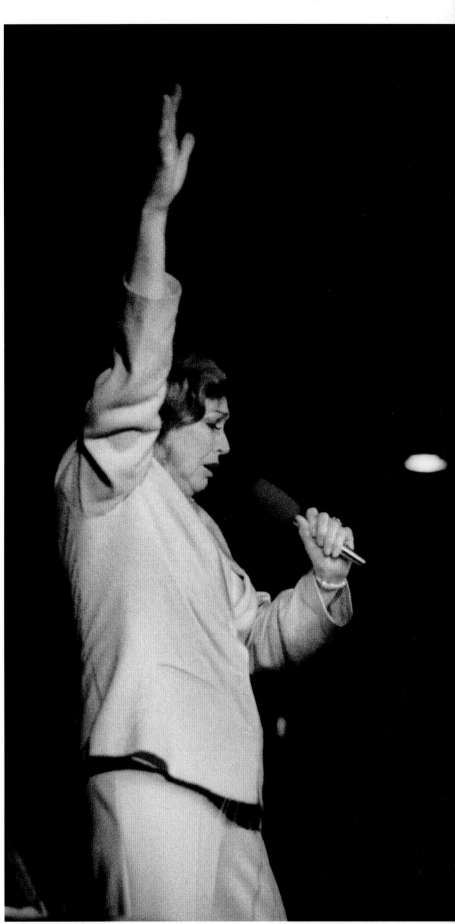

"It's a different world when the music stops."
—Anita O'Day

Jimmy Smith, 1976

Anita O'Day, 1982

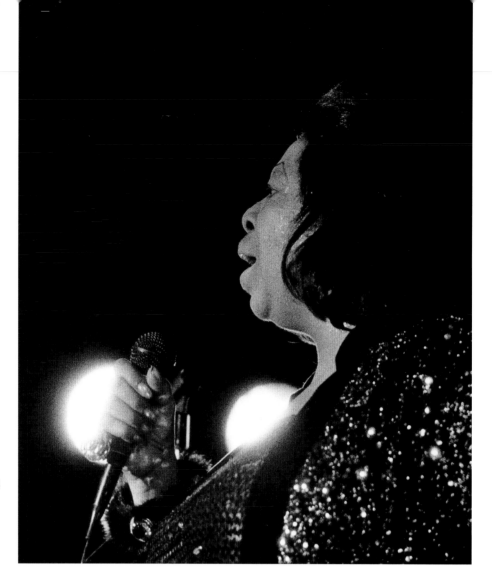

Dakota Staton, 1988

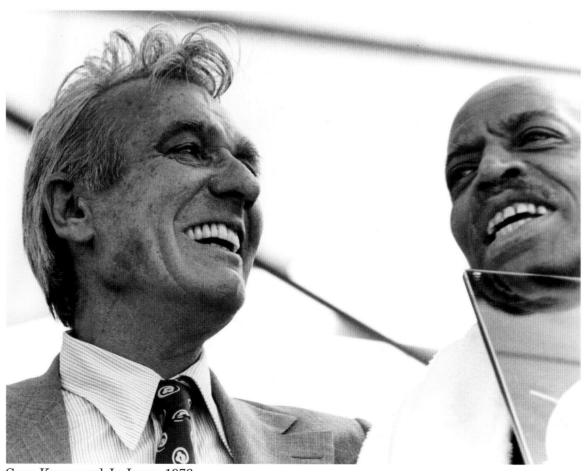

Gene Krupa and Jo Jones, 1973

112

Wynton Marsalis, 1994

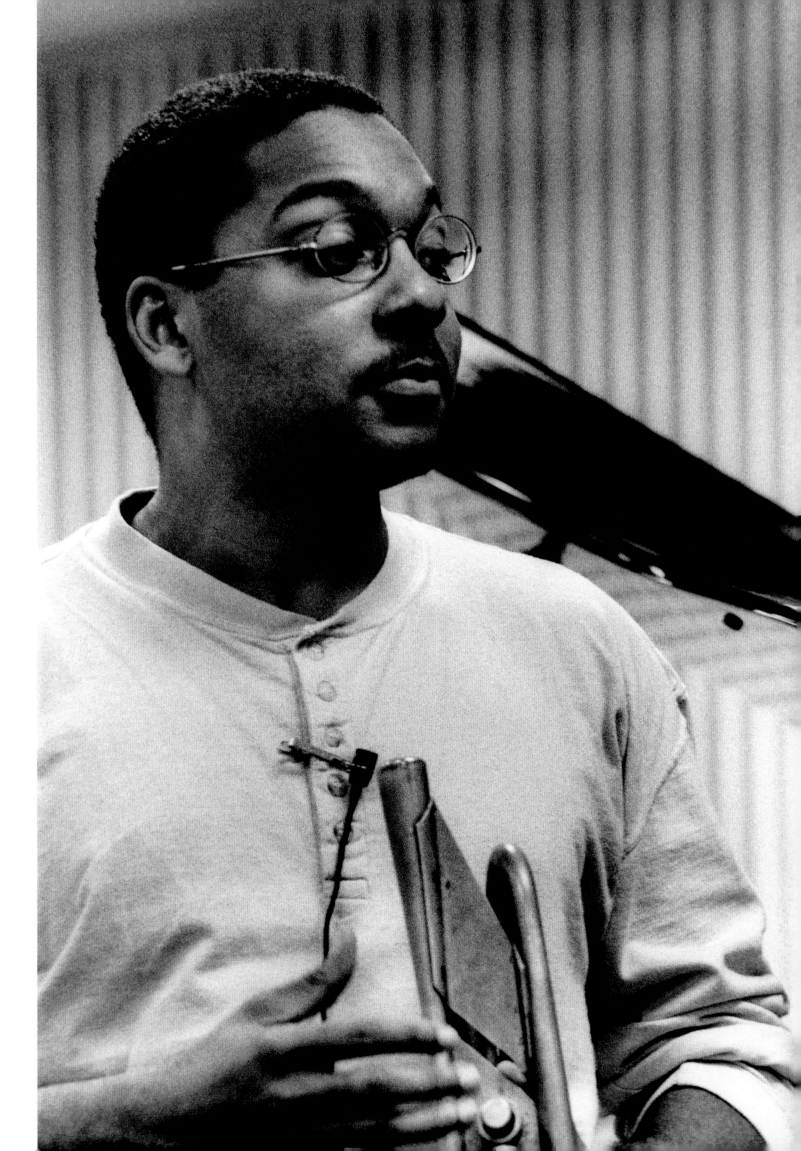

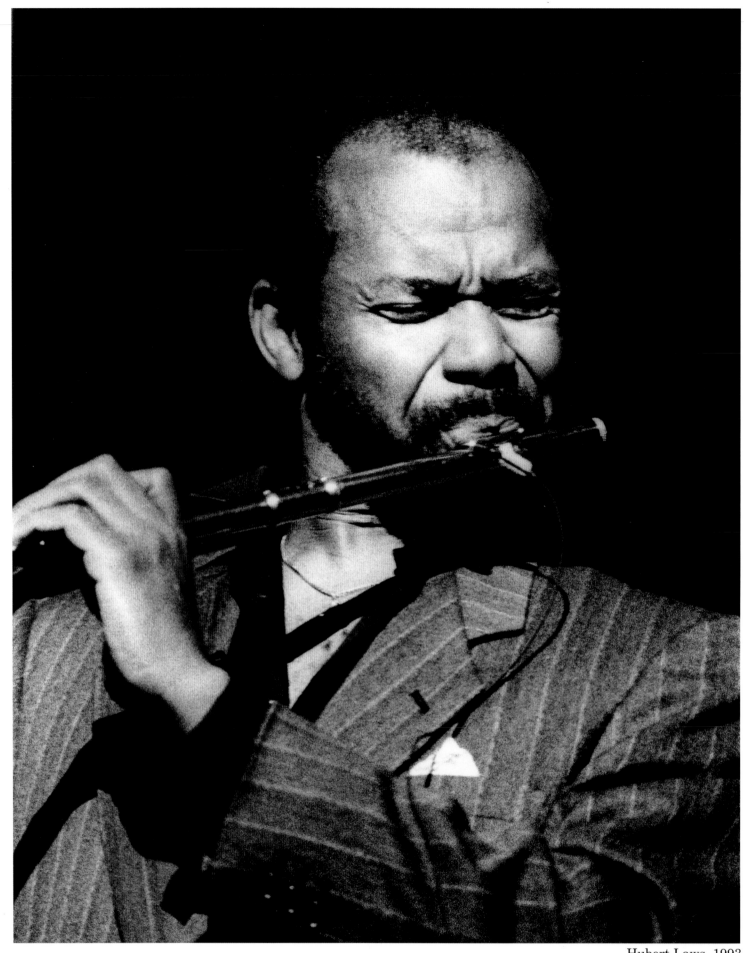

Hubert Laws, 1993

Mundell Lowe, 1993

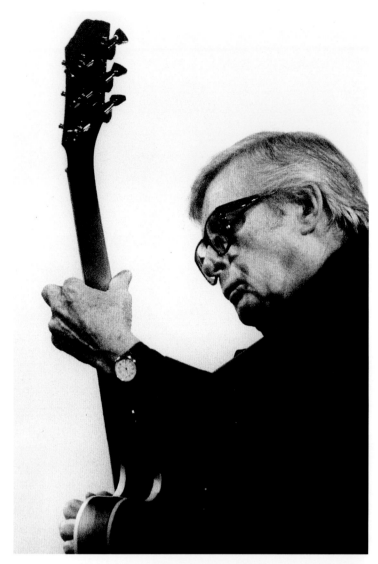

"As artists we have a responsibility, because people learn through what they see and hear. So we have a responsibility to let them hear that which is necessary." —Yusef Lateef

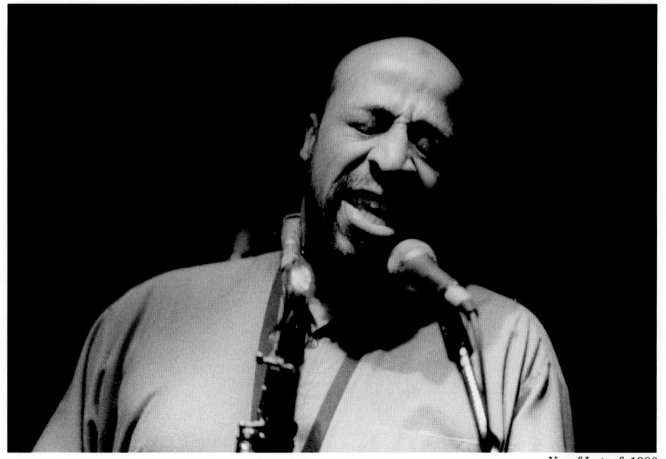

Yusef Lateef, 1980

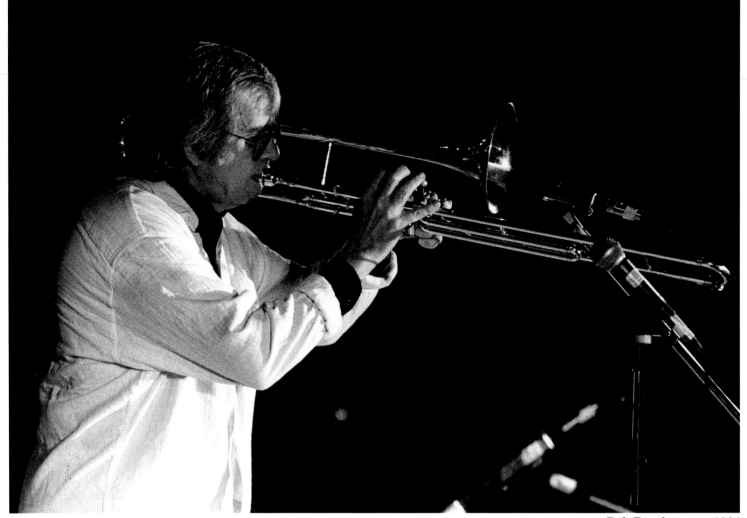

Bob Brookmeyer, 1991

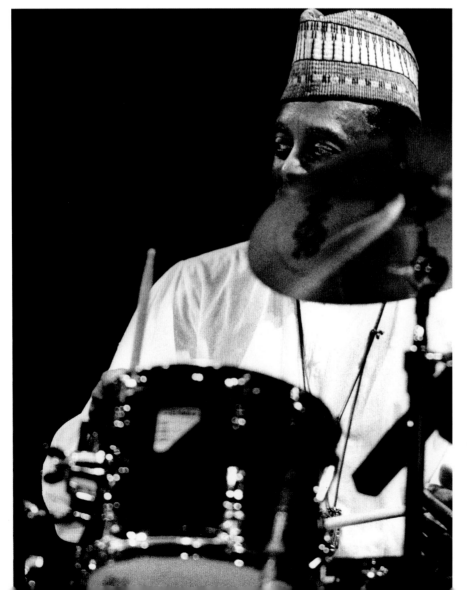

"All artists work a general field. It's a field of earth. Our job is to go out every morning and work that field all day long doing what we do. Once in awhile, the musician, whoever it is, comes and drops a seed, and we get a Coltrane or a Charlie Parker or a Jelly Roll Morton or a Louis Armstrong. But the rest of us go out there and plow every day anyway. That's our job."
—Bob Brookmeyer

Al "Tootie" Heath, 1992

Paquito D'Rivera, 1988

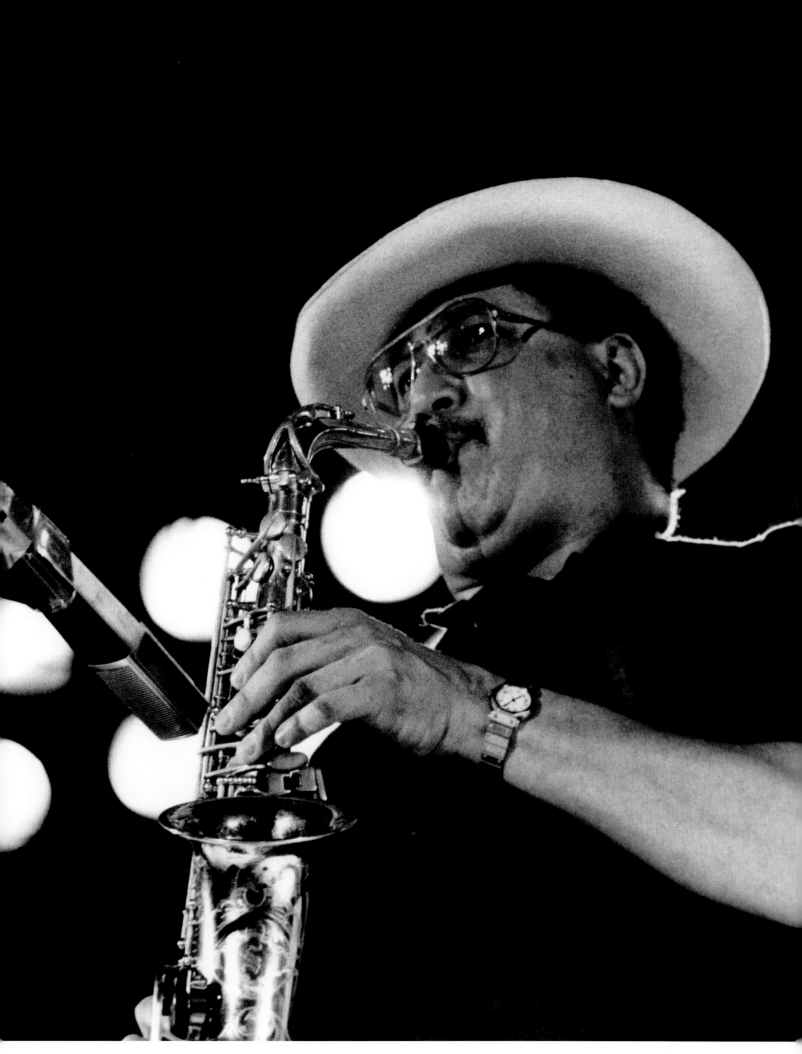

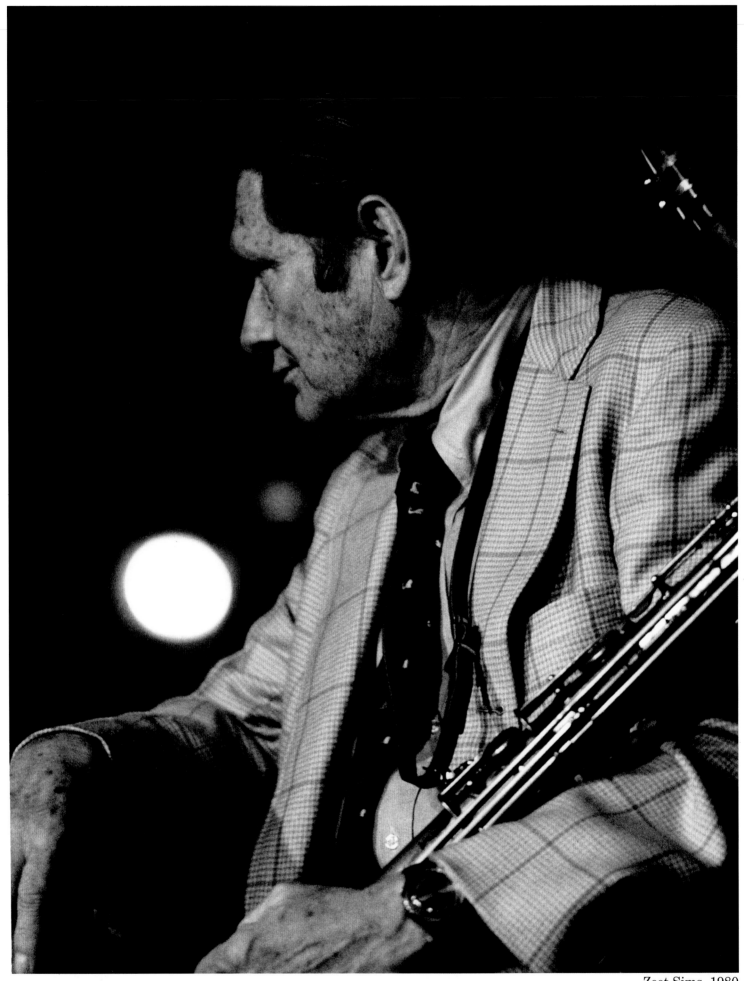

Zoot Sims, 1980

"As long as you got your horn in your mouth, you're developing."
—Zoot Sims

Terence Blanchard, 1989

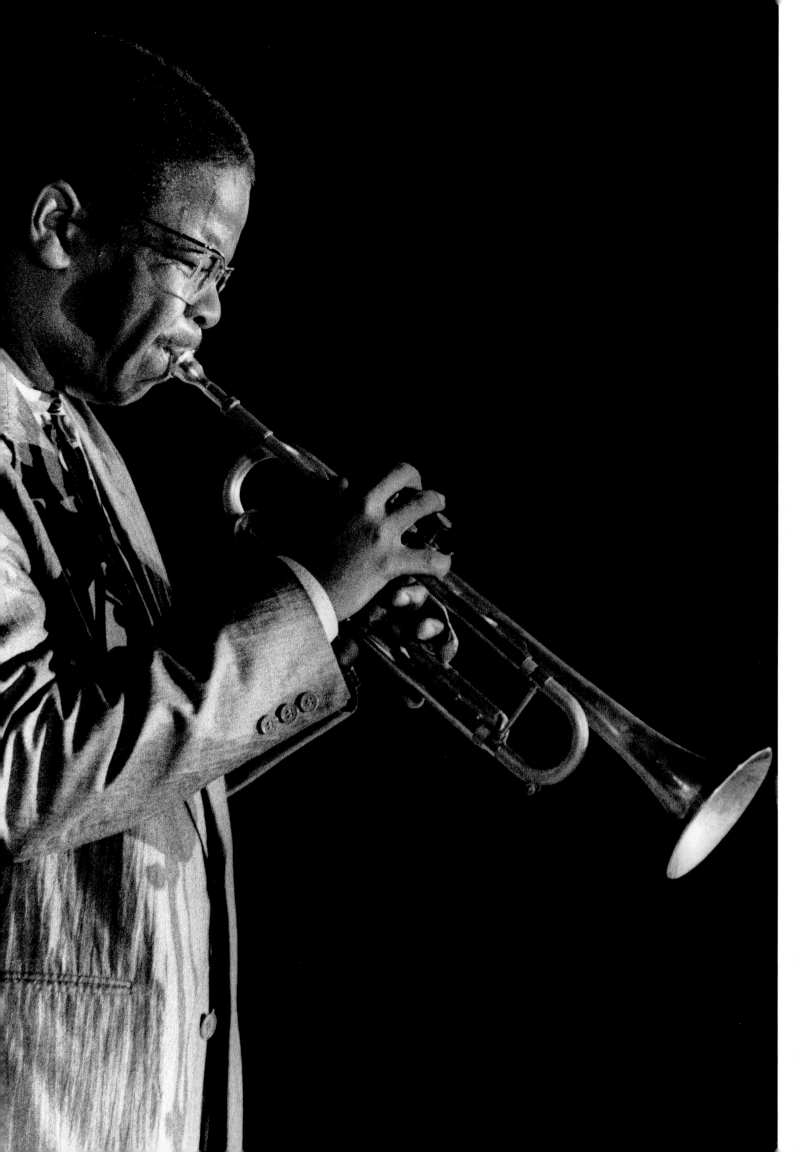

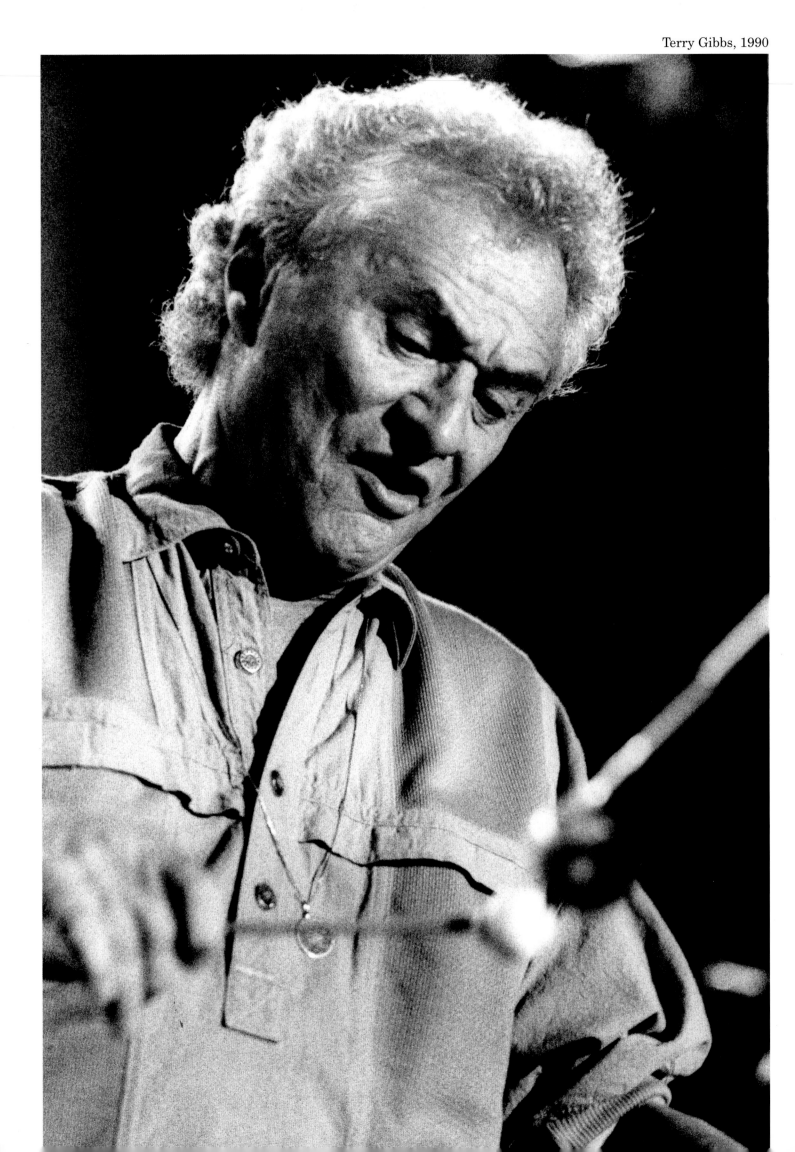

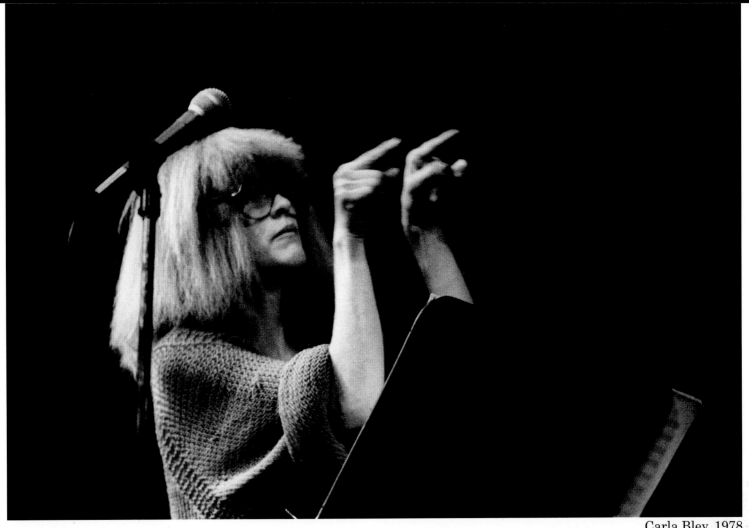

Carla Bley, 1978

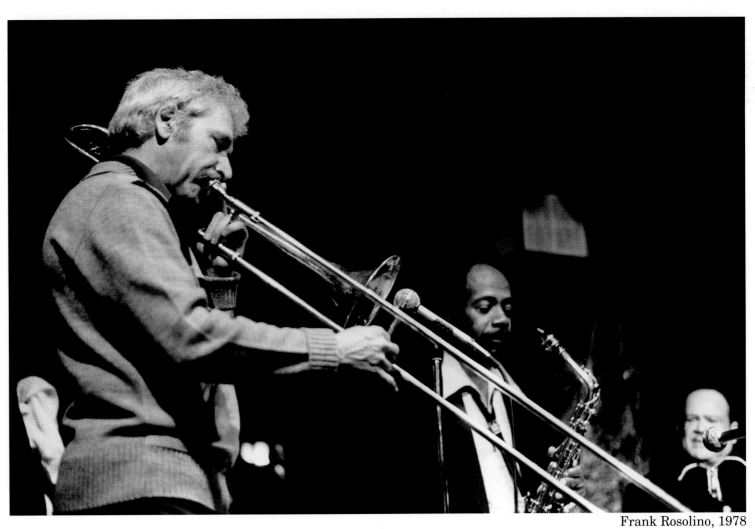

121

Frank Rosolino, 1978

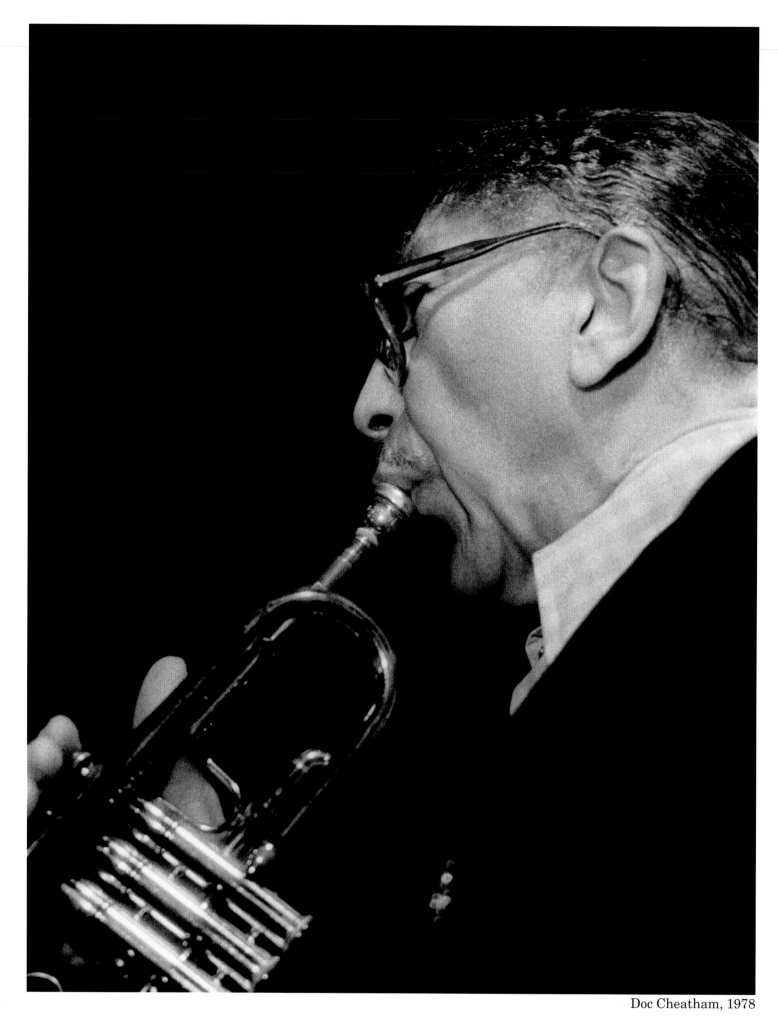

Doc Cheatham, 1978

"Music means my life. I don't know anything else." —Doc Cheatham

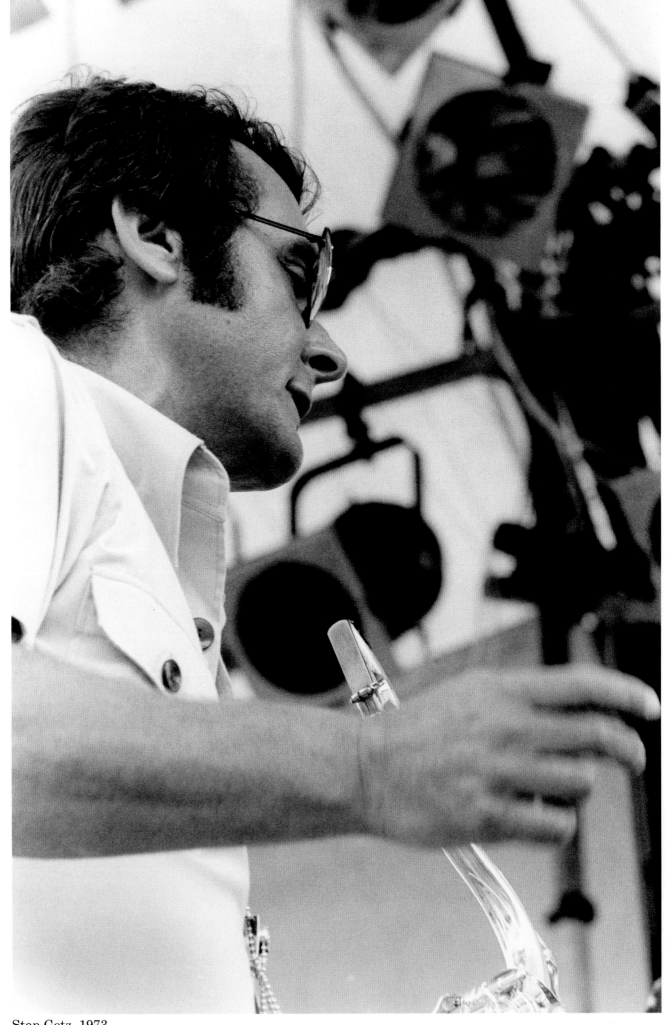

Stan Getz, 1973

"There are four qualities to a great jazz man. They are taste, courage, individuality and irreverence." —Stan Getz

"I gained a lot of freedom working with Miles Davis and also a sense of responsibility along with that freedom. Every time we went up there we had to be in charge of that freedom. 'Long as everybody can hold up their end.' That was one of the statements Miles would make all the time. In other bands that didn't even exist. You didn't have to really work to hold up your end. That's what makes a band mediocre."
—Wayne Shorter

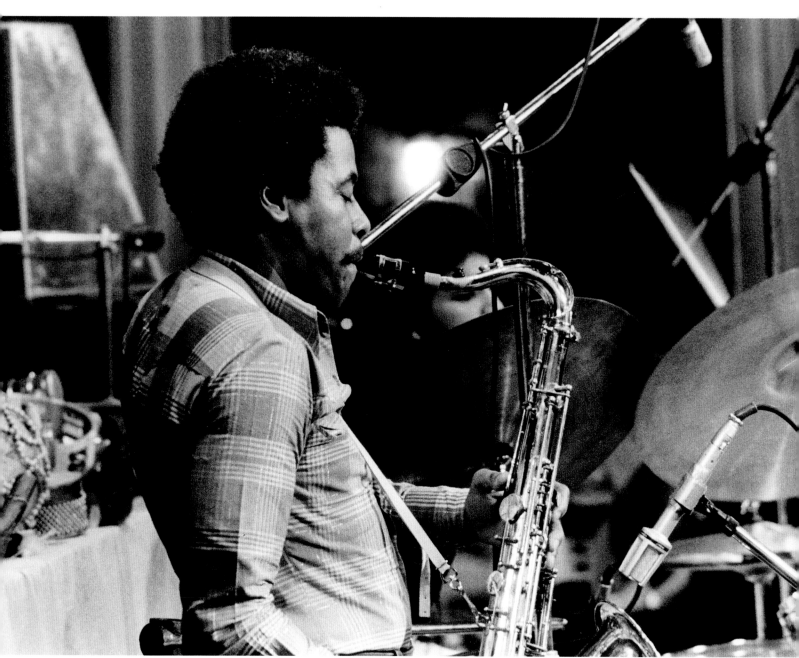

Wayne Shorter, 1976

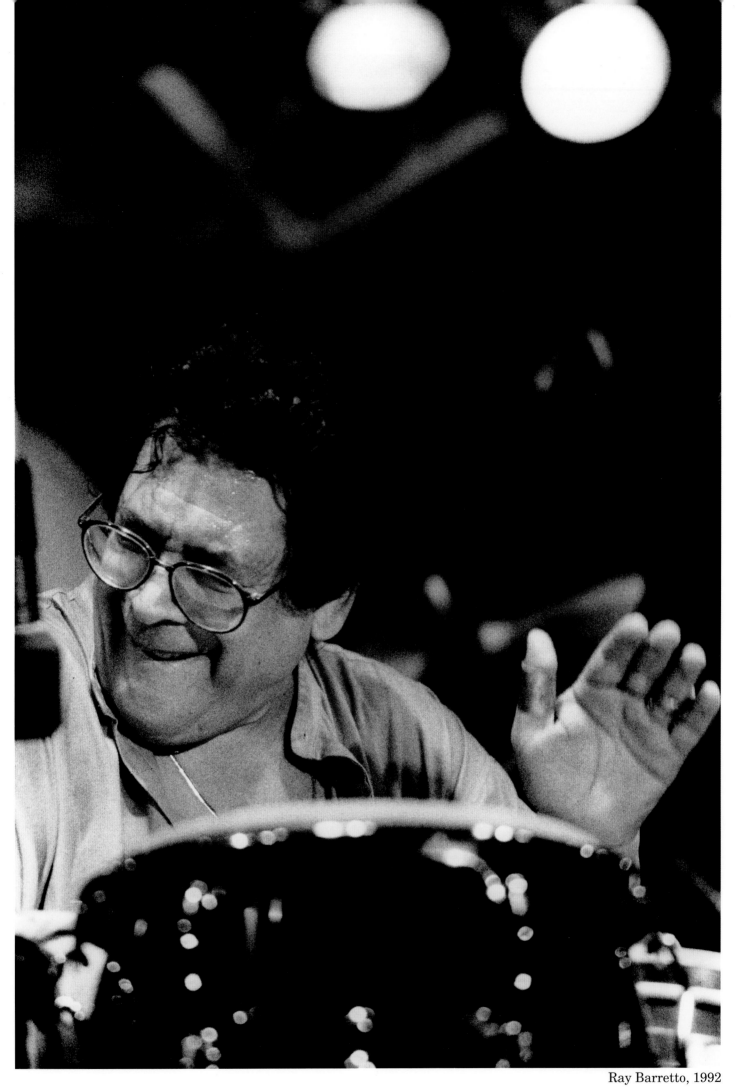

Ray Barretto, 1992

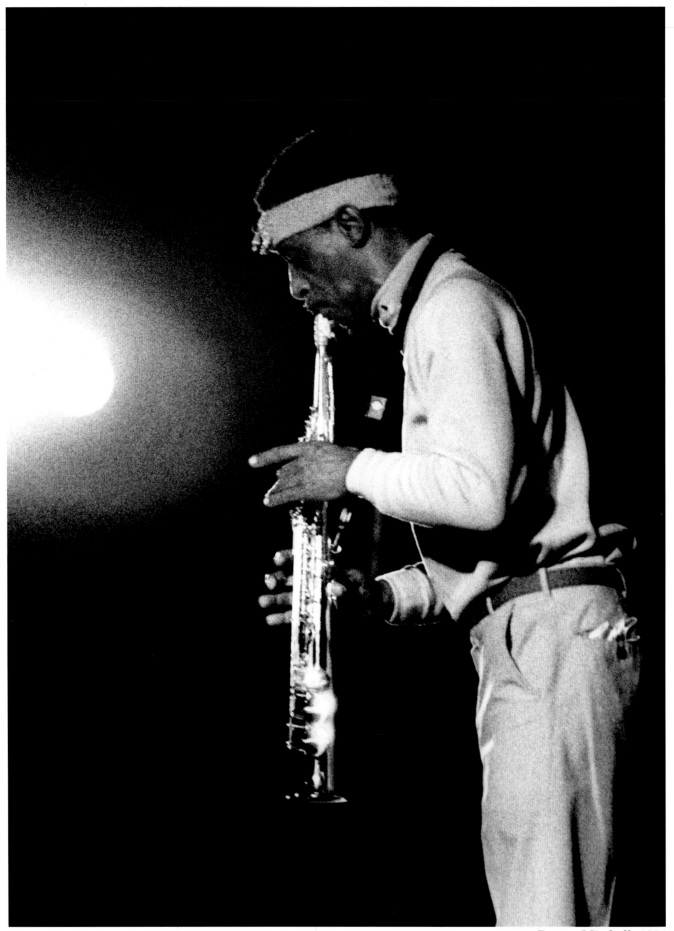

Roscoe Mitchell, 1991

Ramsey Lewis, 199

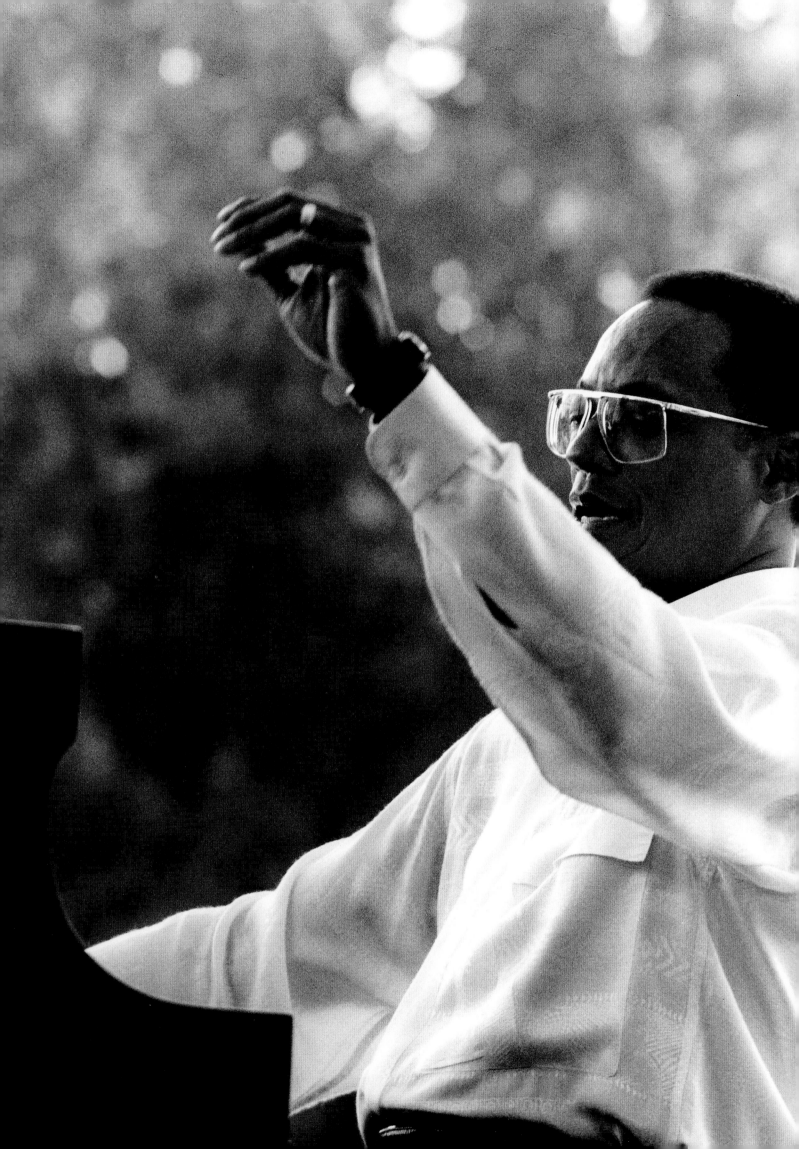

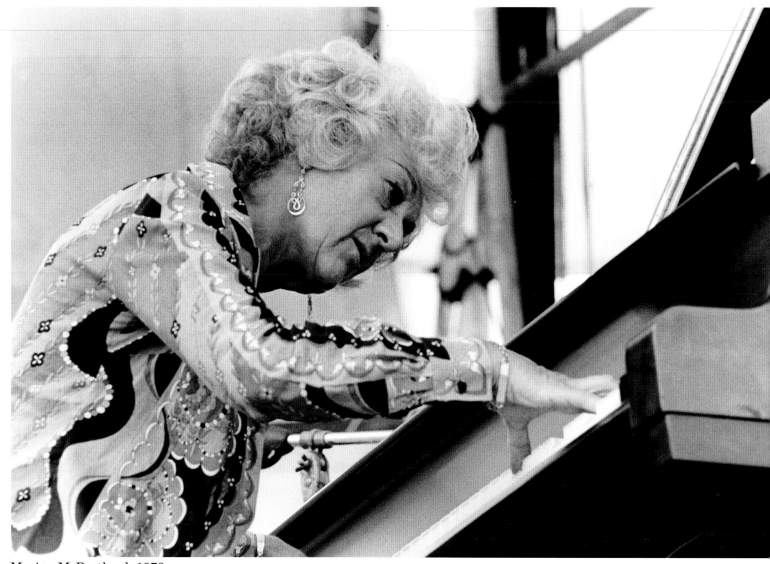

Marian McPartland, 1973

"It's very gratifying to be playing music that I like and making a living in a structure of self-expression rather than grinding out the music by the pound."
—Barney Kessel

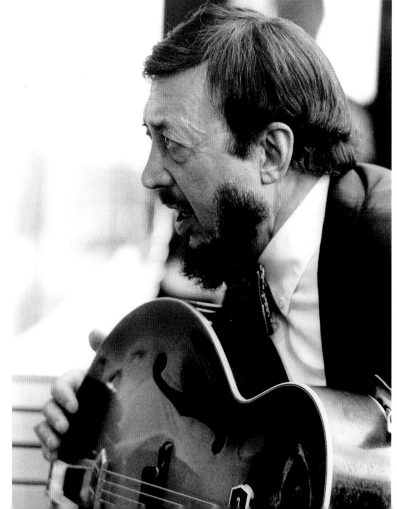

Barney Kessel, 1991

"I have realized myself as an instrument to the source that the music comes from. I'm just the tool."
—Billy Harper

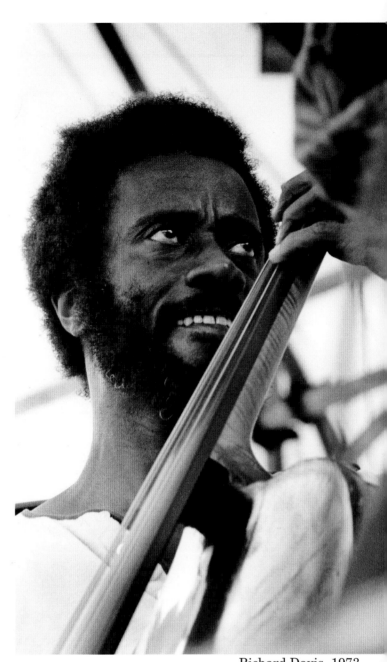

Richard Davis, 1973

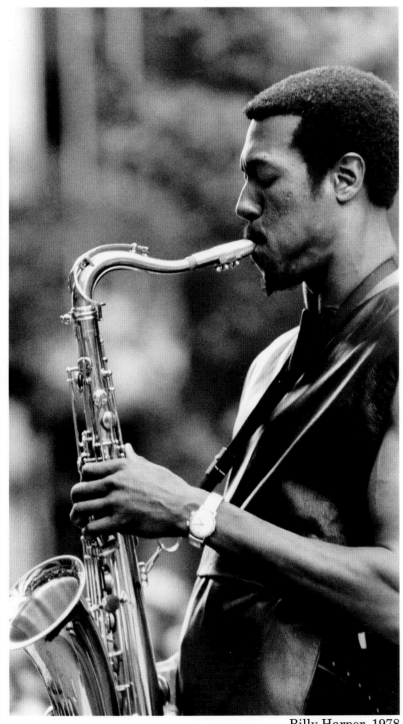

Billy Harper, 1978

Eddie Palmieri, 1993

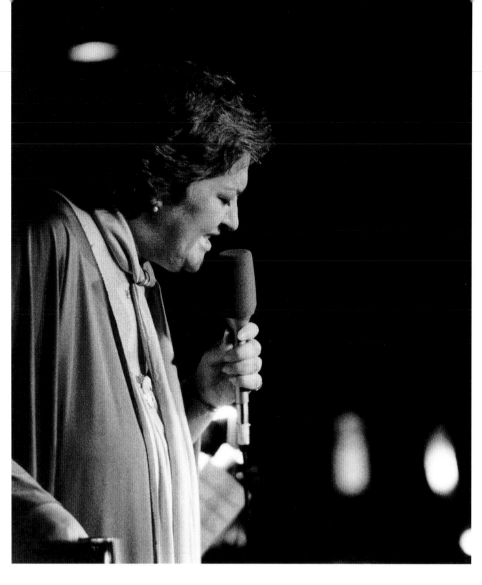

Morgana King, 1981

"I never think about trends or fads. I just love to play, so when I get some work, I play."
—Gil Evans

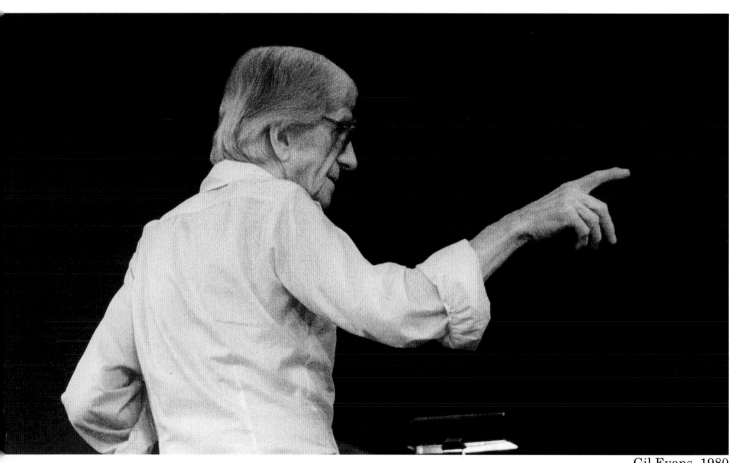

Gil Evans, 1980

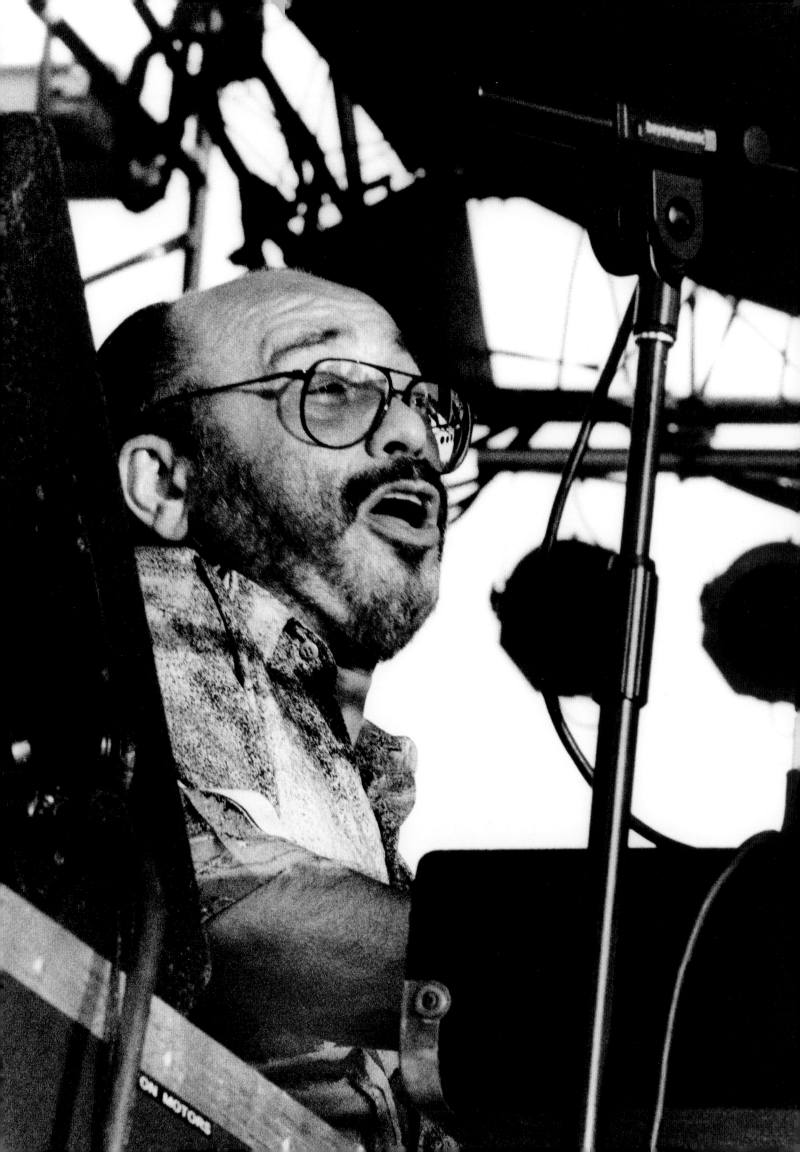

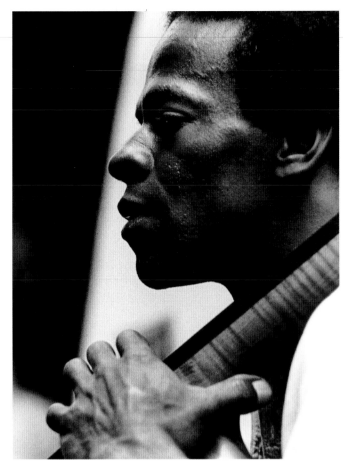

Cecil McBee, 1978

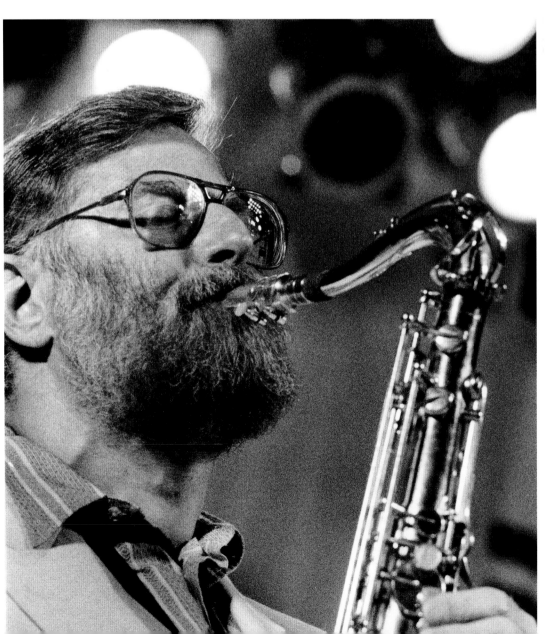

Lew Tabackin, 1990

"Either your instrument handles you or you handle the instrument. You're not tripping through tulips with it."
—Eddie "Lockjaw" Davis

Eddie "Lockjaw" Davis, 1981

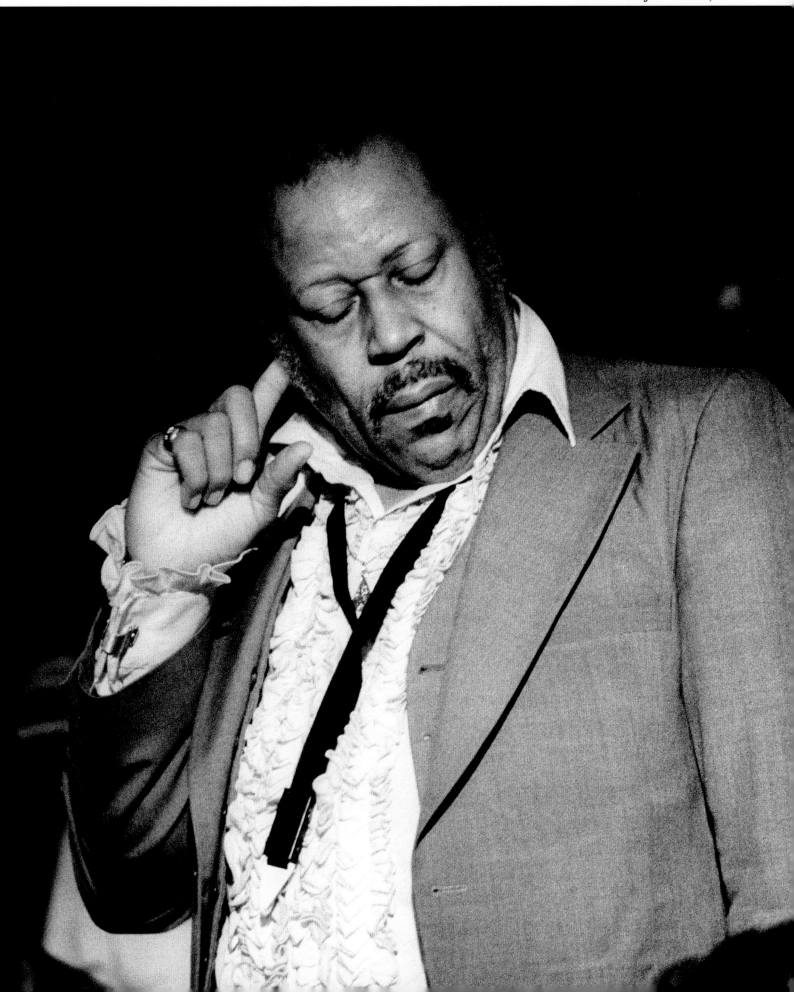

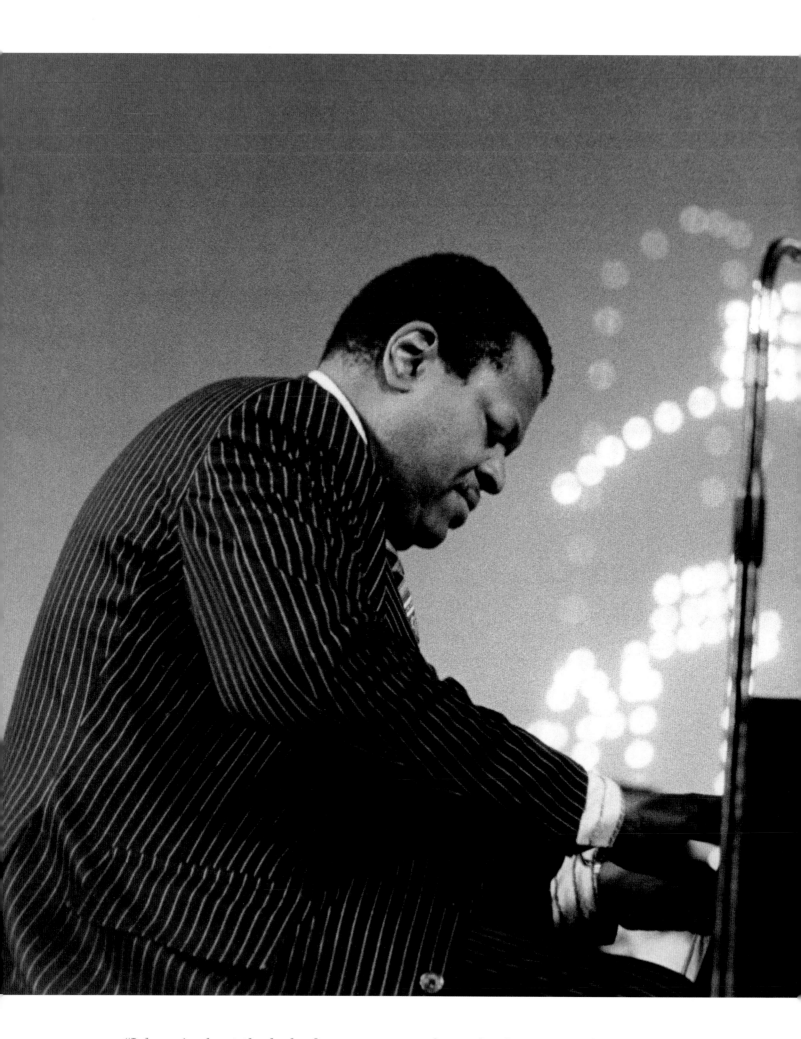

"I despair about the lack of proper respect shown for the piano. If you want it to sound like a traffic jam, go out in the street and create a traffic jam and forget the piano. That's not a piano sound." —Oscar Peterson

Oscar Peterson, 1975

"The concept of boiling down who plays guitar well to just a few people you've heard is very deceptive. I run into people all the time who are absolutely phenomenal guitar players in one way or another."
—Charlie Byrd

Charlie Byrd, 1979

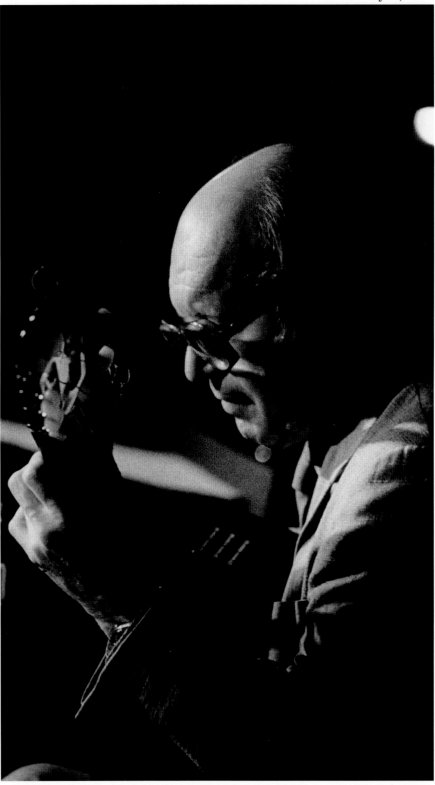

135

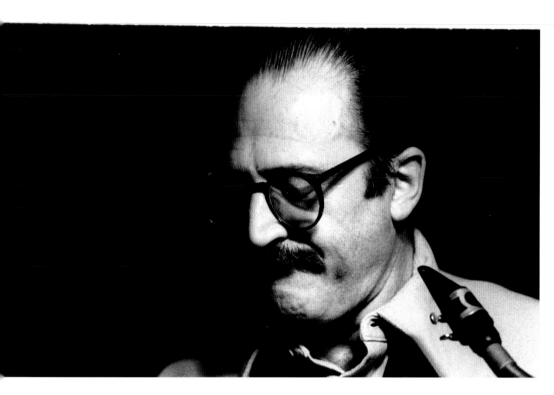

Al Cohn, 1976

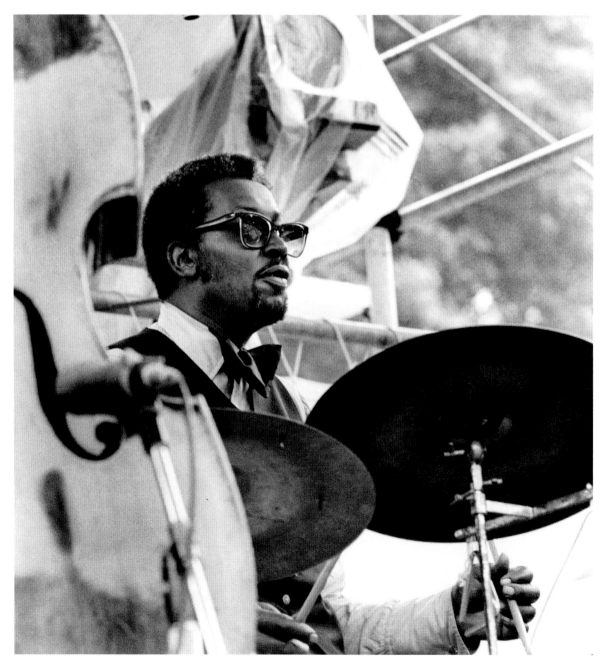

Connie Kay, 1973

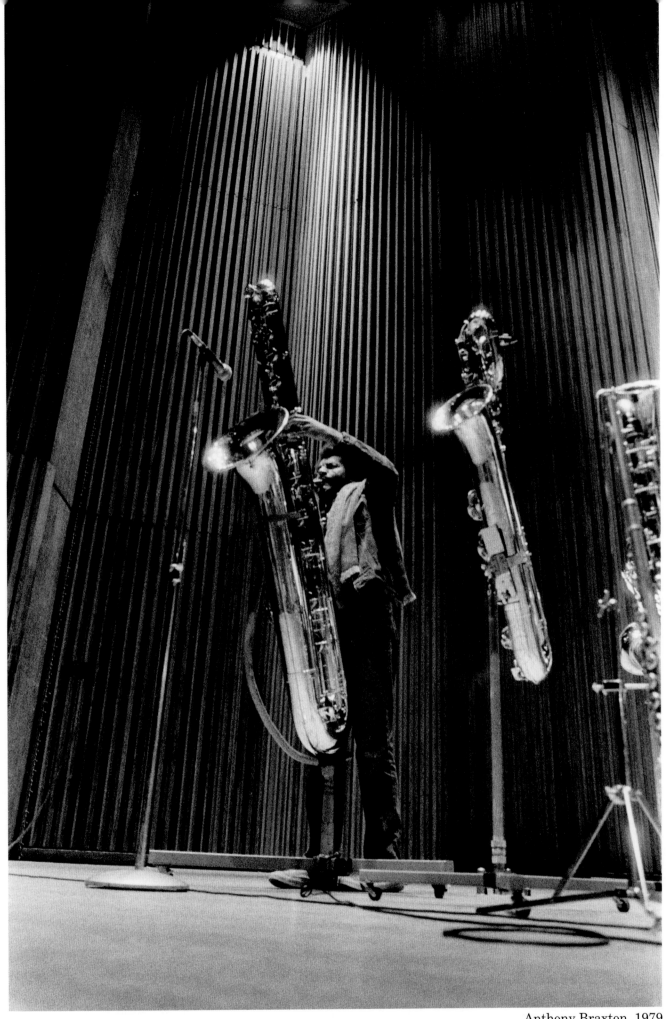

Anthony Braxton, 1979

"I swear, the more I learn about music, the more I see there's no excuse for staying in the same place. There are so many possibilities."

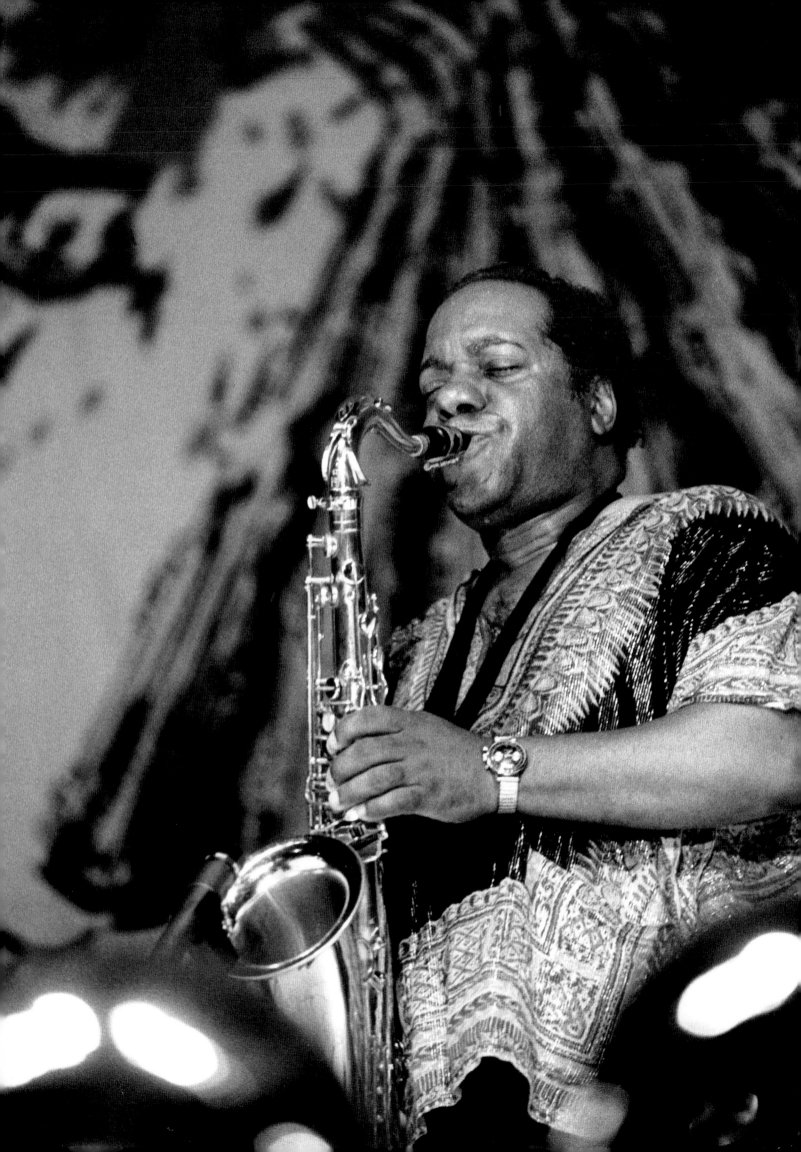

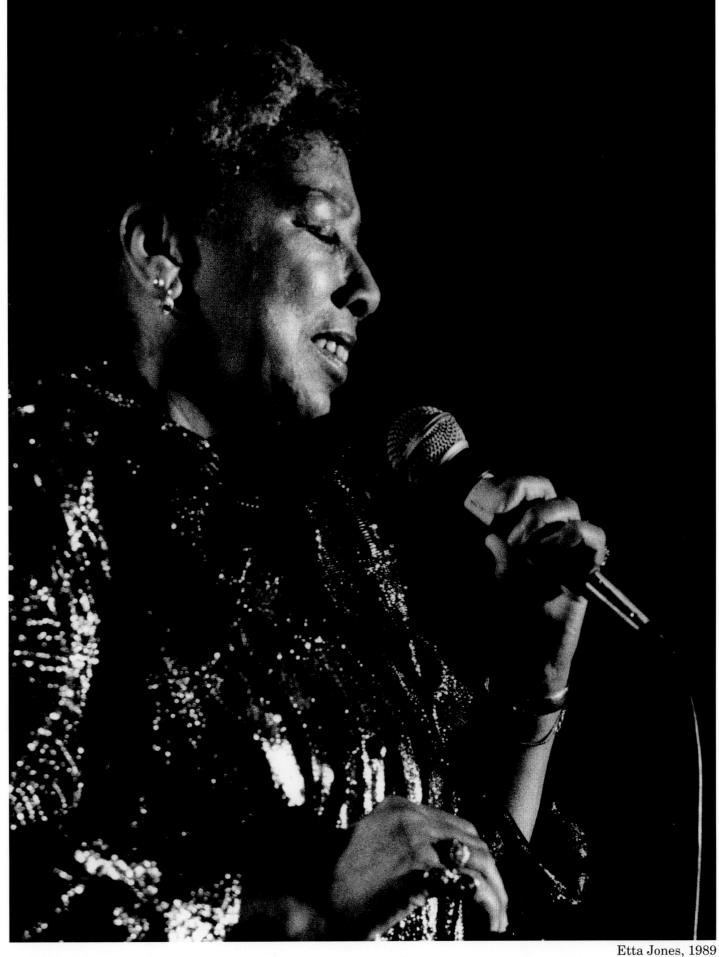

Etta Jones, 1989

"I like a good lyric that's not jumping into bed in the next line. I like a lyric that means something, one that can be around 200 years from today." —Etta Jones

Eddie Harris, 1983 139

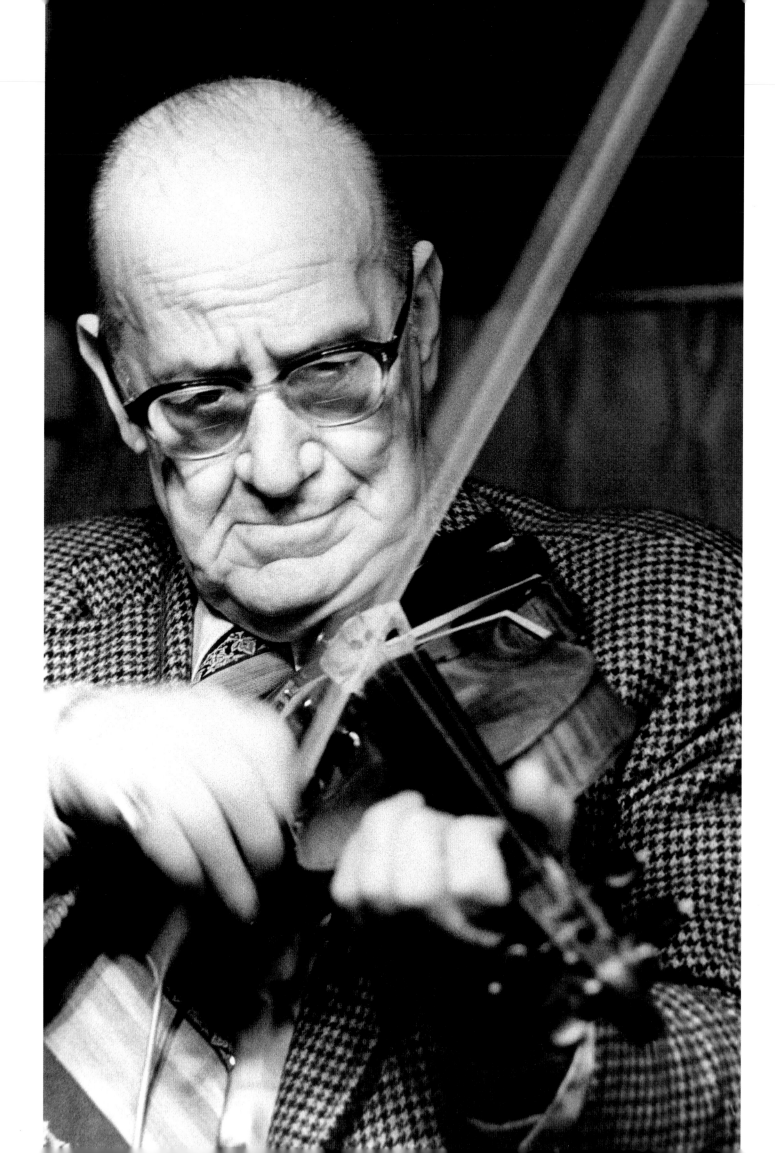

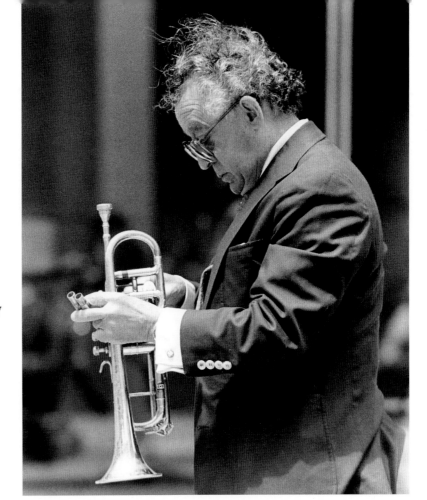

Max Kaminsky, 1977

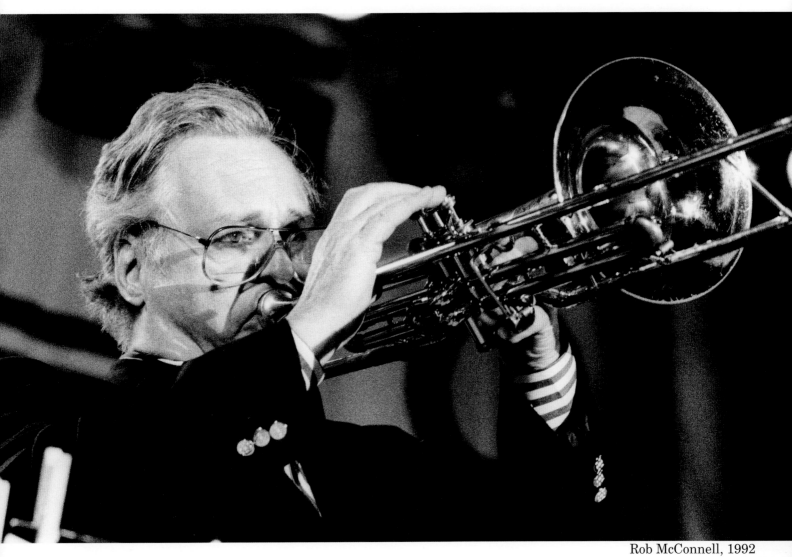

Rob McConnell, 1992

Joe Venuti, 1976

141

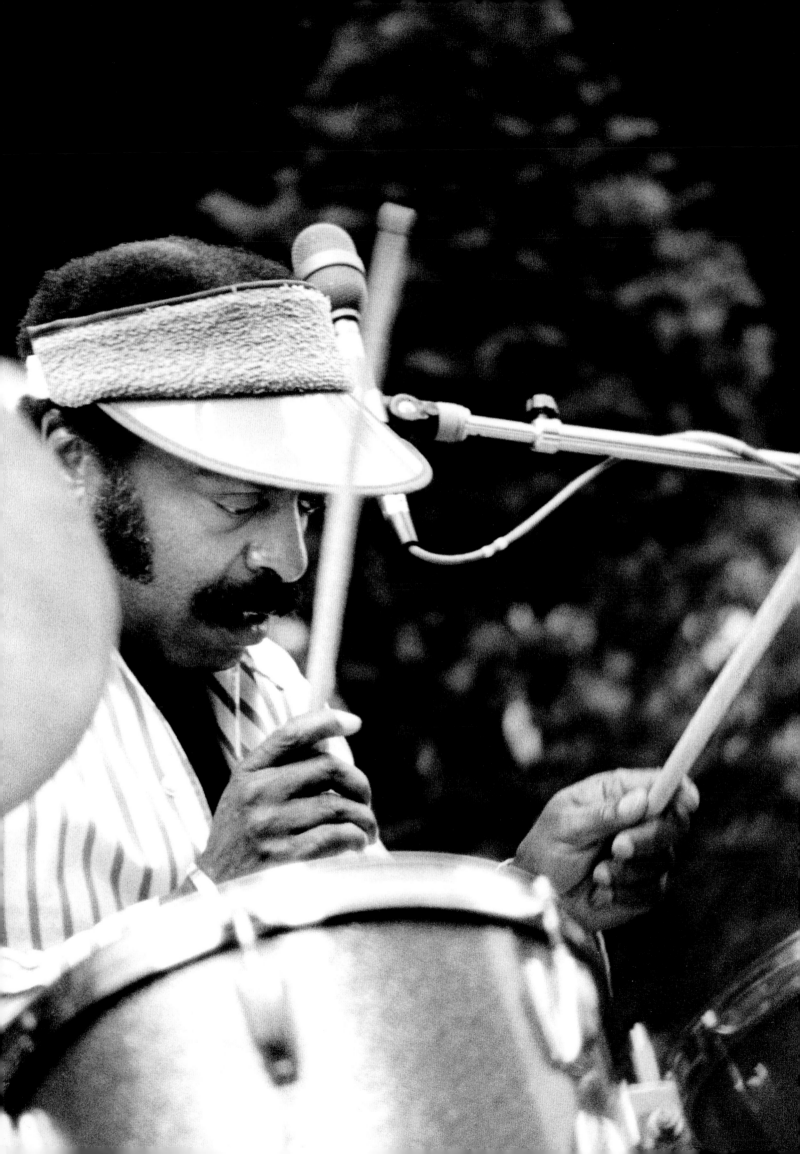

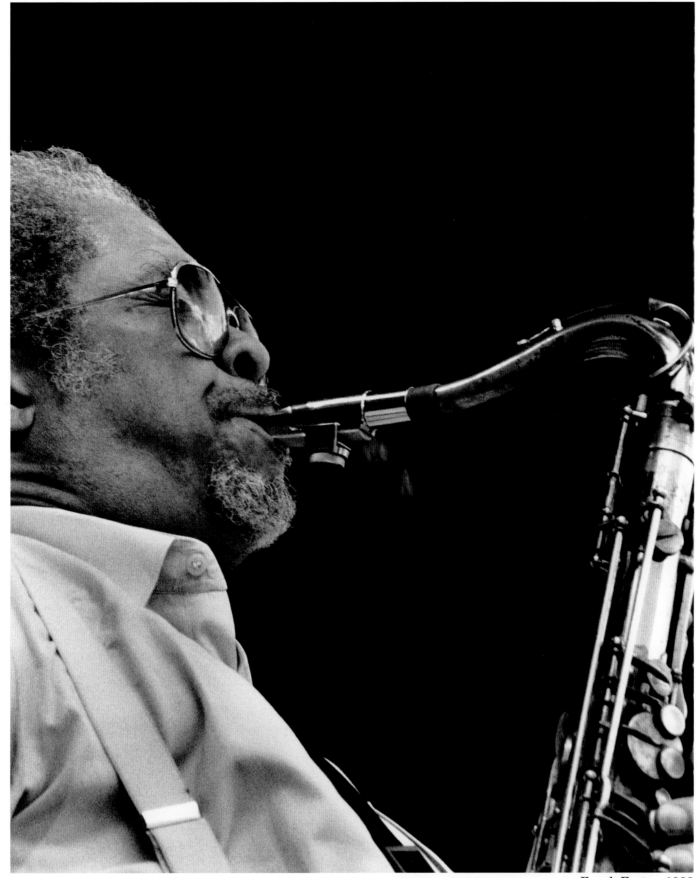

Frank Foster, 1988

"Everything happened in my life during the Count Basie period. I learned most of all the significance of the rhythm section. I learned how to *swing*."
—Frank Foster

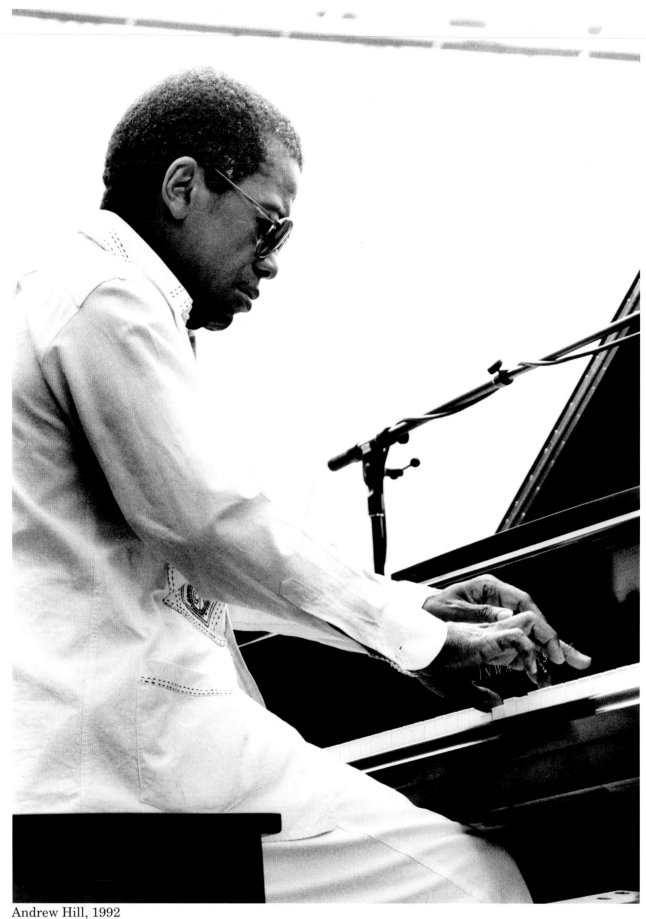

Andrew Hill, 1992

"When I was six years old I used to be able to play stride piano and boogie-woogie extremely well. I used to make the Chicago Wrigley Theatre amateur hour, on Thanksgiving, and I used to win a turkey for my family. I was a sure turkey-getter."
—Andrew Hill

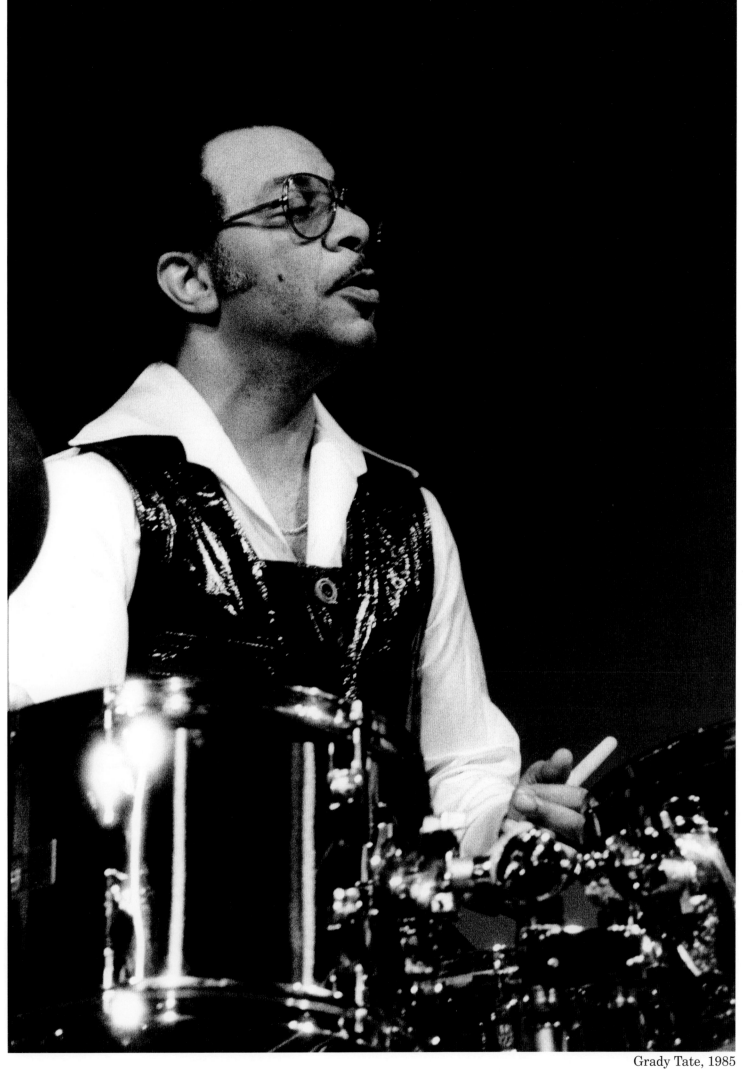

Grady Tate, 1985

Judy Roberts, 1990

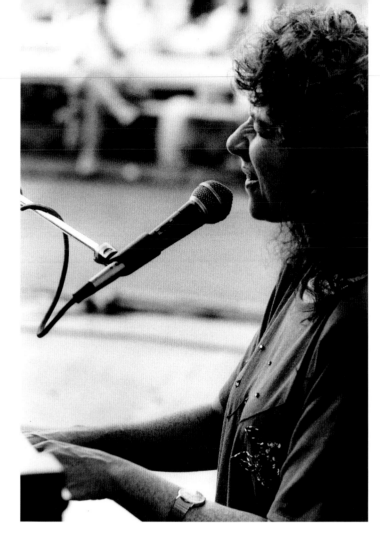

"A band can demonstrate unity among men more than anything else in the world." —Sun Ra

Sun Ra, 1990

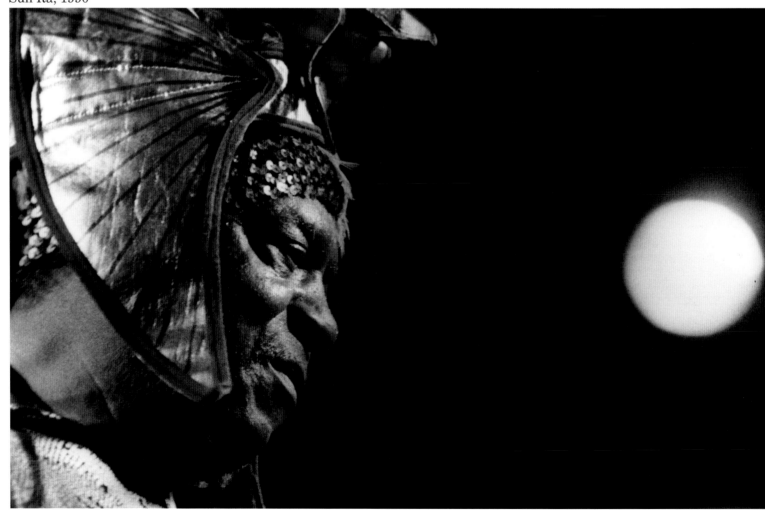

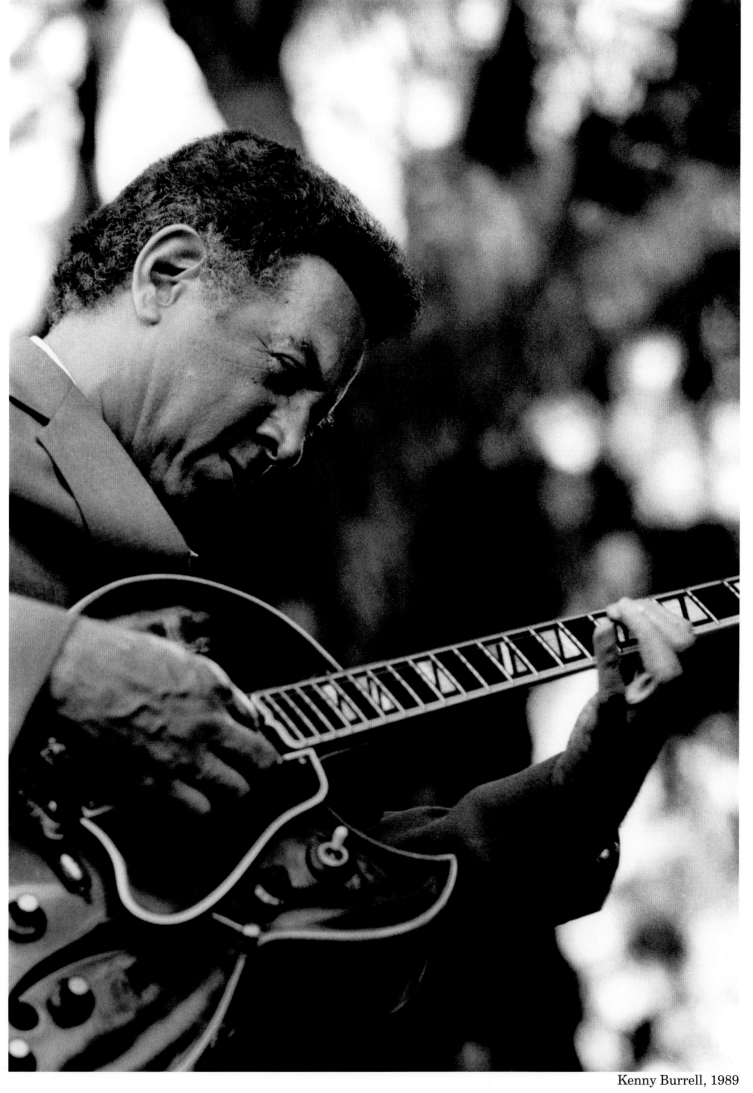

Kenny Burrell, 1989

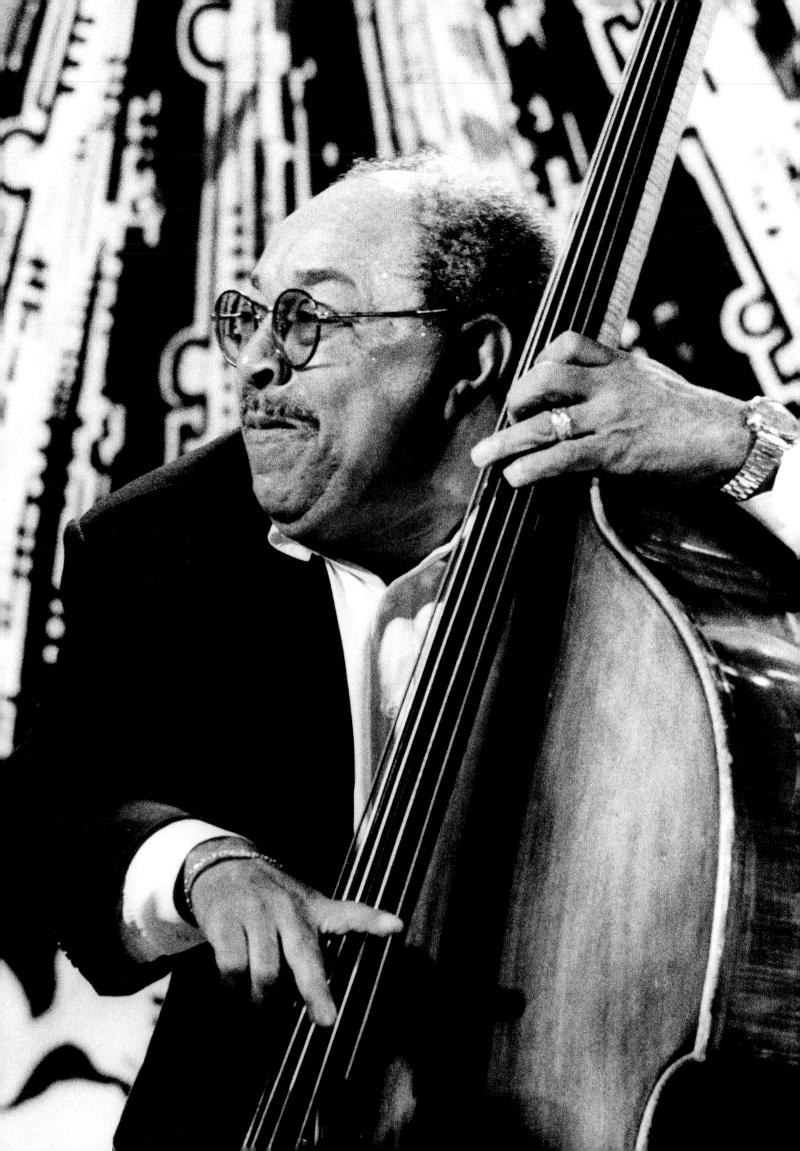

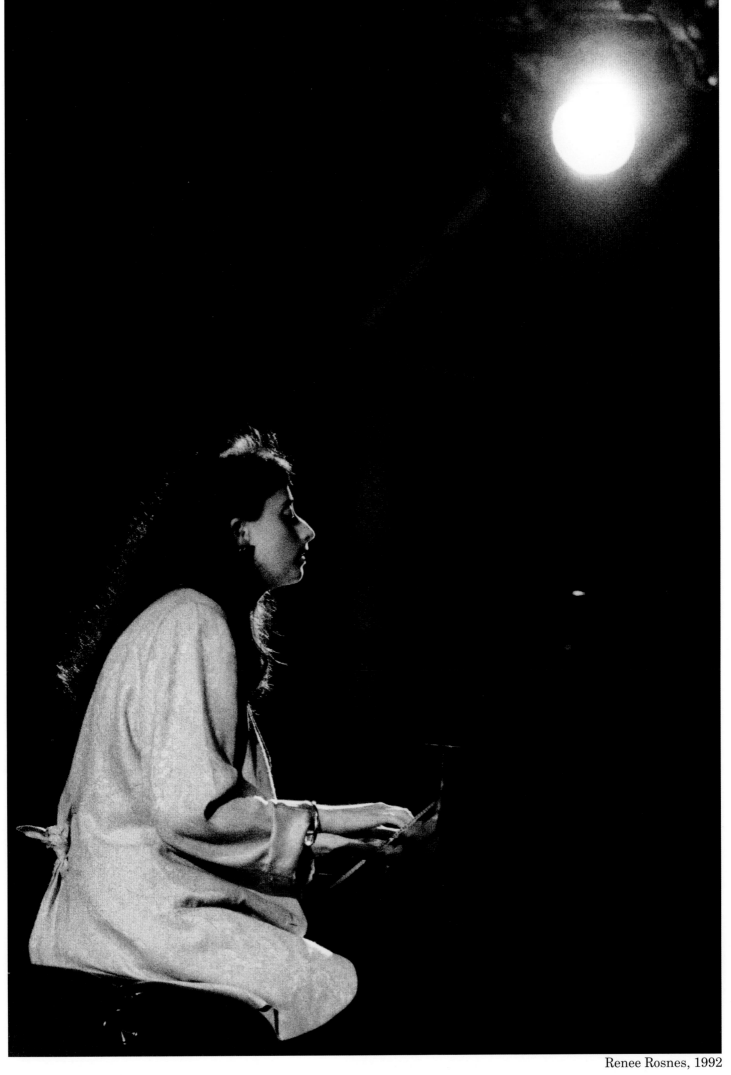

Renee Rosnes, 1992

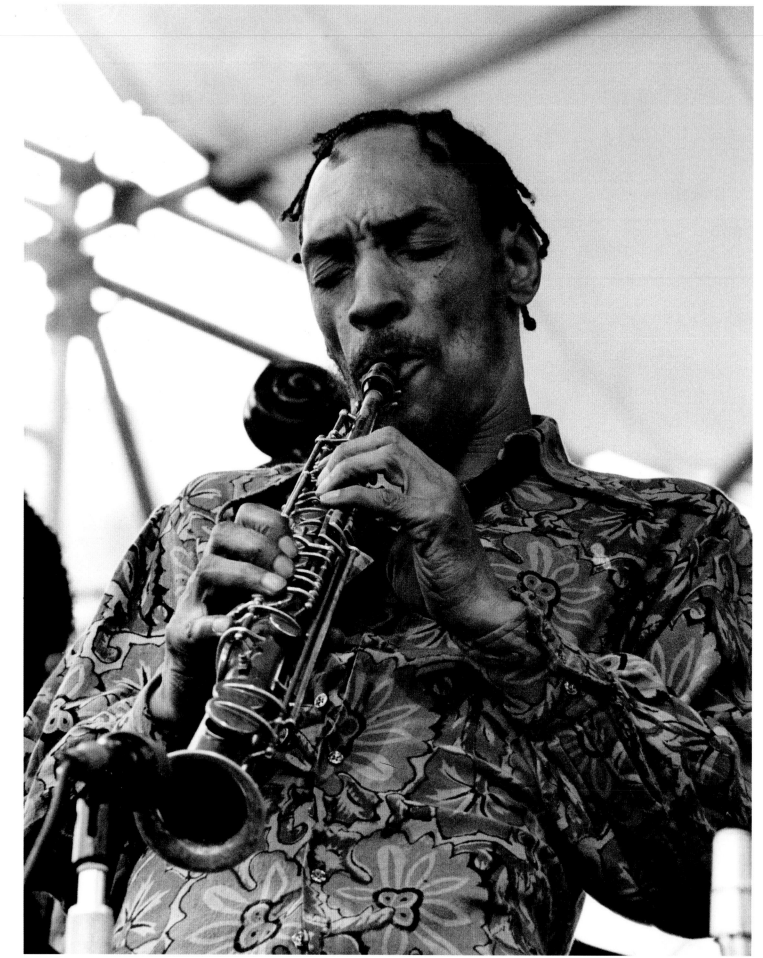

Sam Rivers, 1973

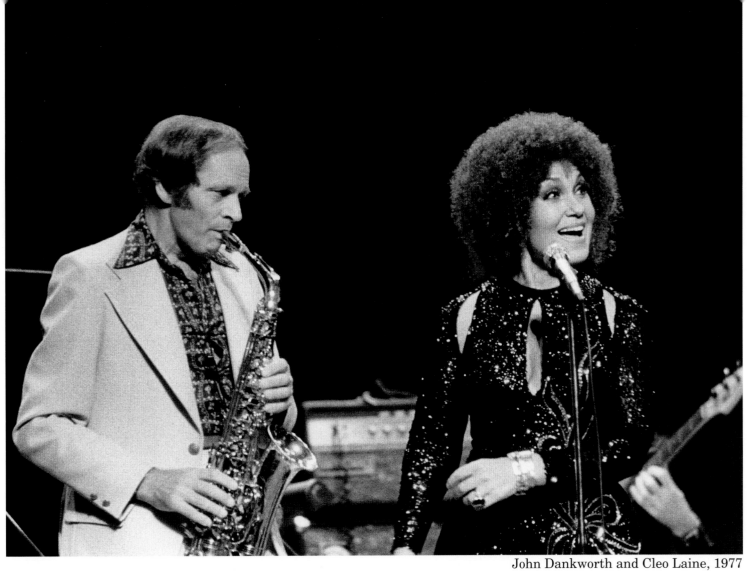

John Dankworth and Cleo Laine, 1977

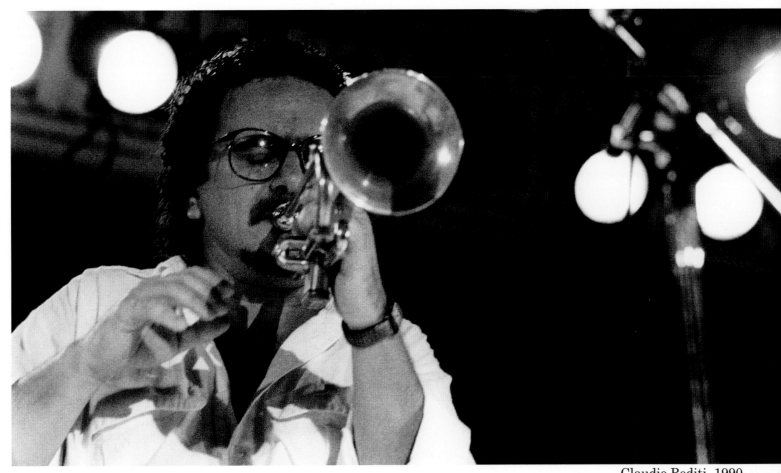

Claudio Roditi, 1990

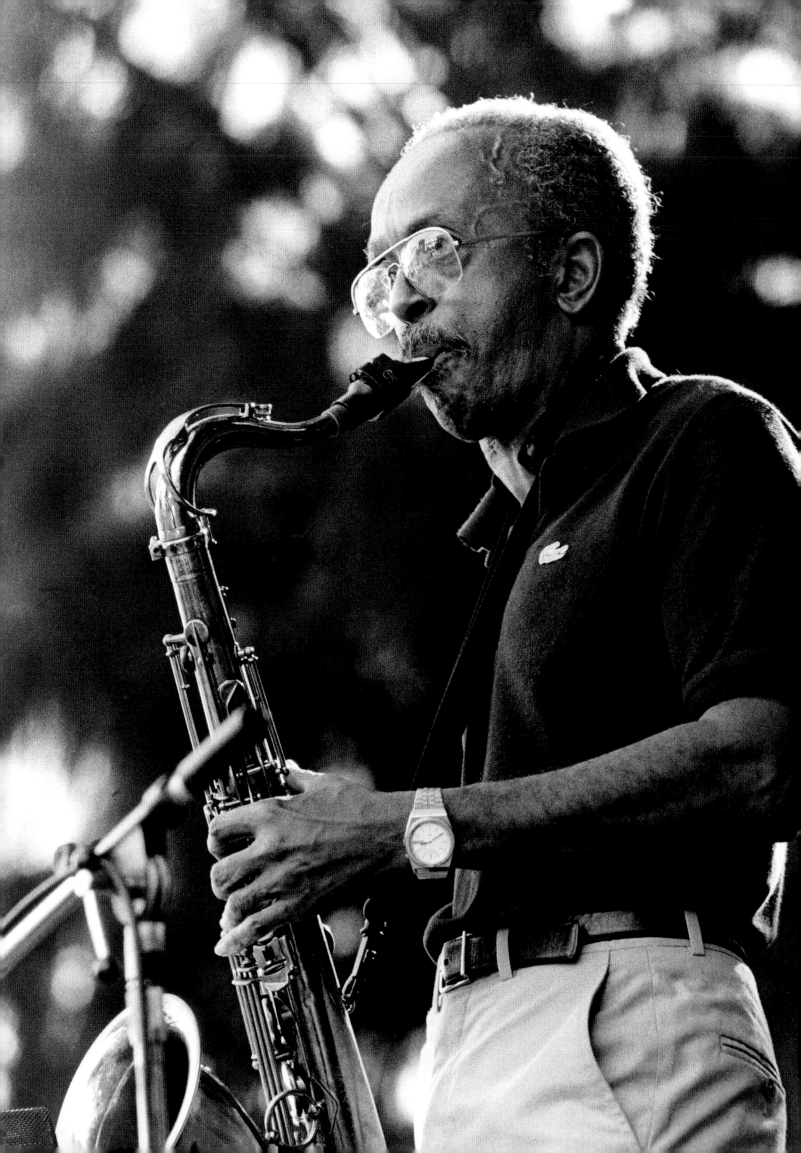

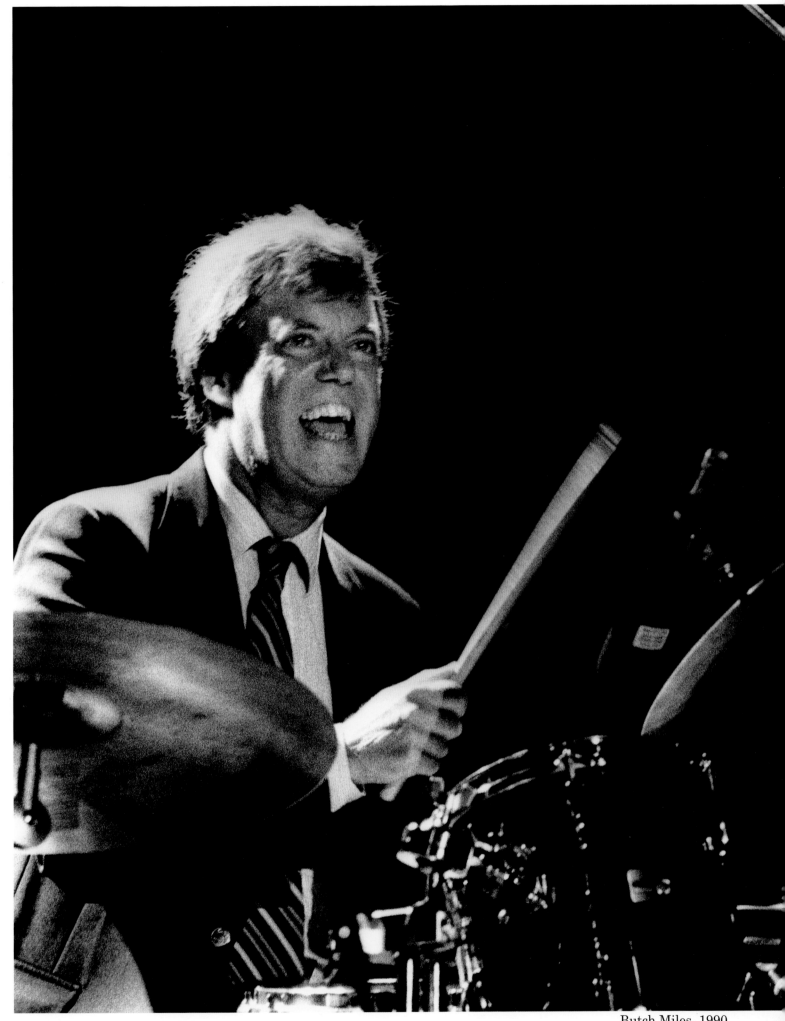

Butch Miles, 1990

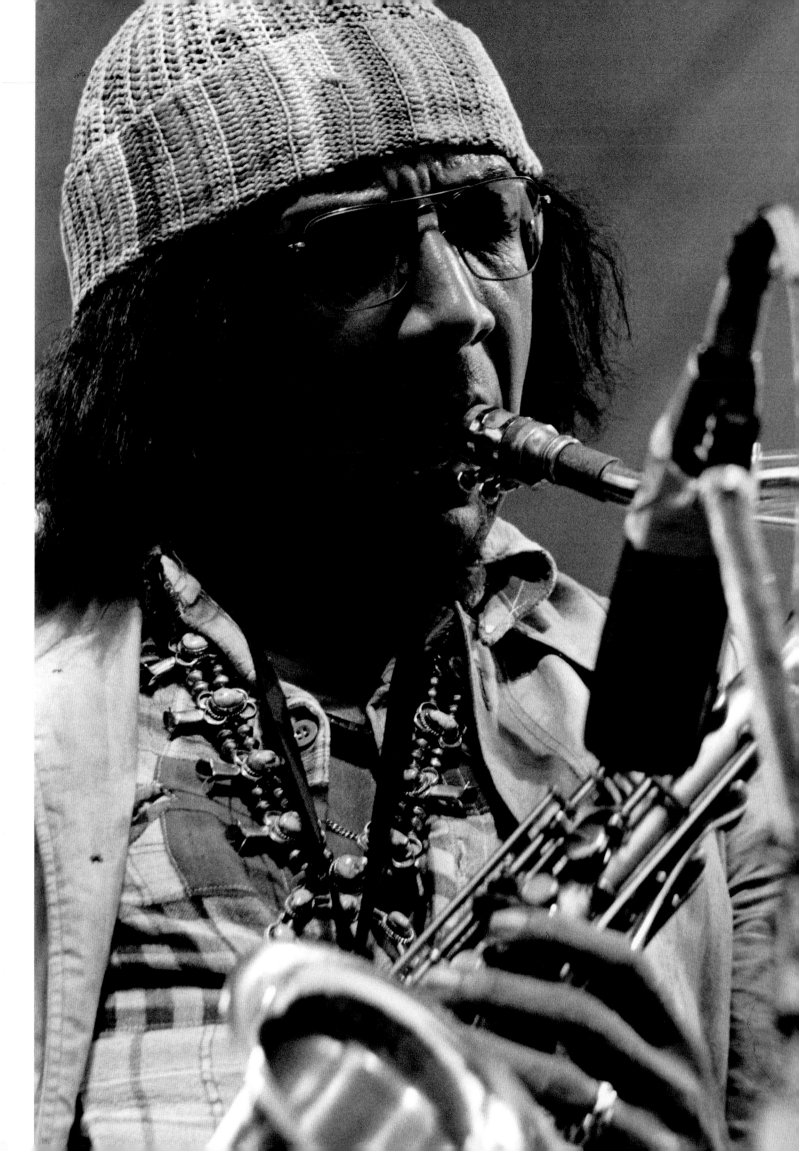

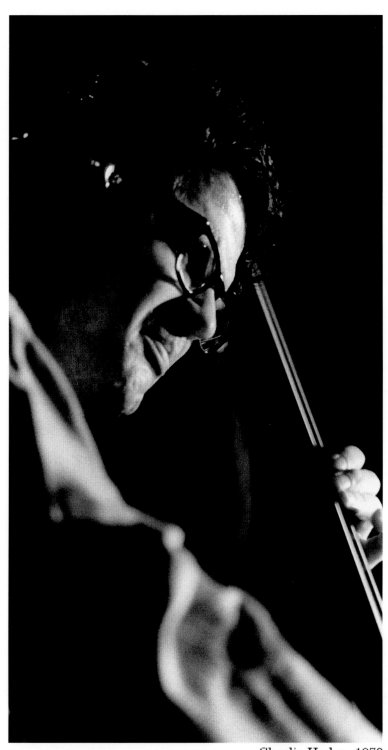

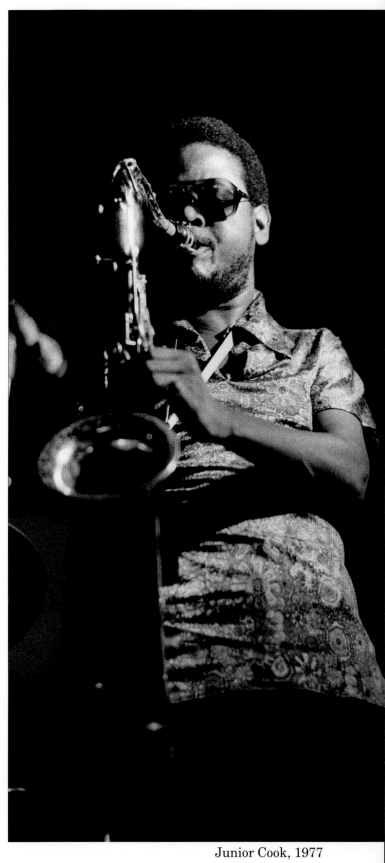

Charlie Haden, 1973

Junior Cook, 1977

Charles Lloyd, 1973

155

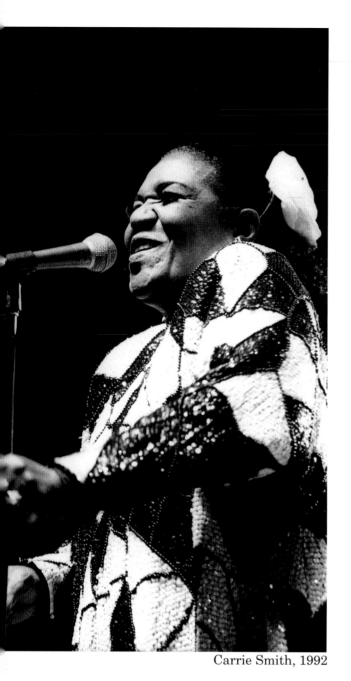

Carrie Smith, 1992

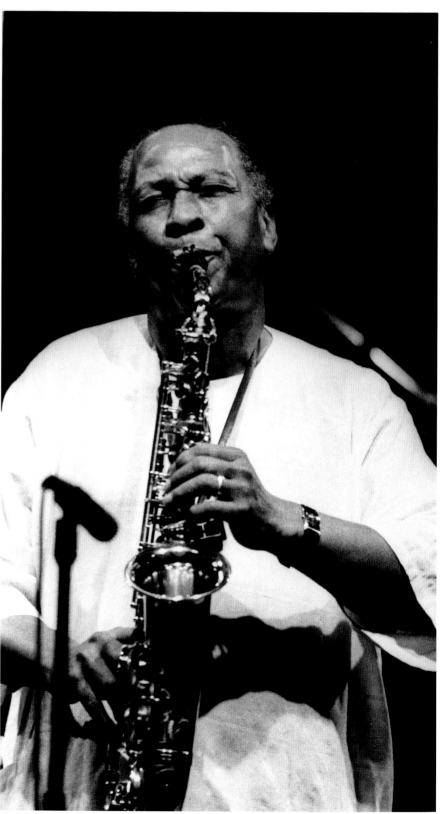

Frank Morgan, 1992

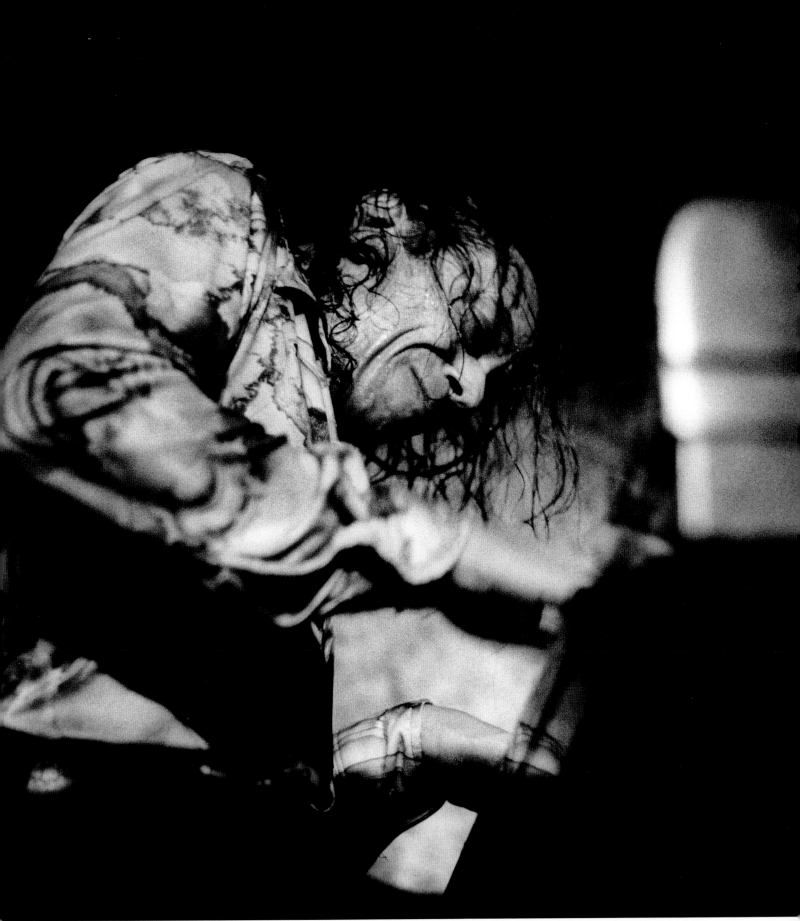

Horace Silver, 1977

"I came to a point in my career where I said to myself, 'Well, I'm going to find myself, there's something in my playing that's original.' That's when I decided to take my Bud Powell collection and my Monk records and all the other records and put them in the closet and lock the door and just work on trying to develop that part of the solo playing that I felt was not Bud but was *me*." —Horace Silver

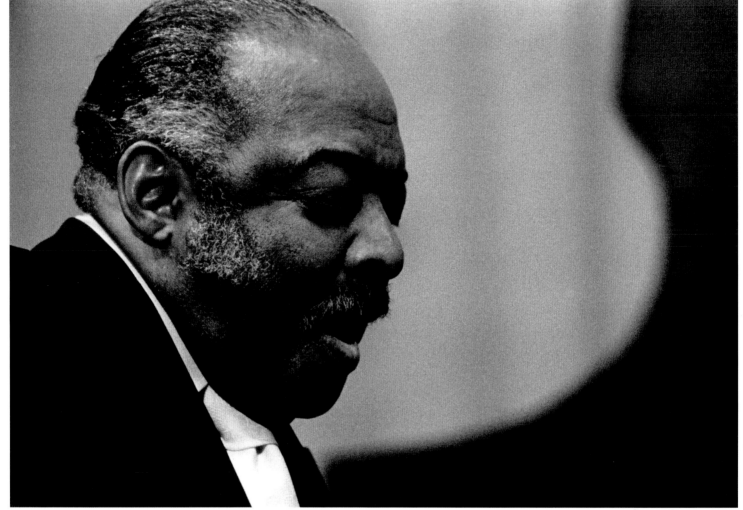

Count Basie, 1976

"Everything was mostly fun, the whole thing." —Count Basie

Index

WOODFORD PRESS
(A division of Woodford Publishing, Inc.)

Jon Rochmis
Editor

Jim Santore
Art Director

Laurence J. Hyman
Publisher and Creative Director

David Lilienstein
Marketing/Distribution Director

Kate Hanley
Assistant Editor

Tony Khing
National Account Executive

Paul Durham
Marketing Assistant

OTHER BOOKS ABOUT MUSIC BY WOODFORD PRESS

GOING TO CHICAGO: A Year on the Chicago Blues Scene, 1990
DAMN RIGHT I'VE GOT THE BLUES: Buddy Guy and the Blues Roots of Rock-and-Roll, 1993

ALSO BY WOODFORD PRESS

THREE WEEKS IN OCTOBER: The Official Book of the 1989 'Bay Bridge' World Series
TALES OF THE DIAMOND: Gems of Baseball Fiction, 1991
A SERIES FOR THE WORLD: The Official Book of the 1992 World Series
A SERIES TO REMEMBER: The Official Book of the 1993 World Series
NUGGETS ON THE DIAMOND: Professional Baseball in the Bay Area from the Gold Rush to the Present, 1994
PORTRAIT HOLLYWOOD: Gary Bernstein's Classic Celebrity Photographs, 1994

ABOUT THE PHOTOGRAPHER

David D. Spitzer is a fine-art photographer, exhibiting artist, college professor and jazz aficionado. He began photographing jazz musicians in 1972, and his images appear in books, periodicals and on album and CD covers. Mr. Spitzer, a member of the Art & Philosophy department at Miami-Dade Community College, instructs courses in humanities, art appreciation and philosophy. His work has been published in seven books, including *The Encyclopedia of Jazz of the Seventies* by Leonard Feather and Ira Gitler (1977, Horizon Press, New York), *Jazz Spoken Here* by Wayne Enstice and Paul Rubin (1992, Louisiana State University Press, Baton Rouge) and *JazzTalk* by Robert D. Rusch (1984, Lyle Stuart Inc., Seacaucus, N.J.).